Yellowstone

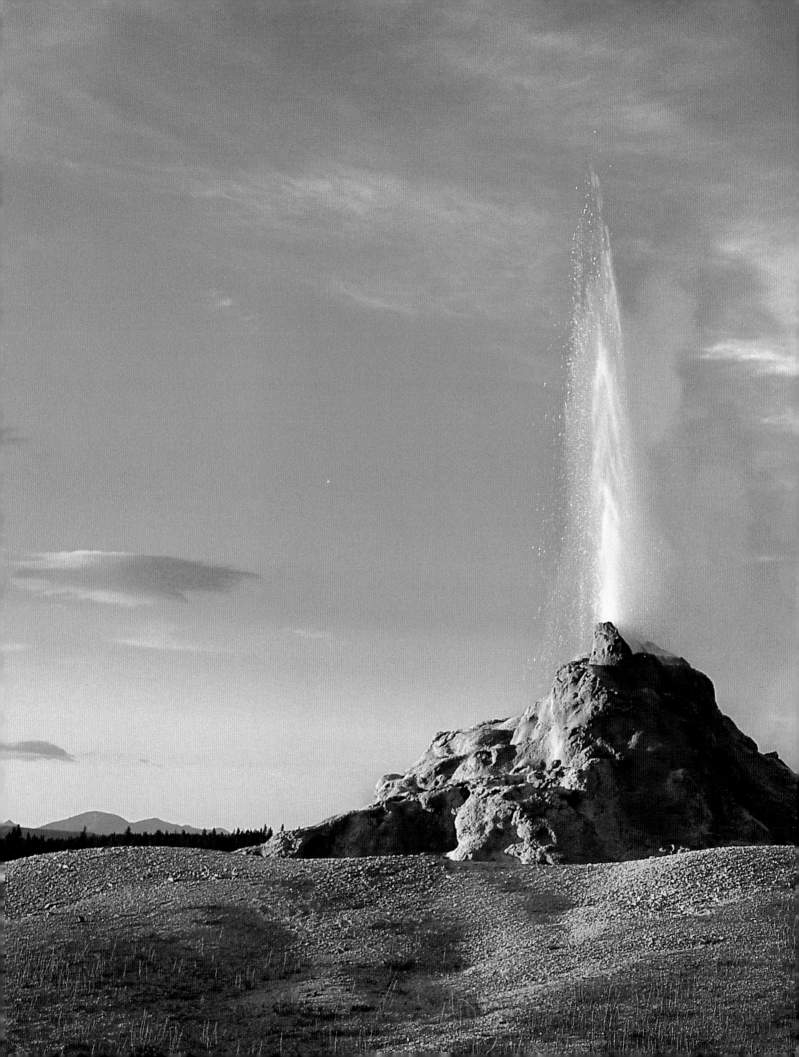

Yellowstone

NORBERT ROSING

TEXT BY NORBERT ROSING
WITH LAUREL AZIZ

FIREFLY BOOKS

A FIREFLY BOOK

Cataloguing in Publication Data

Rosing, Norbert
 Yellowstone

ISBN 0-55209-238-0

I. Yellowstone National Park – Pictorial works. I. Title.

F722.R67 1998 917.87'52'00222
C98-930014-5

Published in Canada in 1998 by
Firefly Books Ltd.
3680 Victoria Park Avenue
Willowdale, Ontario M2H 3K1

Published in the United States in 1998 by
Firefly Books (U.S.) Inc.
P.O. Box 1338, Ellicott Station
Buffalo, New York 14205

We acknowledge the financial support of the Government of Canada through the Book Publishing Industry Development Program for our publishing activities.

Produced by
Bookmakers Press Inc.
12 Pine Street
Kingston, Ontario K7K 1W1

Design by
Janice McLean

Color separations by
Friesens
Altona, Manitoba

Printed and bound in Canada by
Friesens
Altona, Manitoba

Printed on acid-free paper

PREVIOUS SPREAD: RELEASING A THIN JET of steaming water, **White Dome Geyser** is distinguished by a large cone of geyserite. A **wolf cub**, BELOW, is a promising sign that *Canis lupus* is becoming successfully established in the park. RIGHT: Yellowstone River's **Grand Canyon** measures 4,000 feet across and is colorfully accented by red and yellow rock. Seven layers are visible in its walls, a dramatic marking of geologic time. The layers include deposits of volcanic ash, glacial till from the last Ice Age and sediments left when the territory was flooded.

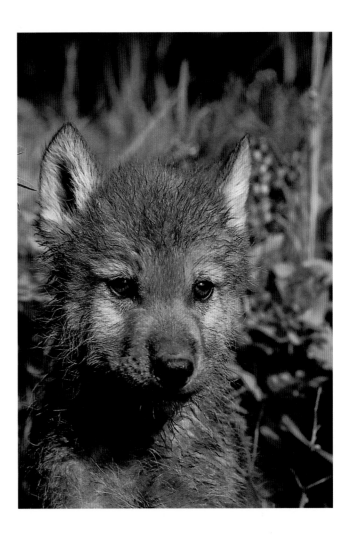

BOOKINGHAM PALACE BOOKSTORE
580 4400 32ND ST.,
VERNON, B.C.
V1T 9H2
PH:260-6274
GST# 138314794

SALE PRICE $11.95

Sun Mar23-03 2:05pm
Inv: 168226 C 00

Title/ISBN	Qty	Price Disc	Total Tax
*6:BARG	1	11.95	11.95 1

	Subtotal	11.95
	Tx1 GST	0.84

Items	1 Total	12.79
	Cash	20.00
	Change Due	7.21

Returns require this receipt
Returns accepted up to 7 days from
date of purchase

Acknowledgments

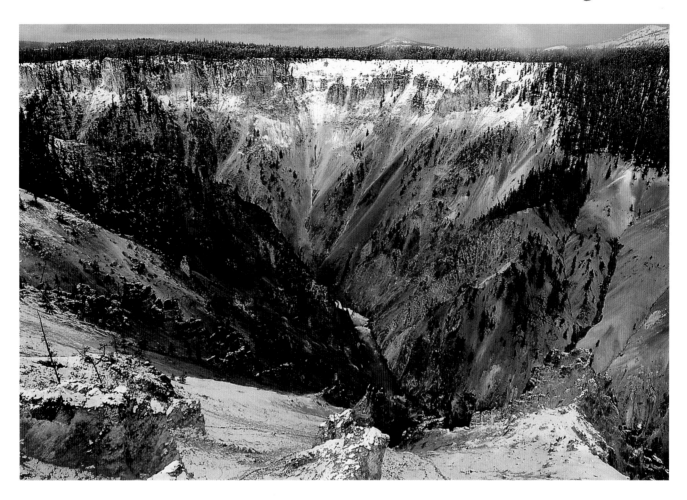

Without the generous assistance of many people, *Yellowstone* would not have been possible. I would like to express a special thanks to my wife Elli, who brought both intelligence and enthusiastic support to the project, standing by me during the good days and the bad, lugging backpacks and tripods through the sweltering summer and the bitterly cold winter. I would also like to thank Ann Deutch and Tom Hougham, park rangers at the Old Faithful Visitor Center; Ralph Taylor, David Liking, Jack Hobart, Lynn Stephens, Rocco Paperiello, Graham Meech and other members of GOSA (the Geyser Observation and Study Association) for sharing information; Stan Osolinsky, a dear friend and colleague, for his tremendous help in organizing the Yellowstone tour; Doug Chapman from Montana Aircraft; James Halfpenny and Diana Thompson for their great knowledge of wolves; Sandy Nykerk and Larry Heycock for botanical advice; Doug Hilborn; Delta Airlines for excellent flight service; and the staffs of the Old Faithful Inn and the Snow Lodge.

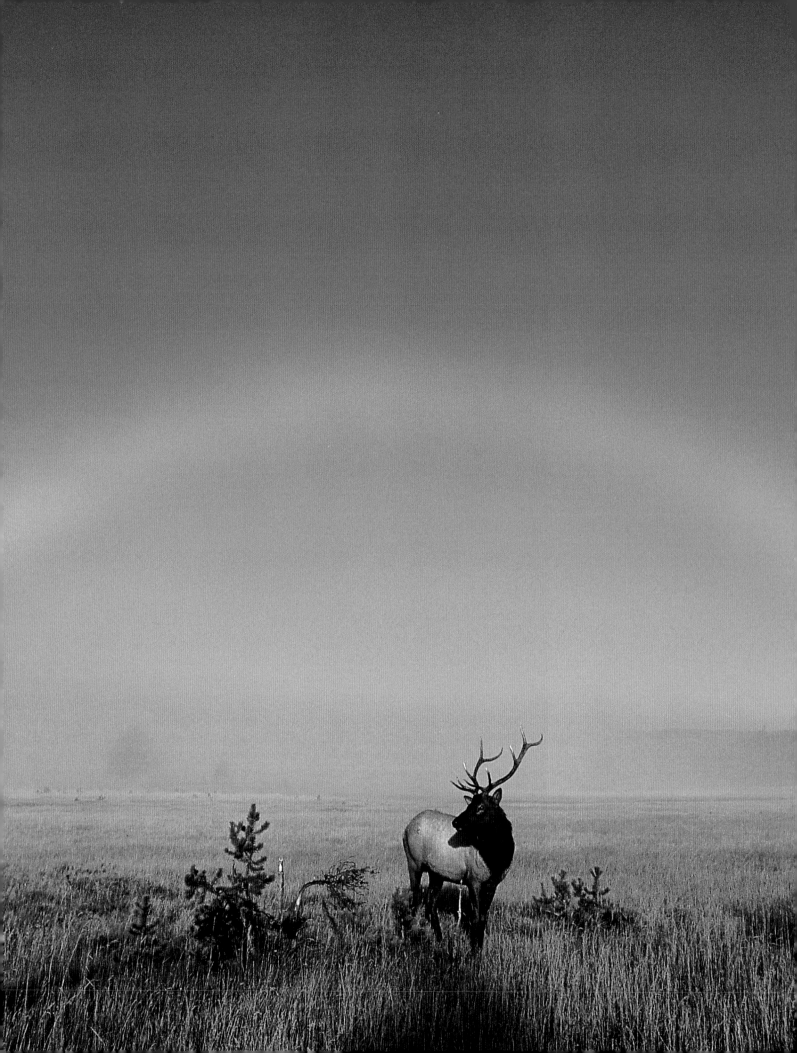

Contents

IN THE EARLY-MORNING LIGHT, A FOGBOW arches above a **bull elk**, LEFT. Fogbows occur when the low sun shines into the fog's suspended water droplets, which fragment the light into its spectral components. Elk roam freely in the park, and in spring and fall, they frequent the meadows along the Madison River and between Mammoth and Old Faithful. In summer, the elk move to higher meadows. While they attract the interest of human visitors, elk also play an important role in the predator-prey cycle of the park's ecosystem. It is estimated that wolves take down a large elk every two to six days.

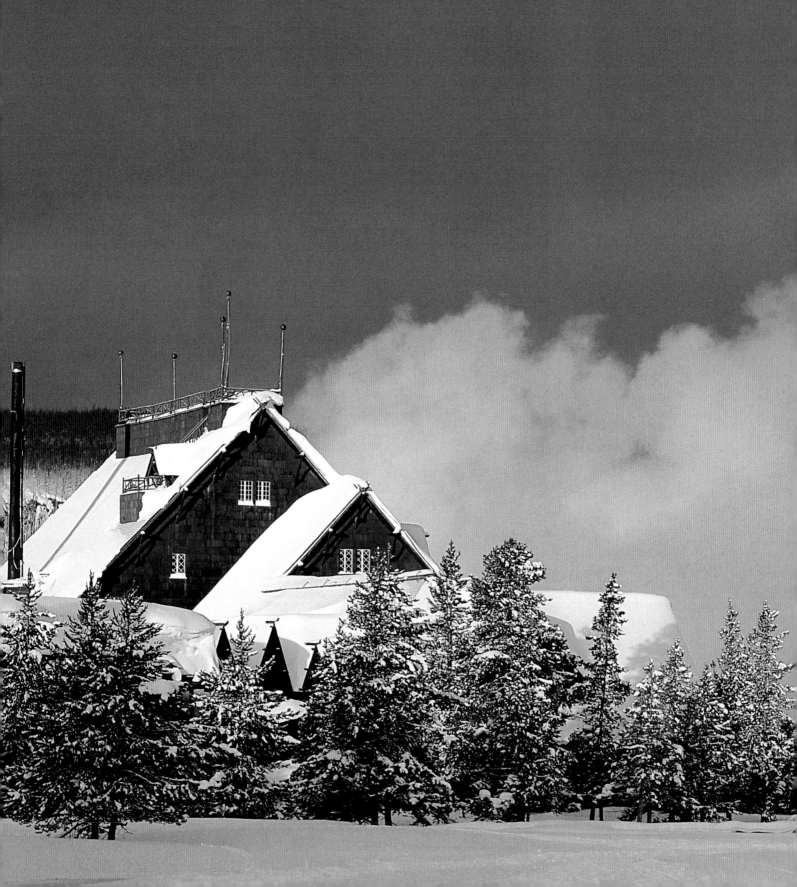

WORLD OF WONDERS

THE FIRST HINT OF ACTIVITY IS THE SOUND OF WATER lightly splashing from Old Faithful's vent. As the world's most reliable geyser gathers strength, the tentative spurts rise and fall intermittently above its sinter-encrusted cone. Then, without further warning, a climbing 120-foot column of water blasts from the Earth's rocky gut, and Old Faithful utters a low, primordial growl as the boiling torrent collides with the cool air. Diaphanous clouds of steam waft from the spray, and there is the slightest sensation of the ground rumbling underfoot.

Old Faithful's sparkling spring rockets skyward more than 20 times a day with the force and fury of a fire hydrant snapped off at street level. Nothing prepares visitors, whether newcomers or old hands, for its high drama. Old Faithful has become the very symbol of Yellowstone National Park, which has more geysers, colorful hot springs and trickling terraces crammed into one place than any other similar-sized area in the world.

CLOSED IN THE DEAD OF WINTER, **Old Faithful Inn**, LEFT, is the hub of visitor activity once it resumes business in May, an unwavering practice since it first opened in 1904. Billed as the largest log structure in the world, the Inn (not the first hotel in the park—there were already four luxury accommodations when it was built) is unique because its architectural style, labeled "rustic," reflects the personality of the surrounding land as envisioned by architect Robert Reamer. "To be at discord with the landscape," Reamer once said, "would be almost a crime."

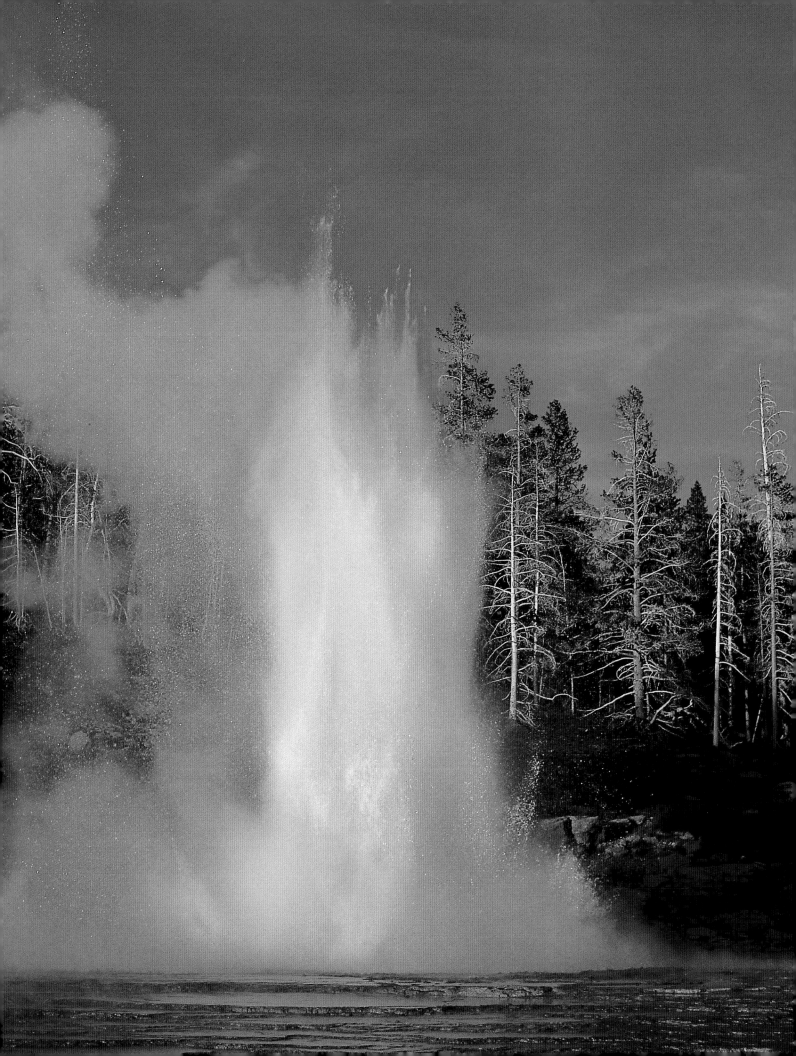

While these hydrothermal wonders represent the 125-year-old rationale for protecting the region that we now know as Yellowstone, the park is much more than a geyser showcase. A link to the past, the geology of the park connects us to a younger, hotter and more volatile Earth. As one of the world's last bastions of large mammals, Yellowstone is a reminder of precontact life in the New World. Its larger-than-life mixed landscape, featuring canyons, waterfalls, alpine meadows, lush valleys and dense young forests bordered by breathtaking mountain peaks, is a rugged wilderness oasis in our increasingly urbanized world. Perhaps the most curious of all are the teeming communities of primitive single-celled organisms that can survive in the hot pools and springs at temperatures above the threshold for photosynthesis. These heat-loving bacteria provide a window to the earliest life-forms that evolved on our planet billions of years ago.

Since the beginning of human history on this continent, people have found sustenance in Yellowstone. The park's records indicate that human inhabitants have traveled through the Yellowstone area for thousands of years. Around the time of the retreat of the glacial ice—12,000 years ago—people of the Clovis culture lived here. Also known as the Llano, these Paleo-Indians radiated throughout North America from their Western origins, where they were hunters of big-game mammals such as mastodons and mammoths. Such prehistoric cultures disappeared with the extinction of their prey.

Among modern peoples, members of the Shoshone Nation inhabited Yellowstone as early as 1200. Native Americans used the region as a hunting ground and obtained obsidian to make tools such as arrowheads and spears. A durable, shiny, glasslike volcanic rock that contains trace elements unique to the region where it is formed, Yellowstone obsidian has been found as far away as Ohio. By the early 18th century, only the Sheepeaters of the Shoshone lived in Yellowstone year-round, although many nomadic bands made seasonal forays into the territory to

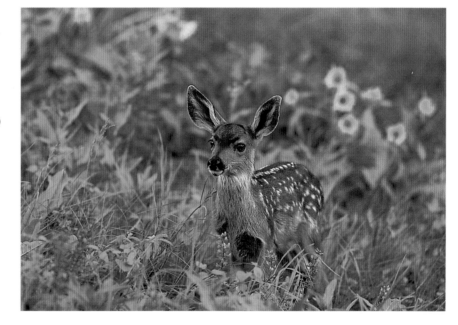

VISITORS WAIT AS LONG AS THREE HOURS to see **Grand Geyser**, LEFT, erupt. Well worth the wait, Grand—located in the Upper Geyser Basin—initially shoots up like a rocket. While the first burst lasts 9 to 11 minutes, it is quickly followed by a second jet that is much higher, reaching up to 200 feet. Two successive eruptions are typical about half the time, but three and four bursts frequently occur. RIGHT: Camouflaged from most predators, a **mule deer fawn** makes its day bed in a colorful spring meadow in June. After the mother gives birth in the long grass, she cleans the fawn thoroughly to render it odorless and thus less vulnerable to attack. While *Odocoileus hemionus* thrives in the park, its cousin the white-tailed deer lost the competition for forage to larger ungulates such as elk and moose and consequently no longer resides in Yellowstone. Spring and summer are prime seasons of the year for mule deer. However, in the harsh Yellowstone winter, with its cold weather and deep snow, it is often difficult for them to find food, and many starve.

hunt the plentiful animals. Judging by the archeological artifacts discovered around geyser basins, the geothermal phenomena—rather than being feared and avoided—may have been the center of community celebration.

While modern native Americans occupied the area for hundreds of years, European-American settlers were slow to recognize Yellowstone. The first white man known to see the park region was a trapper named John Colter, who spent a winter in Yellowstone after finishing his tenure as a member of the Lewis and Clark Expedition in 1806. Colter explored the Yellowstone River, the Grand Canyon, pristine Yellowstone Lake and the Upper and Lower falls. Colter's descriptions of Yellowstone—like those of St. Louis trapper Jim Bridger who followed him some 20 years later—were too spectacular to be believed back in the city.

But the tales continued to come from frontiersmen who retraced the steps of Colter and Bridger. The public desire for an official story led to three formal expeditions, the first of which set out in 1869. Three prospectors from Diamond City, Montana Territory—Charles Cook, David Folsom and William Peterson—saw many of the Colter highlights when they spent 36 days in Yellowstone exploring and mapping the region. They, too, followed the Yellowstone River to Tower, circled Yellowstone Lake and traveled into the Lower Geyser Basin. When they came upon Yellowstone's Grand Canyon, Cook reported: "It seemed to me that it was five minutes before anyone spoke." The trio was so amazed by the landscape that their adventure ended before they reached the Upper Geyser Basin, which contains two-thirds of Yellowstone's hydrothermal features.

Curiosity about this world of scenic wonders climaxed in 1870, when an expedition of credible citizens from Montana Territory, accompanied by Lieutenant Gustavus C. Doane and an army escort, journeyed to the area. Headed by Henry Washburn, surveyor-general of Montana, and Nathaniel Pitt Langford, who was the official record-keeper and would later become the first superintendent of Yellowstone National Park, the Washburn Expedition

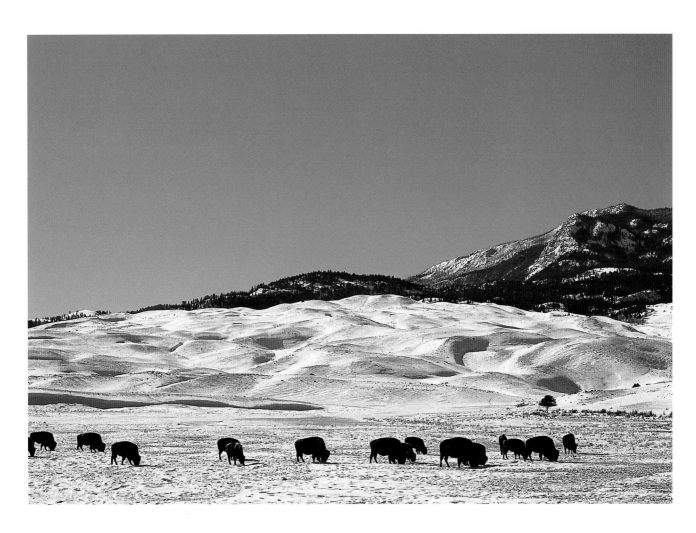

spent a little more than a month in Yellowstone, seeing much of the region and its landforms and naming several of the park's most famous geysers. Upon its return, this crew earned the trust of most people in the West, but publications on the East Coast still treated tales of Yellowstone as American frontier fiction. (Although the question remains a matter of debate, members of this group claim credit, through their diaries, for the birth of the idea for "a great National Park.")

But it was not until the Hayden party made Yellowstone's magic real to the world in 1871 that the park idea was taken seriously. Ferdinand V. Hayden's historic expedition included photographer William Henry Jackson and artist Thomas Moran, who delivered the much-needed hard evidence that persuaded Congress to take steps to preserve the region. In December 1871, bills to protect Yellowstone were introduced in the House of Representatives and the Senate.

Even with the publicity garnered by Jackson's photographs and Moran's illustrations, a heated debate ensued about Yellowstone's "worth." If the region's most spectacular features were without commercial value, argued development-minded congressmen, why preserve it at all? But the works of America's great naturalist writers such as Henry David Thoreau were fresh in the country's consciousness. Nature could not be reduced to a threatening adversary or a resource to be exploited. Rejuvenating, inspiring and spiritual, nature was a joy and an end in itself. If any place on the planet represented the natural world's inherent worth, it was Yellowstone. On March 1, 1872, President Ulysses S. Grant signed the Yellowstone Park Act that set aside 3,472 square miles of western territory "forever, free from settlement, occupancy or sale...for the benefit and enjoyment of the people." The bill made Yellowstone the world's first national park; it remained the only one in the United States until 1890.

To assuage anti-Yellowstone rhetoric in the Legislature, the bill was passed with the understanding that there would be no operating budget for the first national park. Without an "appropriation" to stop abuses, which ranged from

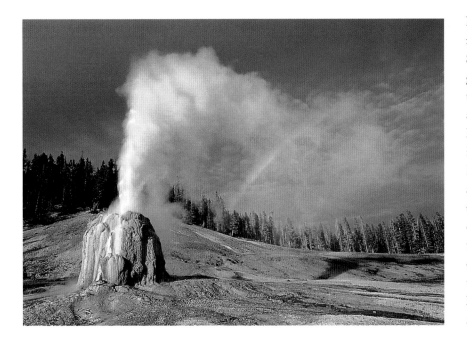

FROM KEPLER CASCADES, IT IS A 90-minute uphill walk to secluded **Lone Star Geyser**, LEFT. This large cone geyser erupts with the most precise timing of all Yellowstone's waterworks and has no record of a dormant period. Every three hours, it jets water 45 feet into the air for 30 minutes. The top of Lone Star's cone has one major vent and several minor openings that contribute to the display. FAR LEFT: **Bison** graze on meadows near the Roosevelt Arch, the North Entrance to the park. Part of Yellowstone's free-roaming herd, these bison are descendants of the herds that once covered the North American plains.

poaching and vandalism to the unregulated establishment of makeshift businesses, the civilian superintendents during the park's infancy were powerless to protect it. But finally, in August 1886, the Cavalry was dispatched from Fort Custer, Montana Territory, to defend the park's resources. The troops remained there for 30 years, until the formation of the National Park Service in 1916.

Once Yellowstone was established, some 1,000 hardy souls traveled annually to experience its wonders. Roughing it in the bush, the adventurers slept in tents or under the stars but were able to travel only a few miles inside the boundaries before becoming entangled in impassable deadfall. Packhorse and foot remained the only means of travel around Yellowstone until the appointment, in 1878, of Superintendent Philetus W. Norris, who understood that improved roads would serve the public's access to the park. By the time Norris left his post four years later, there were more than 150 miles of primitive roadways and the outline of the 140-mile Grand Loop—a figure eight that passes the main highlights

of the park—had taken shape. Completed several years later by the U.S. Army Corps of Engineers, the Grand Loop, still in use today, is linked to each of Yellowstone's five entrances, allowing visitors approaching from any direction a complete tour of the park's most popular sites.

The first luxury hotel, fully equipped with electricity, was opened at Mammoth Hot Springs in 1884. Even as roads and hotels appeared in the wilderness, a Yellowstone excursion remained the exclusive undertaking of the wealthy. In the early years, travelers had to take a train to Corinne, Utah, then embark on a 380-mile stagecoach ride to Virginia City in Montana Territory, which was the closest point of departure for the park. When the train line was finally extended, in 1892, to Gardiner, Montana, near the North Entrance, gentlemen and ladies outfitted in their Victorian Sunday best—complete with starched collars and ankle-length dresses—would climb aboard a 32-passenger Tallyho stagecoach drawn by a six-horse team and head off on a dusty once-around-the-park.

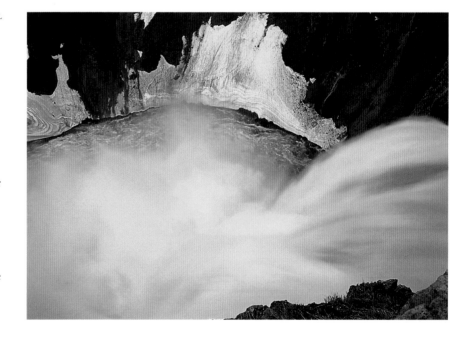

FLOWING IN A GRACEFUL ARC, TORRENTIAL spring runoff from a record winter snowfall spills over the **Brink of the Upper Falls** in early June, RIGHT. Located less than half a mile upstream of the spectacular Lower Falls, this smaller cataract, which drops 109 feet to a quiet pool, is the beginning of the Grand Canyon of the Yellowstone River. The tremendous volume of water flowing over the Upper Falls in spring produces a deafening roar. FAR RIGHT: A **white pelican** paddles through the mist during an early-morning fishing excursion on the Yellowstone River. The clownish-looking *Pelecanus erythrorhynchos*, a seasonal visitor to the park, is almost exclusively a fish-eater and is often seen in cooperative flocks herding schools of fish to make their capture easier. With a nine-foot wingspan and a length of up to 70 inches, the pelican is among the largest of North America's birds.

When automobiles were finally permitted in the summer of 1915 (against the wishes of the stagecoach companies), Yellowstone truly became a park for all the people. Annual admissions of 20,000 before 1916 jumped to 100,000 only seven years later. Today, the park is a mecca for three million naturalists and recreationists annually who enjoy winter and summer facilities, extensive backcountry camping and fishing and more than a thousand miles of trails in addition to the celebrated hydrothermal features.

The challenge in protecting Yellowstone is to safeguard its natural integrity, both inside and beyond the legislated boundaries. As glorious and unique as the park region is, it does not exist in isolation. For example, its hydrothermal phenomena are sensitive to disruption in the aquifers and drainage outside the park; seasonally migrating elk can travel more than 100 miles in search of food; grizzlies are wide-ranging creatures that call hundreds of square miles home. Yellowstone's fortunes are tied to the ongoing health of the Greater Yellowstone Ecosystem, a 15-million-acre ecosystem (by moderate estimates) that includes Grand Teton National Park to the south, six national forests and three national wildlife refuges.

If Yellowstone is to remain viable, it must, to some degree, be left to its own wild instincts. "One of the many truths about Yellowstone," notes the National Park Service, "is that by preserving this special place, we preserve much more than we understand today." Proof of Yellowstone's self-direction is evident daily in the park's features. Old Faithful has erupted more than a million times since the Washburn Expedition first visited the region. Regardless of the season, the weather or the time of day, the geyser soldiers on, humbly outlasting generations of witnesses. And yet, despite our endless observations, we remain largely ignorant of its mysterious inner workings. That fact makes Old Faithful no less amazing to the millions of admirers who see it every year. Each time a cheering crowd celebrates this symbol of Yellowstone, it pays homage to America's wild nature—past, present and future.

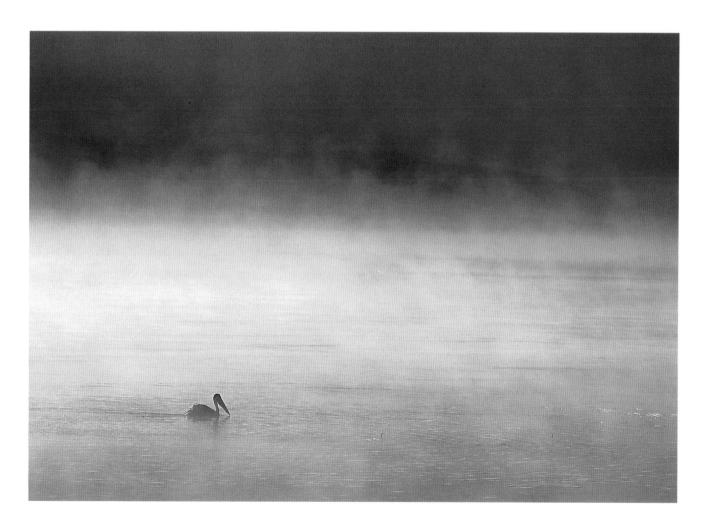

A HERD OF **pronghorns**, RIGHT, AWAITS AN OPPORTUNITY TO cross the swollen Gardner River after a heavy rain. Unique to North America, pronghorns are very social animals that prefer open grassland and grassy bushland. They have adapted for survival as a plains species by evolving a wide field of vision, and they can detect movement up to four miles away. Once, more than 12 pronghorn species existed on this continent, but these are the only survivors. The best places to view pronghorns in Yellowstone are in the meadows at the North Entrance and in the Lamar Valley.

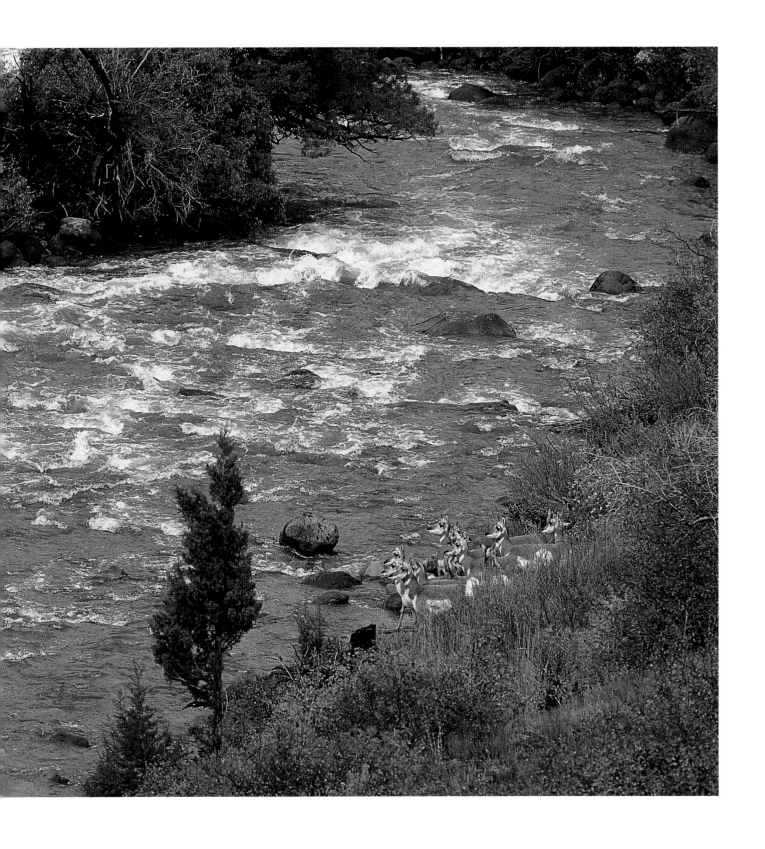

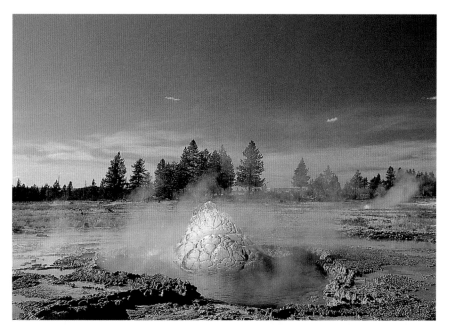

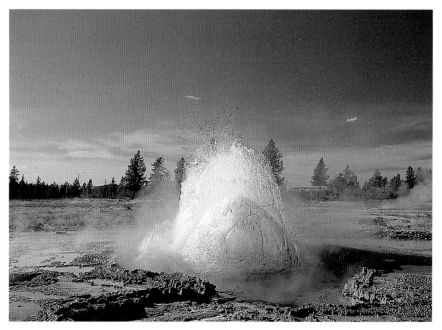

Burbling and sputtering almost continuously, this **spring in the Lower Geyser Basin**, above, top and right, almost conforms to a class of hydrothermal features known as "perpetual spouters," constantly active fountains that are neither noneruptive springs nor true geysers. It does not precisely fit the definition, however, because its bubbling is occasionally interrupted by a few seconds of near calm. Every three minutes, the water rises in the geyser, and a huge bubble appears, then bursts a second later.

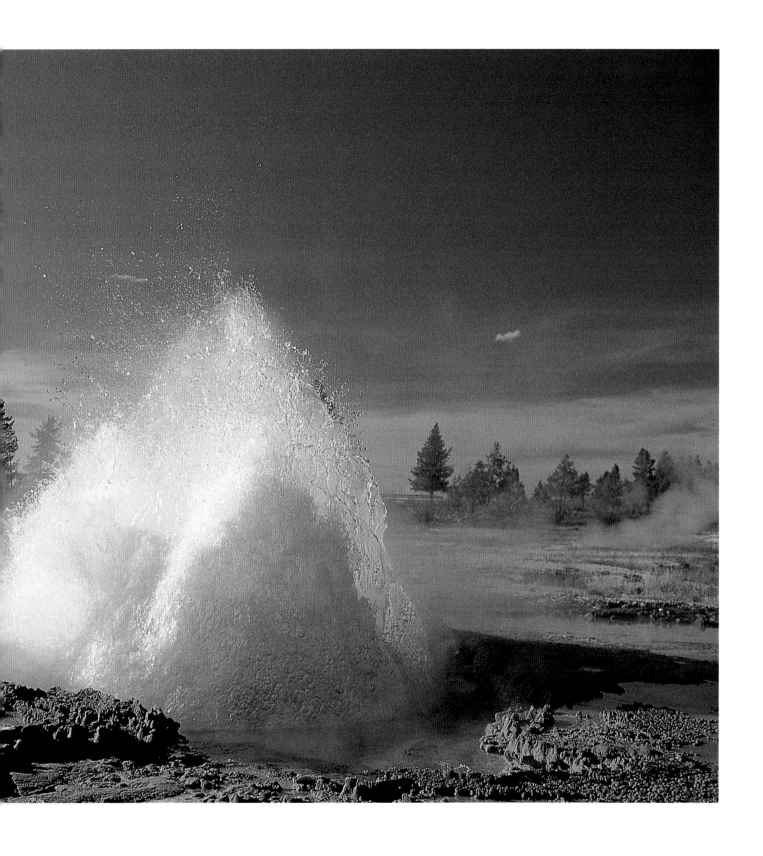

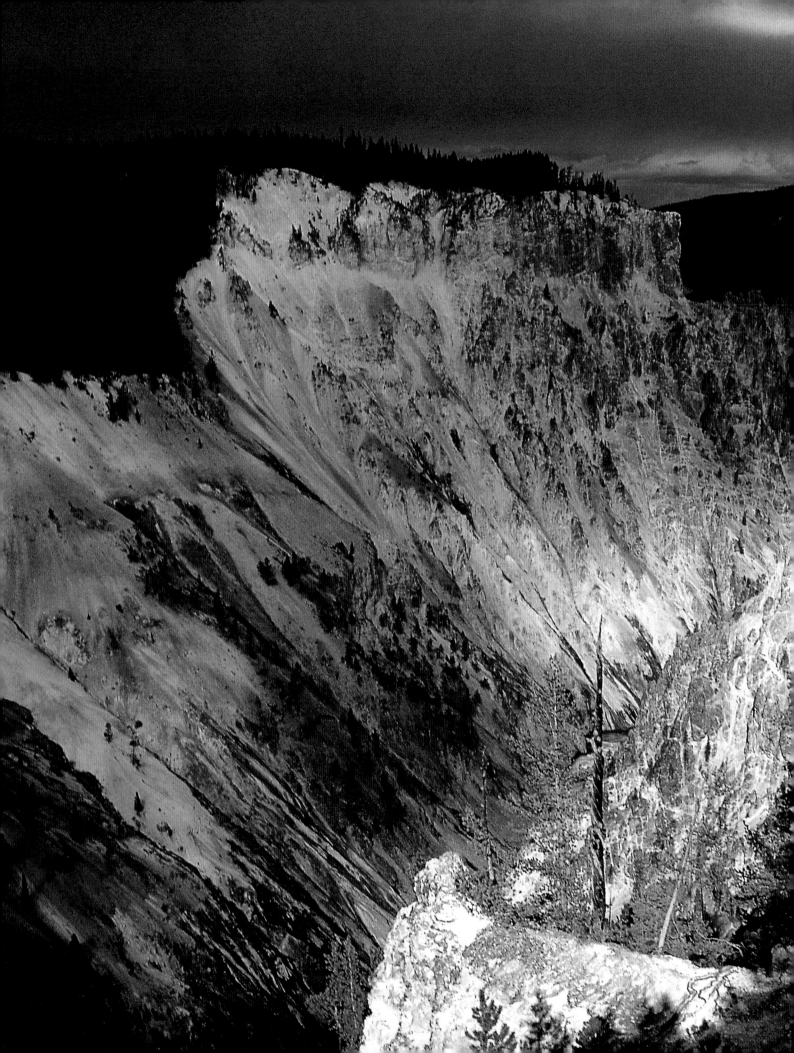

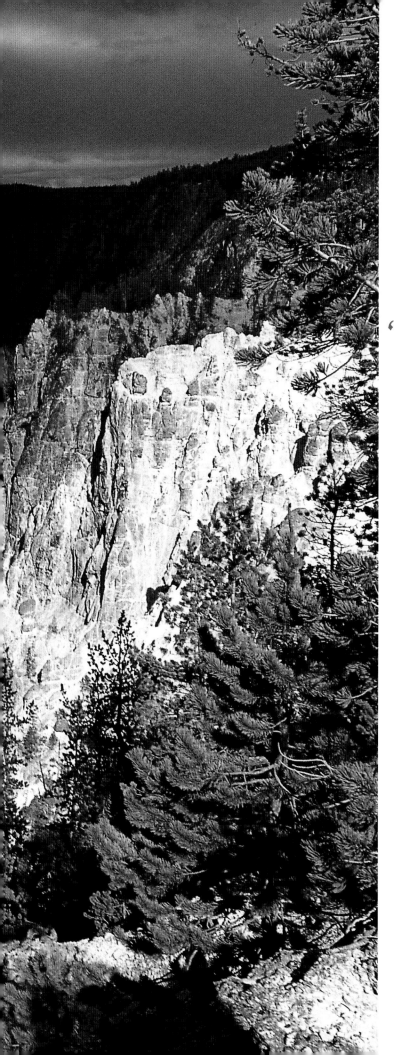

Main Attractions

VISIONS OF GRANDEUR

"MY MIND IS SO CONFUSED," WROTE NATHANIEL PITT Langford, "that I hardly know where to commence in making a clear record of what is at this moment floating past my mental vision." Langford's confession about the majestic beauty of a day spent exploring Yellowstone's canyon and its spectacular falls expresses the incomparable scenic wonders and the overwhelming power of Yellowstone National Park.

Visitors passing through the Roosevelt Arch are destined to feel some of Langford's pioneering reverence. The rolling meadows where pronghorn and elk graze with the massive rock of Electric Peak in the background are a reminder that perhaps the last unspoiled paradise in North America lies ahead. The scale and scope of Yellowstone are instantly apparent. Its breathtaking and diverse landforms surpass anything that might be created by humankind. Only nature working ceaselessly over millennia could manipulate the landscape with such splendor.

THE **Grand Canyon of the Yellowstone River**, LEFT, which is located in the north-central section of the park, is a magnificent 25-mile gorge that combines the grandeur of Niagara Falls with Colorado's Grand Canyon in one breathtaking view. When winter arrives in late September, the canyon receives a light sprinkling of powdered-sugar snow that dampens the soil on the canyon walls, highlighting their colorful layers. By following the hiking trail around the South Rim, a visitor is afforded a fresh perspective of the deep V-shaped valley at each turn.

21

Yellowstone is a land of superlatives. Each of its unique phenomena—geysers, hot springs, waterfalls, sparkling lakes, petrified forests, valleys, mountains and meandering rivers—is a majestic symbol of wilderness. As commentators throughout history have noted, any one of these alone is worthy of preservation as a monument.

It has taken millions of years to create and shape the face of the Yellowstone we see today. Similarly, it is no surprise that each day in the park is different and each of its spectacles complex. In July, the meadows become oceans of colorful flowers as far as the eye can see. By fall, the bull elks are using the same territory to battle for harems of females. At Mammoth Hot Springs, glistening terraces change completely over the course of a few months as the marvelous pools quietly dry up and die. The Grand Canyon of the Yellowstone River, which is the centerpiece of every visitor's trip, cannot be appreciated with only one viewing. With every change of season and the sun's position, the canyon walls catch the light in a slightly different way, depending on where you stand, and its layers of rocky sediments glow in a kaleidoscope of ever changing colors.

The inherent magic of Yellowstone transcends comparison with the world's other natural wonders. The abundance of its riches sets it apart and demands something extra from those who travel here. Langford observed that visitors can witness and readily appreciate the beauty of individual landmarks such as Niagara Falls, taking away a vivid memory of the place that becomes a touchstone for reliving their experience. But the sensory overload one experiences in Yellowstone is, in Langford's words, "a new phase in the natural world…while you see and wonder, you seem to need an additional sense, fully to comprehend and believe."

ONE OF YELLOWSTONE'S MOST RECOGNIZABLE LANDMARKS, **Liberty Cap** at Mammoth Springs, RIGHT, is a 37-foot-high travertine deposit left behind by a now defunct hot spring. Layers of calcium carbonate, dissolved in the water that once flowed from its top, gradually built up to form the 2,500-year-old cap. FAR RIGHT, a bird's-eye view of the torrential waters that roar over the **Lower Falls**. When the river is swollen by spring runoff, an estimated 60,000 gallons of water per second can pass over these falls, spilling 308 feet to the canyon below. Several vantage points along the canyon rim offer views of this spectacular cataract. While water flows from elevated plateaus to low-lying regions in at least 25 areas within the park boundaries, the Lower Falls was singularly mesmerizing for Yellowstone's early explorers. "The Almighty has vouchsafed no grander scene to human eyes," wrote Nathaniel Pitt Langford, the official record keeper for the Washburn Expedition of 1870, one of the pioneer exploration parties that catapulted Yellowstone to national prominence. "There is a majestic harmony in the whole, which I have never seen before in nature's grandest works."

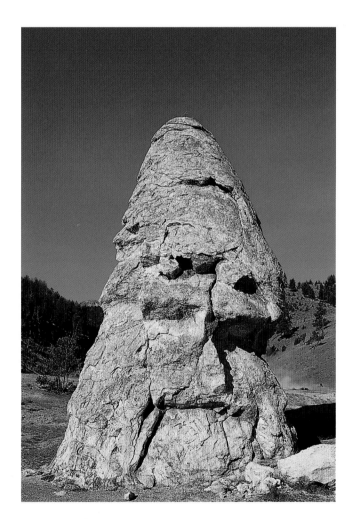

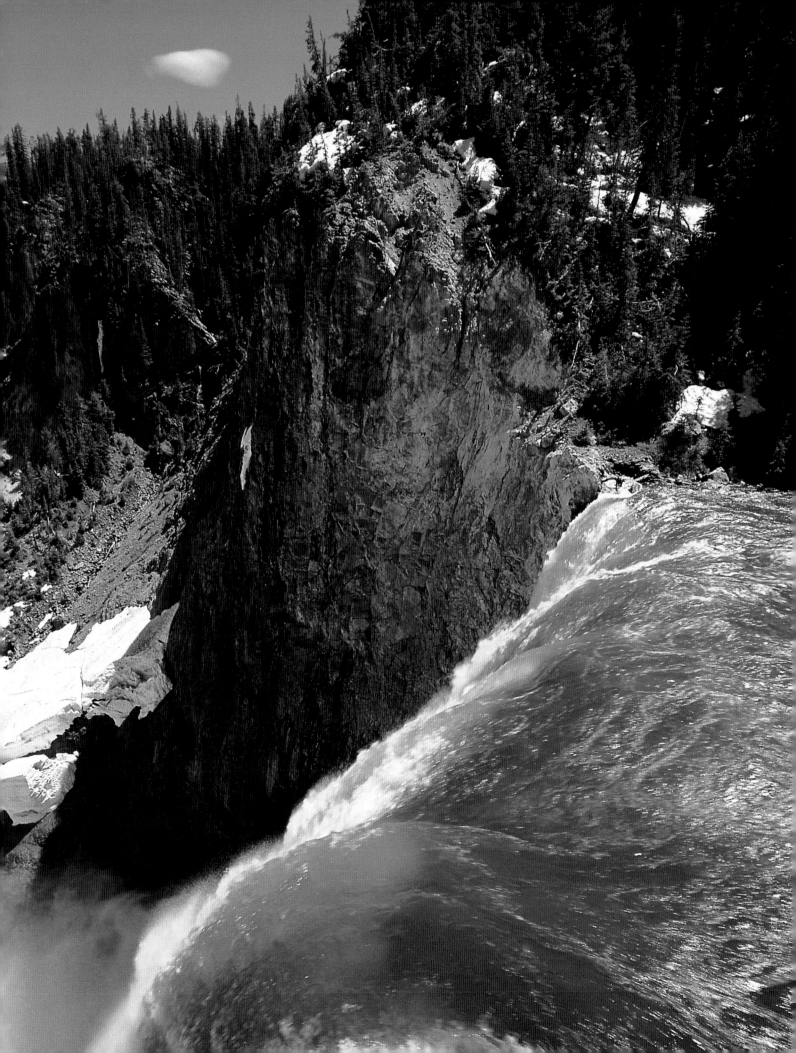

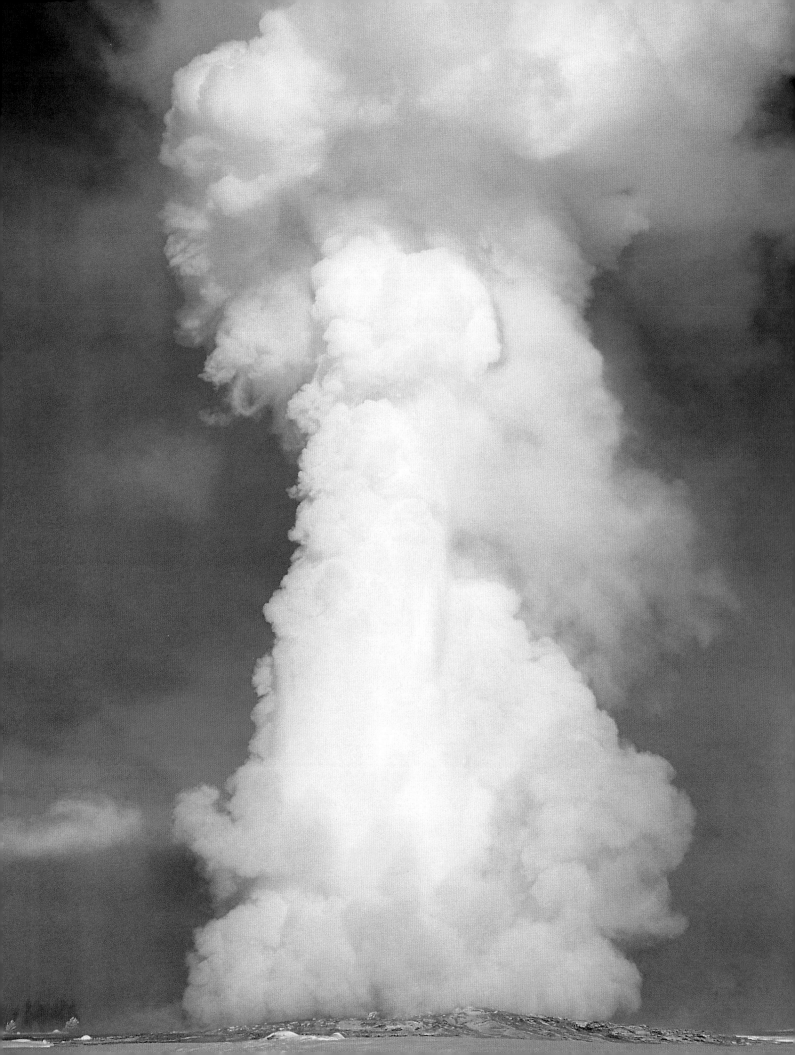

Big Cone Geyser, ABOVE, IS A REMNANT ROCKY RIDGE SITUATED
in Yellowstone Lake. In early spring, rising levels of meltwater
from winter runoff flood the cone. Largely dormant, Big
Cone occasionally erupts a few feet into the air. Nearby, the
legendary Fishing Cone bears an apocryphal reputation for
being a prime fishing spot where anglers could cast a line
while standing on the geyser's cuff and then cook their catch
in its steamy waters. Even in the dead of winter, **Old Faithful**,
LEFT, named by the members of the Washburn Expedition
of 1870, lives up to its reputation as Yellowstone's most
famous and reliable geyser. While larger geysers can be found
throughout the park, none can outdo Old Faithful for its
consistently impressive and frequent eruptions. Located in
the Upper Geyser Basin, it continues to shoot water upward
to 185 feet every day at approximately 80-minute intervals,
winter and summer.

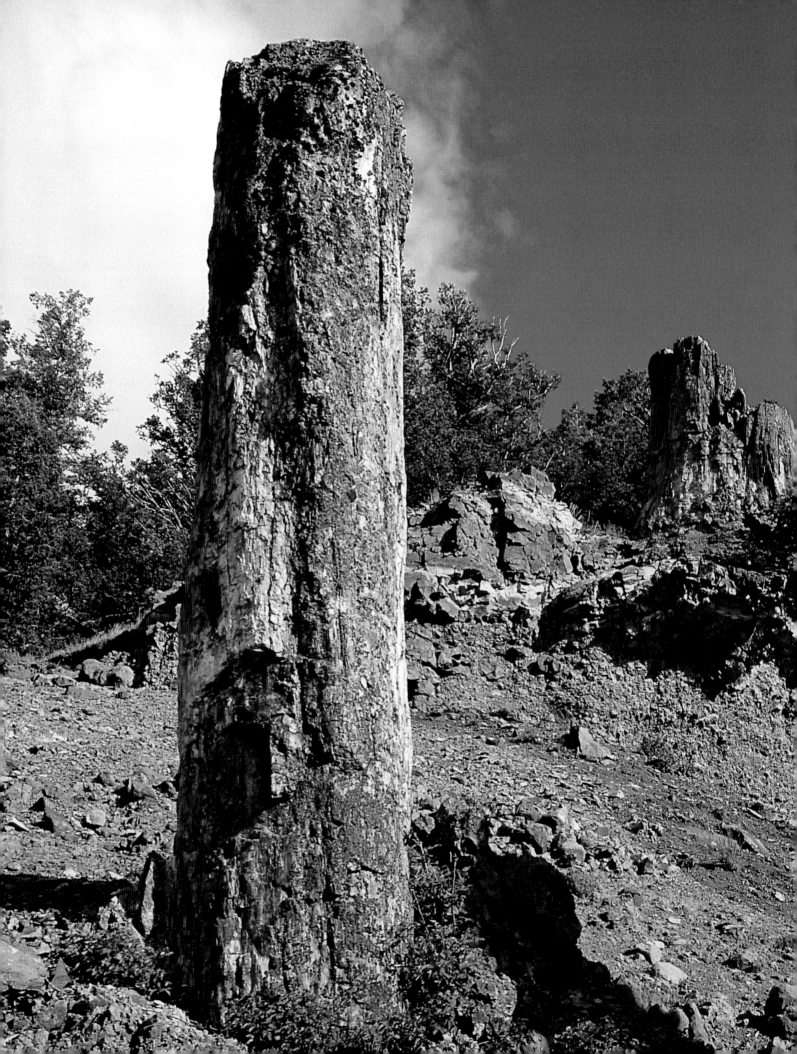

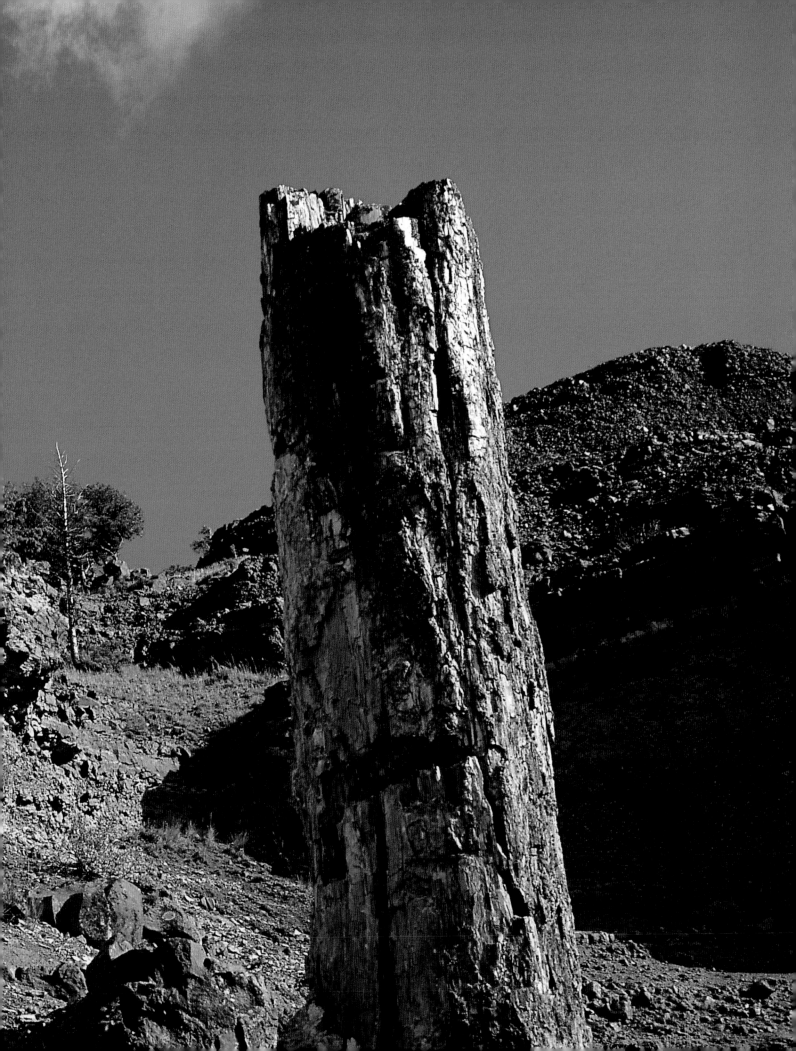

PREVIOUS SPREAD: YELLOWSTONE PARK BOASTS THE LARGEST aggregation of standing stone trees in the world, covering more than 40 square miles. **Petrified trees at Lamar Valley** are the remains of an ancient forest that grew in Yellowstone some 55 million years ago. Once a subtropical region similar in climate to Virginia, Yellowstone was a paradise of plant life that featured hundreds of varieties of trees such as dogwood, hickory, walnut, chestnut, oak and maple. Over tens of thousands of years, these forests were routinely buried in volcanic ash. Silica in the ash dissolved in the groundwater, and newly emerging trees absorbed it through their roots. As the silica circulated through their elaborate cellular network, the trees literally turned to stone from the inside out. The process was repeated many times over the centuries, each new forest taking root on top of the buried, petrified remains of the previous forest. In one area of the park, there are 27 distinct "generations" of fossilized trees. RIGHT: The **Overhanging Cliffs**, which line the road between Tower Falls and Mammoth, resemble the giant stony pipes of a cathedral organ. Extremely volatile periods in Yellowstone's history of volcanic activity were characterized by extensive lava flows. When the lava flows came to an end about 75,000 years ago, many of the park's spectacular sites, such as these basalt cliffs, were created. The most common form of solidified lava, basalt is a dark igneous rock that was extruded to the Earth's surface by volcanic action. Once deposited on the surface, the rock cooled, contracted and compressed into the familiar stacked-column formation.

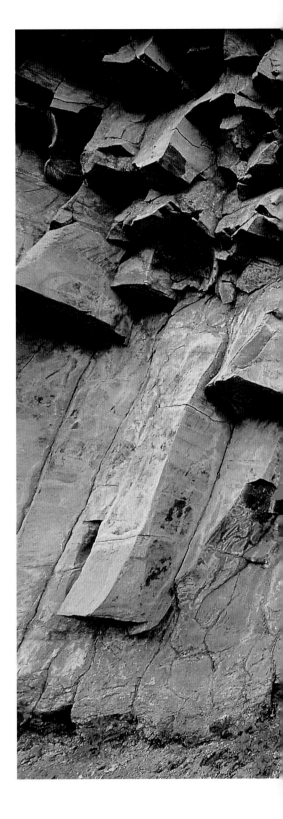

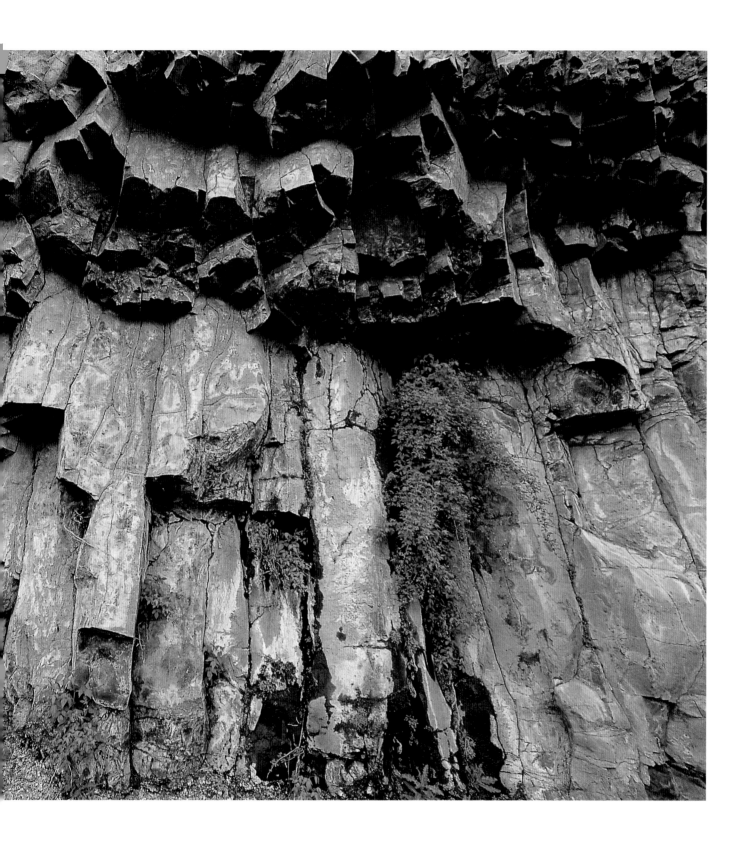

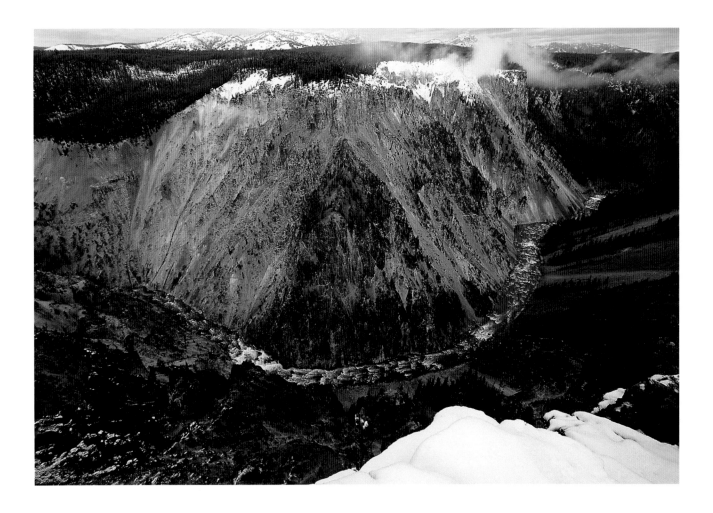

Although lacking the fiery energy that heats up the geysers and hot springs, Yellowstone's rushing waterways have a splendor all their own. The largest and most important of the park's rivers is the **Yellowstone River**, ABOVE. Seen from an overlook along the rim of the Grand Canyon near Artist Point, it threads its way along the deep canyon floor. **Tower Falls**, RIGHT, is a column of thundering water that drops 132 feet, just beyond the northern limit of the Grand Canyon of the Yellowstone River. Nearly 10 times more water flows over the falls in spring than in autumn.

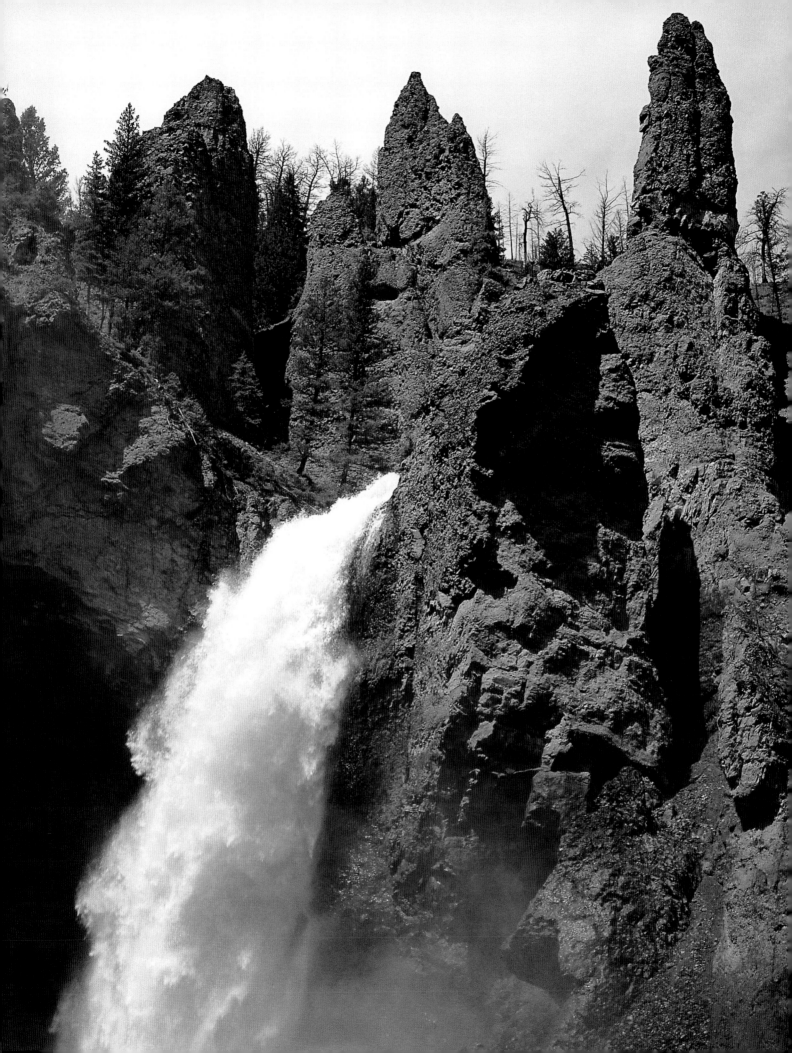

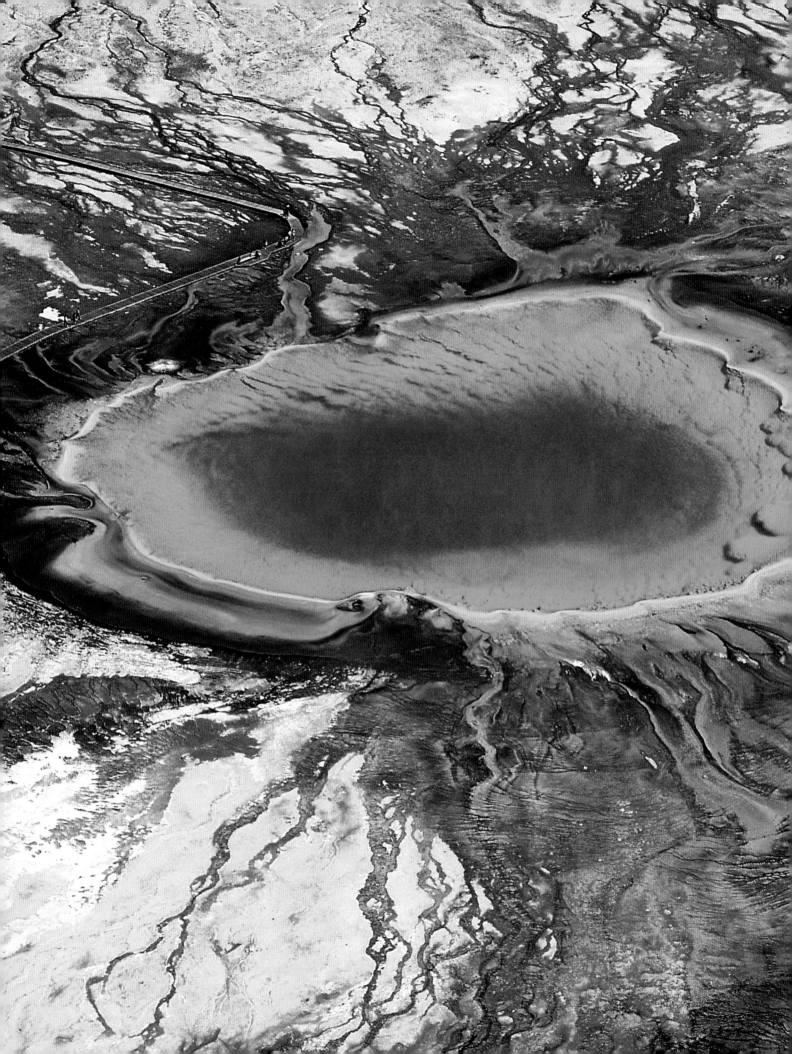

THE WATER WORKS

J EWEL-TONED SPRINGS, TOWERING GEYSERS, SMOLDERING hillsides and simmering mud cauldrons are among the 10,000 thermal landmarks that define Yellowstone National Park. Boasting more geothermal activity in its 3,472 square miles than anywhere else in the world, Yellowstone and its thermal wonders provide us with a glimpse of the inner workings of the Earth's molten core.

Heat is the energy source that makes these phenomena possible. Yellowstone stands on a site with a volatile geologic history and violent volcanic action that shaped the landscape over millions of years and left an enduring legacy: a fiery layer called magma that fuels the hot springs, geysers, mud springs and fumaroles. Yellowstone is one of North America's hot spots. In most locations in the United States, the temperature three miles beneath the land's surface is a moderate 300 degrees F, but in Yellowstone, researchers have found a 350-degree layer only 400 feet down. Enough heat is released through the ground to melt three tons of ice in a second.

SEEN FROM THE AIR, **Grand Prismatic Spring**, LEFT, resembles a flaring blue sun, its golden yellow ruff spreading molten rays across the surrounding landscape. The 370-foot-wide hot-water pool located in the Midway Geyser Basin is the largest in the park and maintains a scalding 150 degrees F. Single-celled thermophilic cyanobacteria, which thrive in temperatures no other organism can withstand, release colorful pigments that give the pool its prismlike hues. A boardwalk around the perimeter of the spring is a reminder of human impact on the park.

33

The magma is overlaid by a volcanic rock called rhyolite, which is buried under several hundred feet of sandy volcanic gravel. Pockmarked with fissures and cracks, this loose layer is saturated with groundwater that fell as snow or rain throughout most of the park, possibly hundreds of years ago. In the geyser basins, for instance, the water accumulates in the twists and turns of displaced rocky plates. These locations build up steam, like giant pressure cookers. Once superheated and potent with pressure from the building vapor, they literally let off steam through openings at the surface. Tempestuous and breathtaking, Yellowstone's 300 regularly active geysers spew millions of gallons of scalding water into the air each day, while more than 3,000 hot springs brew at temperatures ranging from 115 to 199 degrees F.

No two hot-water works are alike. The color, shape and activity of each are determined by temperature and the unique design of the "supply lines" in its subterranean plumbing. For example, the geysers can differ in the timing of their eruptions, which varies from minutes to years, and the eruption patterns can range from spasmodic splashes from a single hole to torrential multiple spouts that rocket hundreds of feet into the air for several hours. While it is not the biggest geyser in the park, Old Faithful, as its name implies, is the most reliable. It has been regularly active throughout the entire 125-year history of the park. Steamboat Geyser, on the other hand, which is the world's tallest geyser, can fall dormant for 5 years or 50—until sufficient steam and water accumulate to cause an eruption.

More tranquil landscapes may lull us into thinking that geologic time ground to a halt after the last Ice Age. But thanks to the thermal splendors of Yellowstone, we can never forget that beneath our feet, there is still a vital and ever-changing energy within Earth itself.

Huffing and puffing like a pot of white chocolate, **boiling mud at Artists' Paint Pots**, RIGHT, is stirred by rising volcanic gases that seep through the sodden soil. Various mud springs throughout the park bubble and spew in concert with seasonal changes in the water table. When groundwater levels are high, some are roiling pots of grimy liquid spraying their contents many feet into the air; when water levels drop in winter, they hiss and fume laboriously. Different minerals in the mud impart brown, pink, white and yellow hues to these steaming pots. FAR RIGHT: **Castle Geyser**, located in the Upper Geyser Basin, is one of the oldest hydrothermal features in the park. The 12-foot-high cone, which may be 15,000 years old, earned its name from early explorers who noted its resemblance to a medieval turret. Castle is one of the main attractions in Yellowstone, spouting water skyward to heights of 65 to 100 feet twice a day for 20 minutes before receding into a 20-minute steam phase.

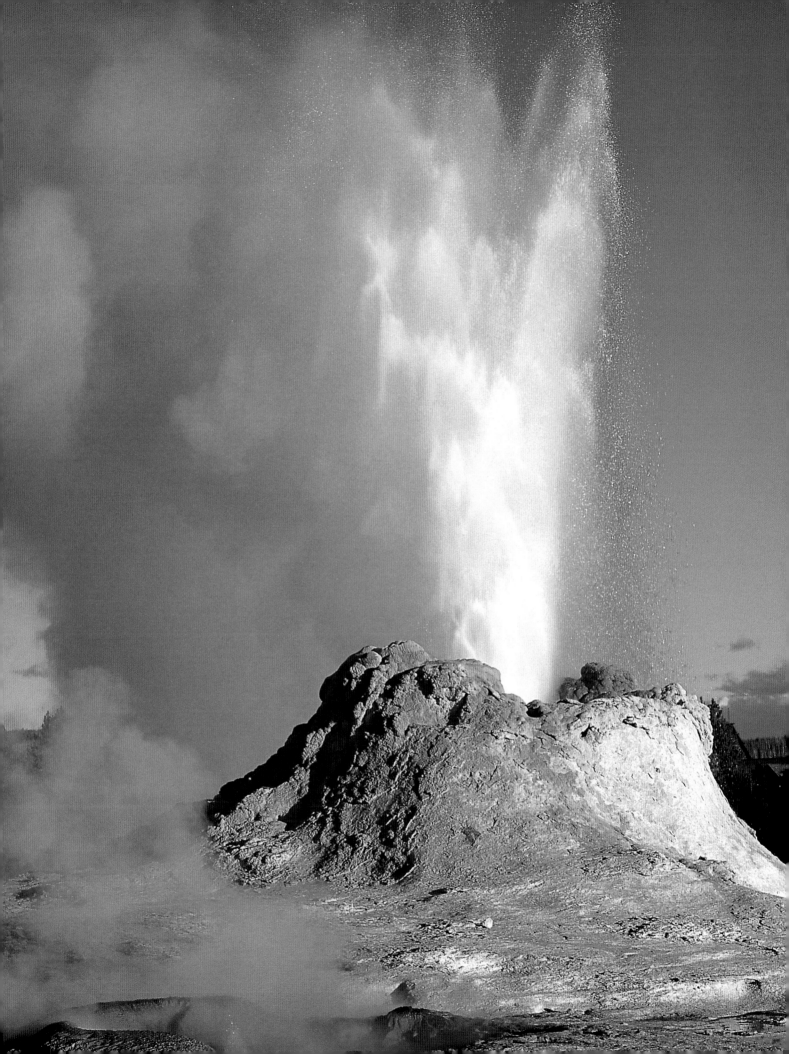

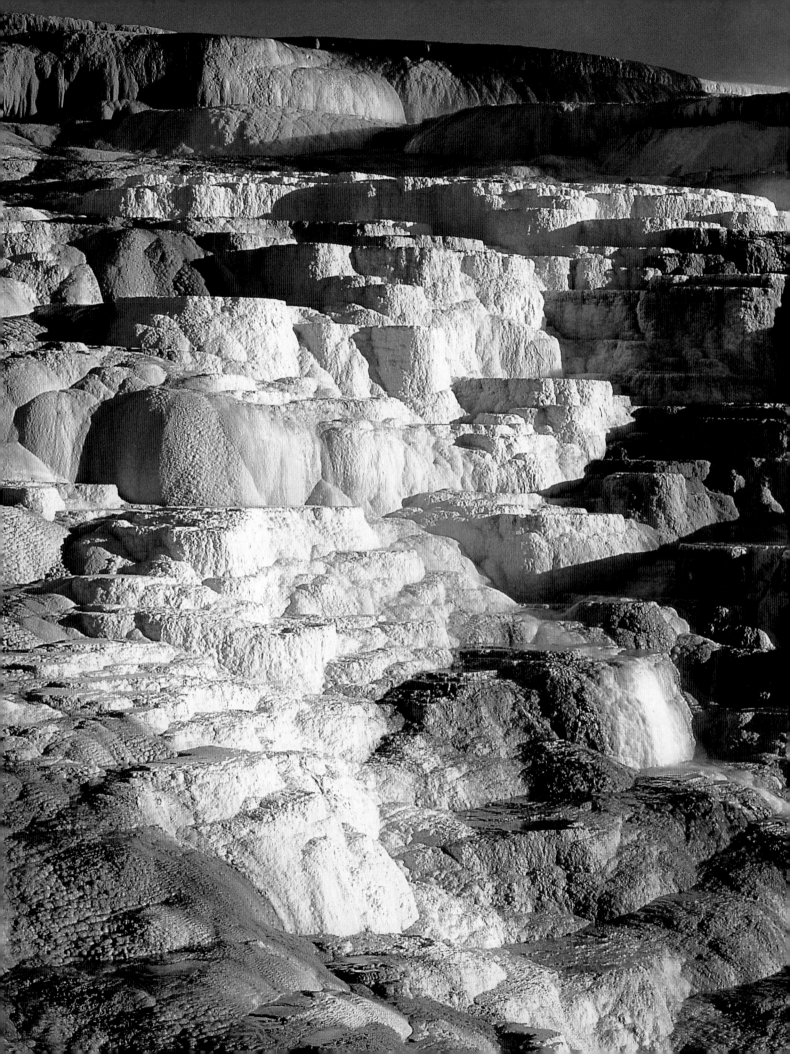

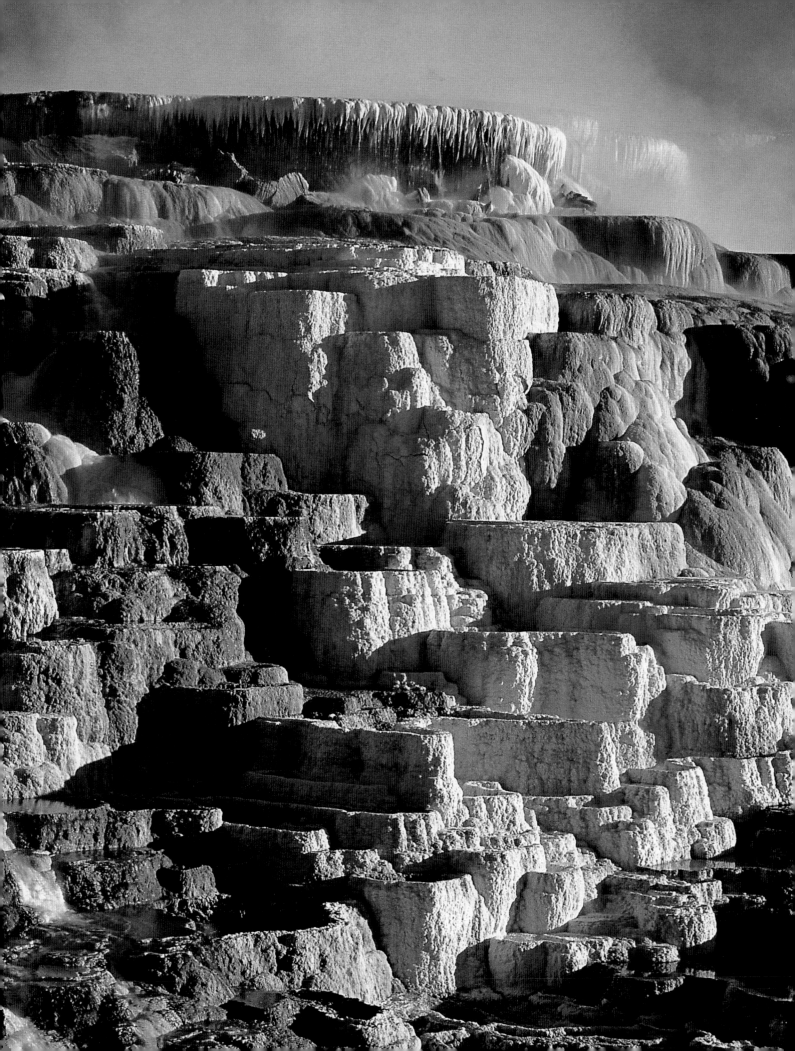

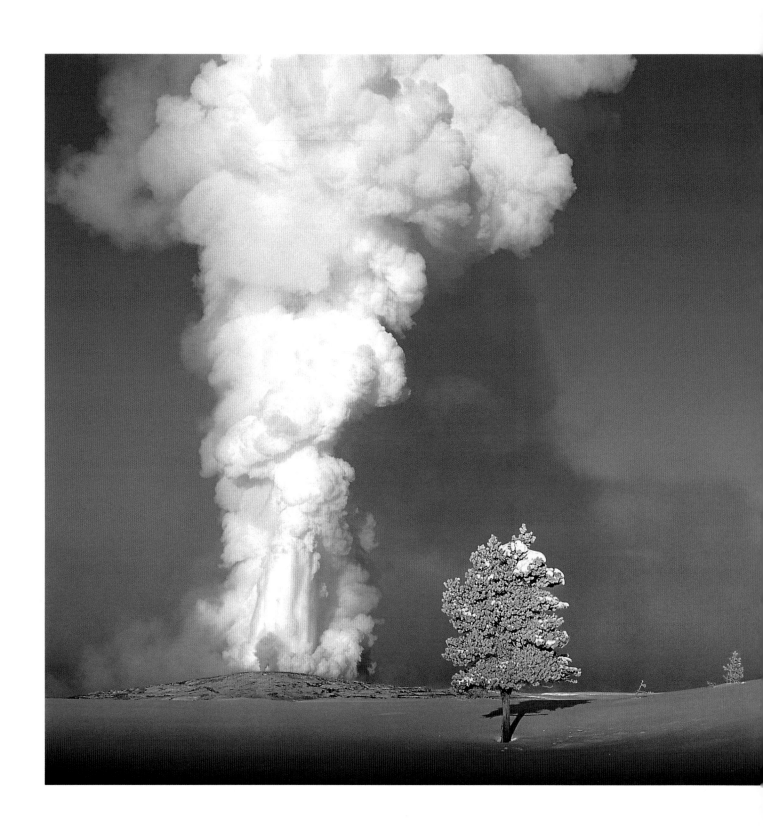

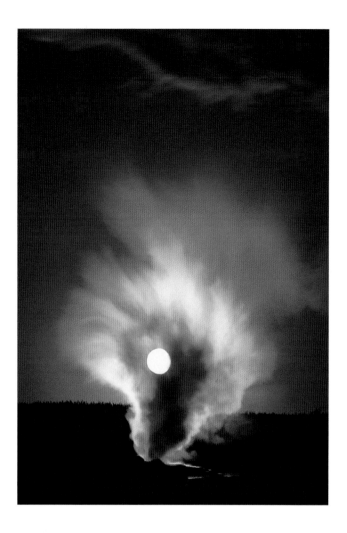

PREVIOUS SPREAD: THOUSANDS OF YEARS OF SLOWLY PERCOLATING water from **Canary Spring Terraces** have helped to carve the elegant travertine steps and bulging rock formations at Mammoth Hot Springs. A geologically dynamic feature of Yellowstone's landscape, the terraces grow 6 to 10 inches each year and change noticeably—some of the colorful terraces die, while others, chalky white and dead, come to life again. In total, the springs that make up the Mammoth formation carry to the surface each day an estimated two tons of dissolved limestone, which trickles off at a rate of 500 gallons per minute. LEFT and ABOVE: With a ghostly full moon glowing behind it, steam rises from **Old Faithful**. Described by Nathaniel Pitt Langford of the Washburn Expedition of 1870 as "an immense body of sparkling water projected suddenly and with terrific force into the air," Old Faithful is North America's most celebrated and reliable geyser.

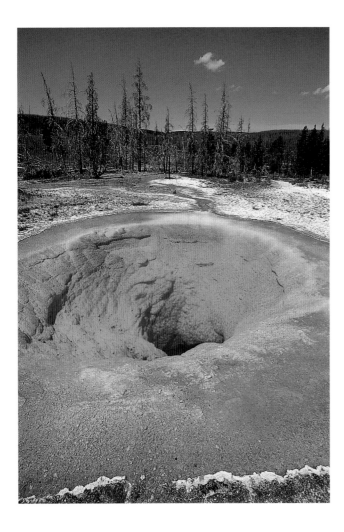

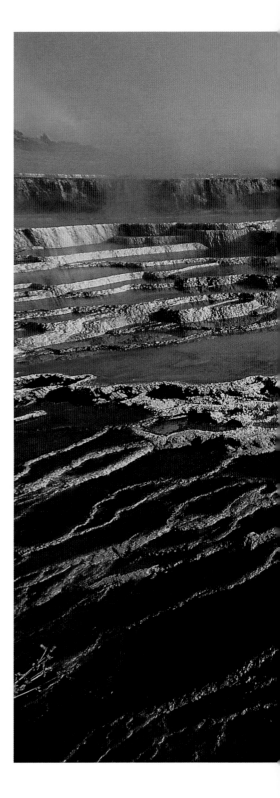

WITH ITS SCALLOPED EDGES AND FUNNEL-SHAPED DEPTHS,
Morning Glory Pool, ABOVE, in the Upper Geyser Basin, is
reminiscent of its namesake flower. The park's most popular
hot spring, Morning Glory originally maintained a high
enough temperature to discourage cyanobacterial growth and
had the distinctive crystal-clear aquamarine color common to
Yellowstone's hottest pools, which absorb the red rays of the
solar spectrum and reflect the blue. The influx of hot water
was eventually partially blocked by debris tossed in by visitors,
which lowered the temperature. When Morning Glory was
cleaned in 1950, coins by the thousands, handkerchiefs, rocks,
bottles, tin cans and clothing were retrieved from the basin.
Today, Morning Glory Pool is clear again. RIGHT: In September
1995, a pool on the travertine terrace of **Mammoth Hot
Springs** came briefly to life. While travertine is deposited as a
white mineral, water on the terrace surface causes glistening
colors from tiny living bacteria and algae. Within a year, how-
ever, this terrace was a dry, white calcium-carbonate memory.

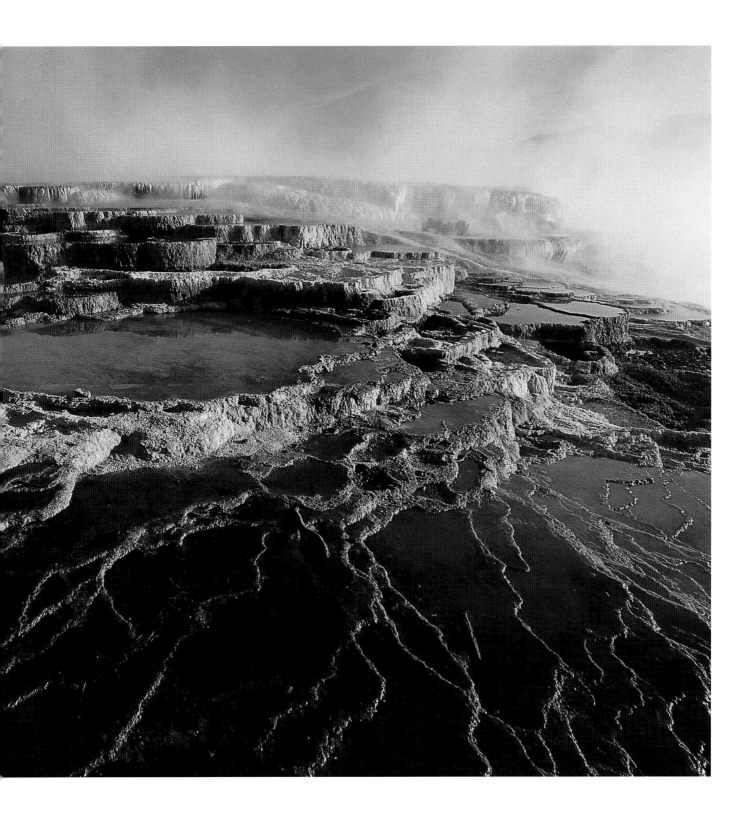

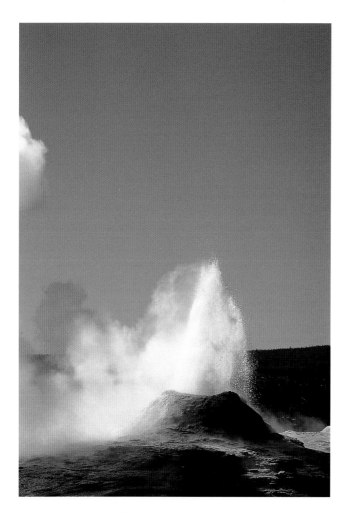
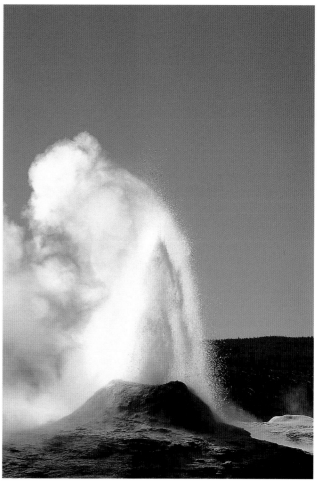

THESE TIME-LAPSE IMAGES OF AN ERUPTION FROM THE CONE OF **Lion Geyser**, LEFT, ABOVE and RIGHT, suggest the increasing pressure in its underground plumbing. Located in the Upper Geyser Basin, Lion Geyser sprays a column of water 50 to 70 feet into the air for five minutes at a stretch. Many of Yellowstone's geysers let out a loud booming or thumping sound moments before they erupt, as the pressure from boiling water builds up to violent levels beneath the surface. Lion Geyser earned its name because of the catlike roar that announces its explosion. Yellowstone's geysers are mainly of two types: A fountain geyser erupts in spasmodic spurts from a large pool of water that may resemble one of the thermal pools during quiet times; a cone geyser, of which Lion Geyser is an example, generally erupts in a continuous spray of steam and water from the opening in a mineral mound. The cone is typically made of geyserite—a kind of opal—that is left behind.

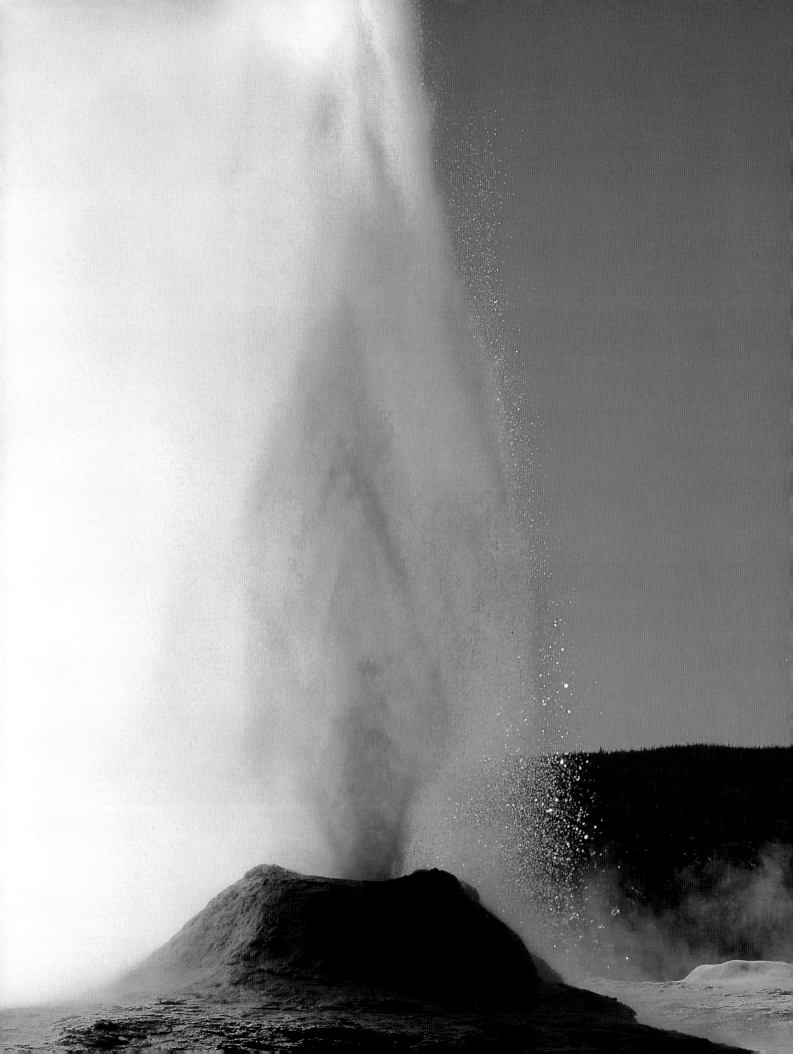

A MICROSCOPIC WORLD THRIVES IN A HOT RUNOFF CHANNEL, RIGHT, in **Norris Geyser Basin**. As long as hot water flows through it, this area of the park is inhospitable for most living things; only single-celled bacteria and algae can exist here. Similarly, a channel from **Grand Prismatic Spring** looks like a river of liquid gold as it flows away from the giant "eye of Yellowstone," BELOW. The slightly cooler water of runoff channels supports colonies of organisms that mix with mineral traces such as iron oxide to produce these spectacular hues.

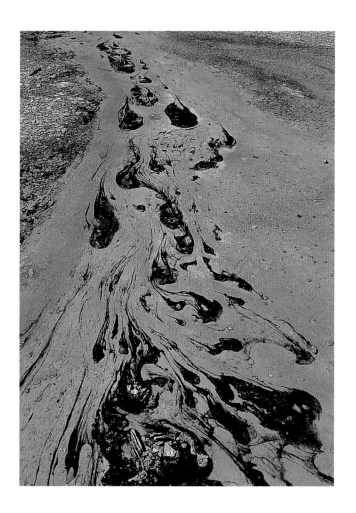

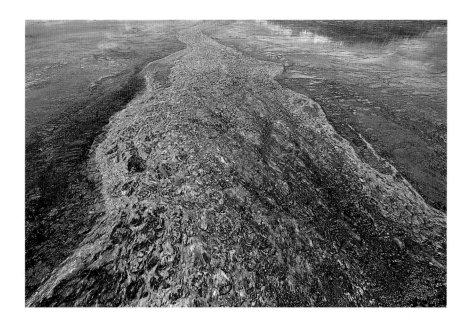

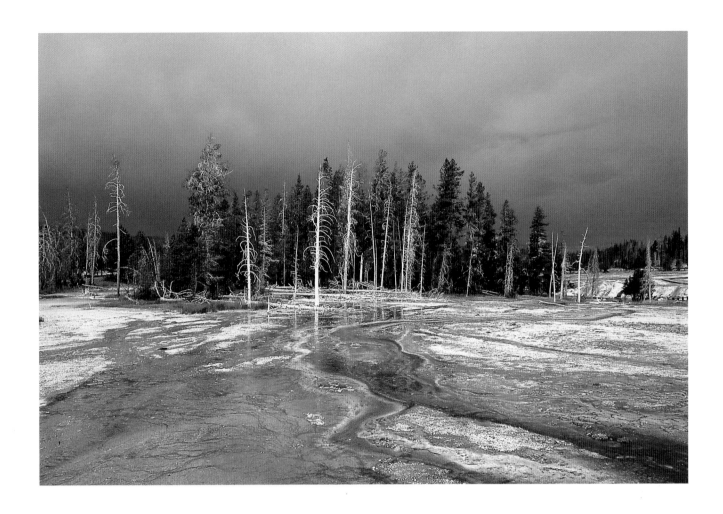

AN INCOMING THUNDERSTORM IS AN EERIE BACKDROP FOR THE
dead trees in a **runoff channel from Castle Geyser**, ABOVE.
The condition of the trees is typical of the fate faced by green
plants in the highly acidic, silica-laden waters that run off
from the geysers and hot pools of Yellowstone.

After more than a hundred years of relative dormancy, **Cascade Geyser**, RIGHT, erupted into a stream of steaming water in early 1998. Until the end of the 19th century, Cascade, which is located in the Upper Geyser Basin, had been a centerpiece of Yellowstone, renowned for the 40-foot-high eruptions that often occurred only 10 minutes apart. After that time, the eruptions were sporadic and less than spectacular until January 9, 1998, when Cascade began to erupt to heights of 10 to 30 feet every 6 to 15 minutes.

The Upper Geyser Basin is a paradise for visiting geyser gazers and can take several days to explore. This explosive land is marked with steaming vents and towering columns of boiling water and should be investigated with caution. For safety, visitors must stay on the well-traveled boardwalks and pathways. Visiting the park today is not the dramatic adventure faced by Yellowstone's earliest explorers, who had little idea of what they would find. "In the valley before us," Nathaniel Pitt Langford wrote of the Upper Geyser Basin, "were a thousand hot springs of various sizes and character and five hundred craters jetting forth vapor." During that historic trip, Langford, who was nicknamed "National Park" Langford and who later served as the first superintendent of Yellowstone, reported that his team witnessed a dozen geysers in action in less than 24 hours.

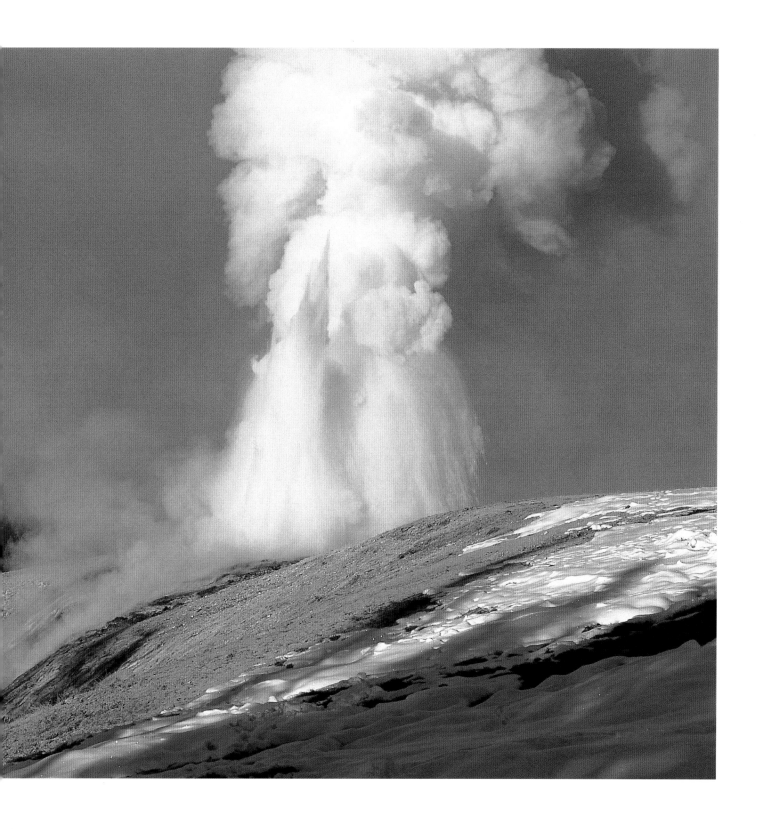

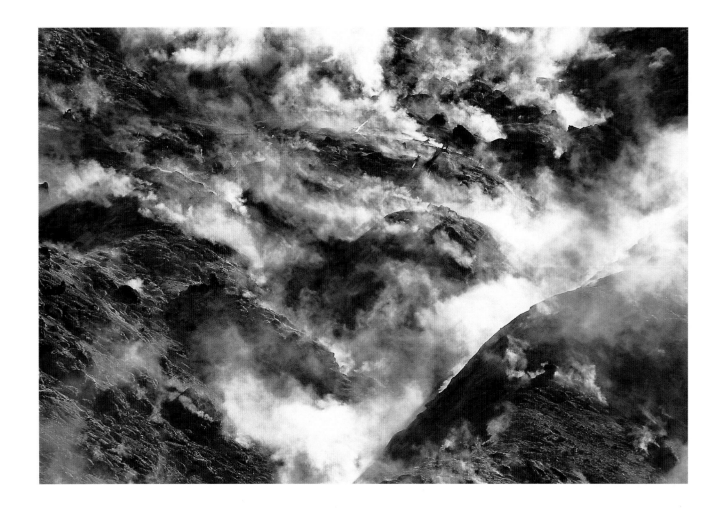

EARLY MORNING IS ONE OF THE PRIME TIMES TO WITNESS THE steaming, otherworldly fumaroles at **Roaring Mountain**, ABOVE, located on the road to Mammoth. Fumaroles form where the heat beneath the ground is so great that it converts the limited amount of water to steam before it reaches the surface. The steam released from these fuming vents is above the boiling point, which, when adjusted for Yellowstone's high elevation, is 199 degrees F. Although it is quieter today, Roaring Mountain earned its name because the sound of its "roar" could be heard a mile away as it released its steam to the atmosphere. RIGHT: The end of the dry summer season leaves the mud pots at **Fountain Paint Pot** parched and cracked. The largest collection of mud pots in the park, Fountain Paint Pot resembles a vast mud puddle in spring and early summer.

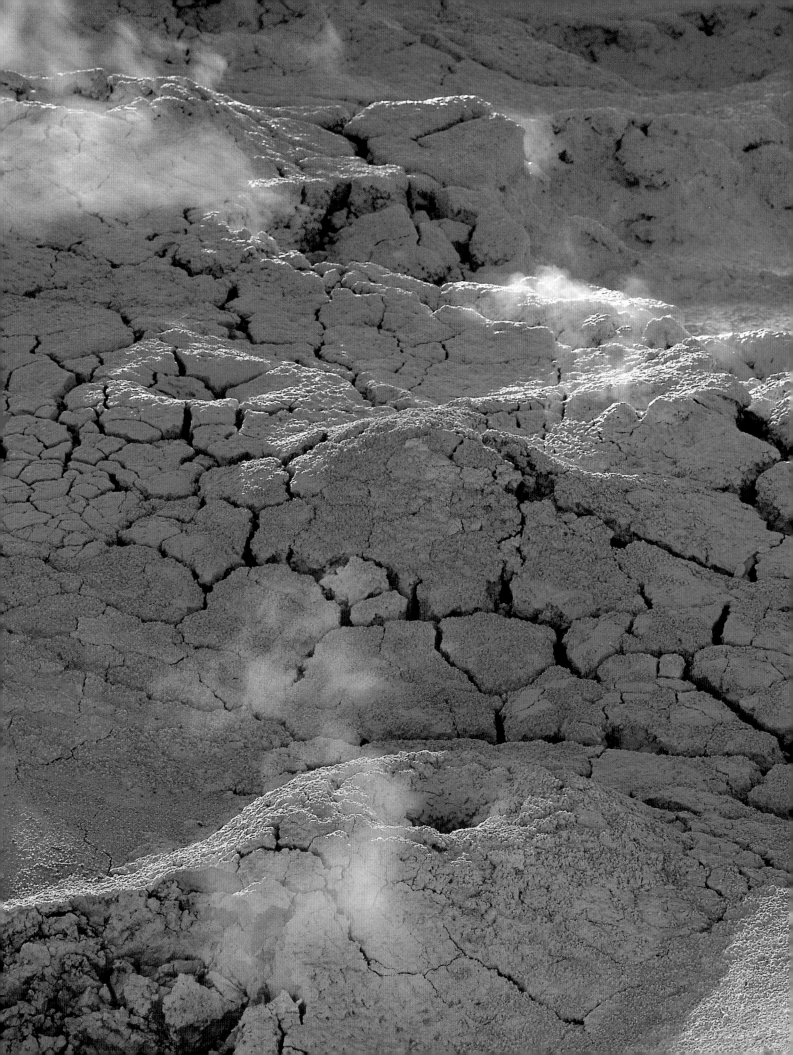

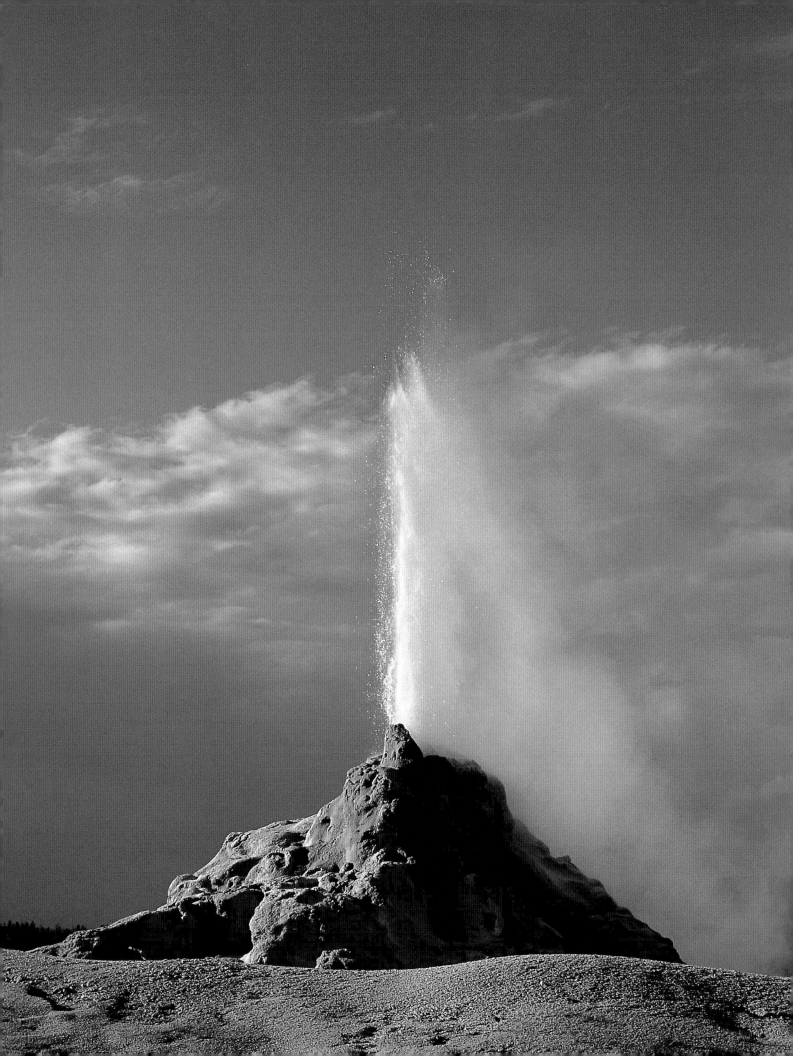

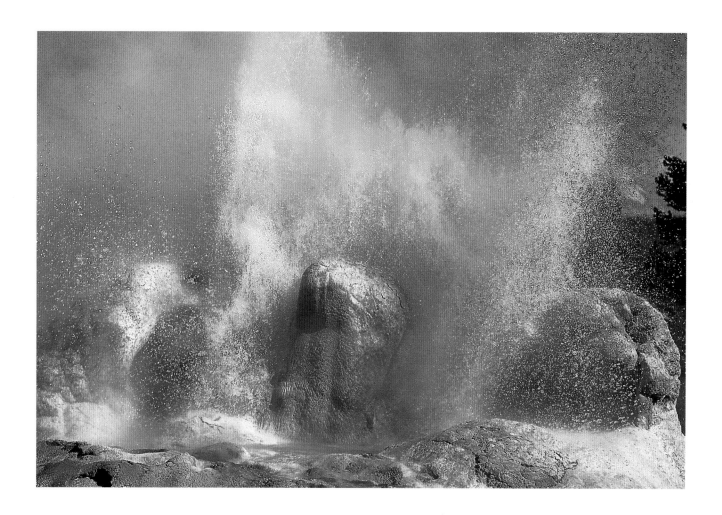

LEFT: THE MASSIVE 12-FOOT GEYSERITE CONE ON **White Dome Geyser** is perched atop a mound of minerals expelled from an ancient thermal ancestor. Years of activity have started to plug the vent inside the cone, and only a five-to-seven-inch opening remains to release its delicate stream of superheated water, which peaks at about 30 feet. ABOVE: **Grotto Geyser** is one of the very active geysers in the park. Even when it is dry, its cone is a beautiful shape, formed from the geyser spraying siliceous sinter over dead tree stumps, which today are completely covered and petrified. Although its fountains typically jet only about 40 feet into the air at their peak, Grotto Geyser is famous for the marathon eruptions that occur every few days and can last an amazing 16 hours, releasing over 350,000 gallons of water—more than Old Faithful, Yellowstone's most reliable geyser, expels in three days.

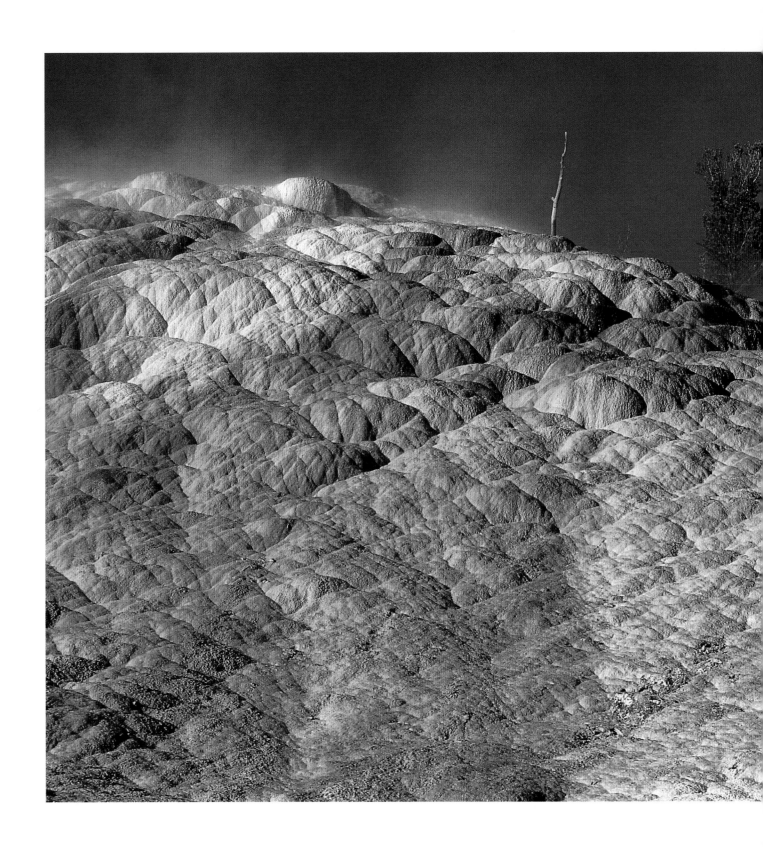

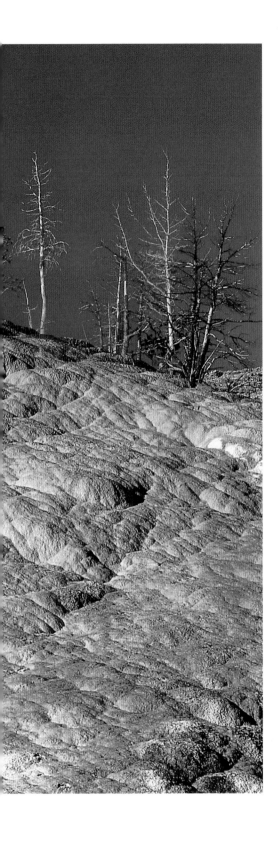

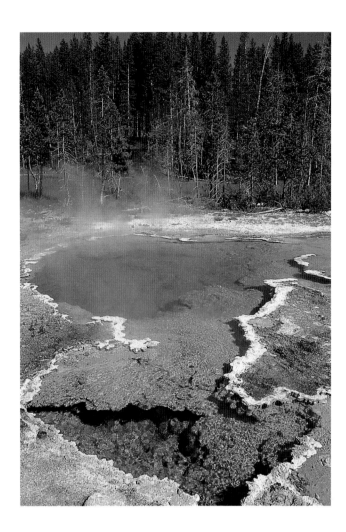

IN CONTRAST TO THE NEATLY TIERED GIANT STEPS IN OTHER sections of Mammoth Hot Springs, some of the terraces at **Palette Spring**, LEFT, are deeply creased cascading rocks. The natural terraces in the Mammoth complex are the largest in the world, but when the angle is too steep for the percolating water to form steps, it spills down, making bulbous calcium-carbonate formations. ABOVE: **Octopus Pool** in the White Creek area is a small blue spring with crystal-clear water edged with beautiful sinter ornamentations formed from mineral deposits. Yellowstone's thermal pools have played a role in forensic science and our understanding of disease. Scientists first identified the heat-loving bacterium *Thermus aquaticus* near White Creek and extracted an enzyme from the microscopic organism that speeds up the replication of DNA. Because of its heat tolerance, the enzyme allowed researchers to copy and augment specific genetic material for laboratory identification. The resulting process is known as DNA fingerprinting.

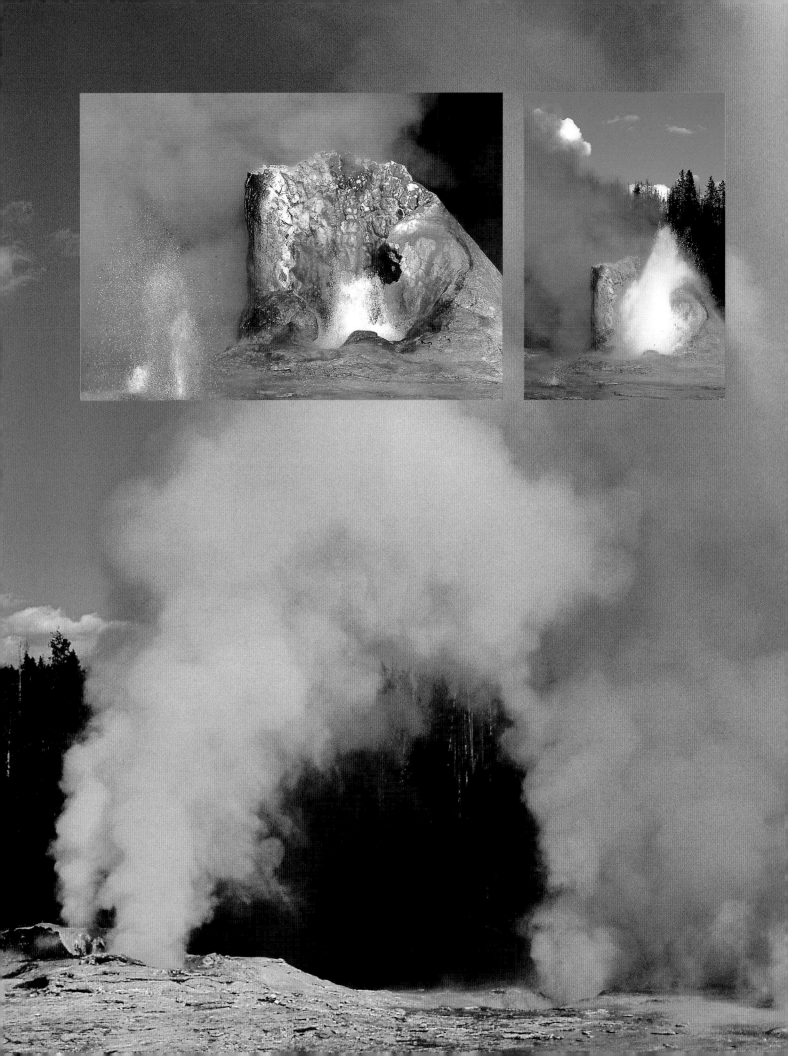

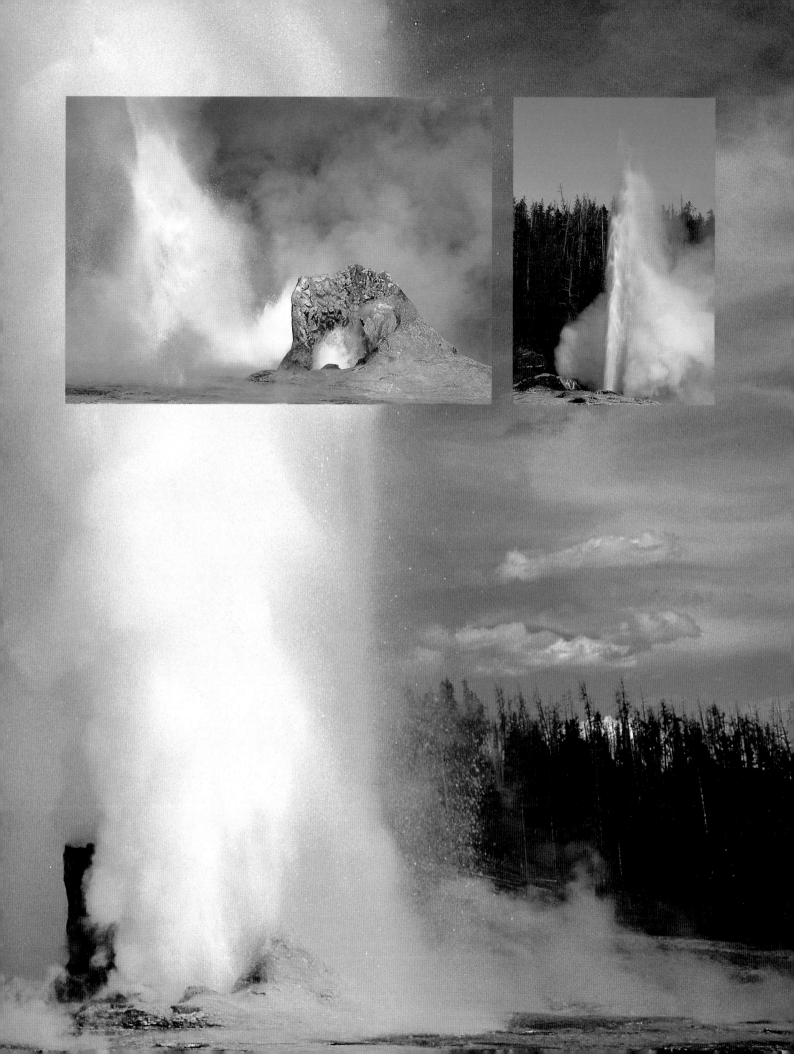

Previous spread: It is known that water, heat and pressure are needed to create a geyser, but because the internal plumbing is entombed beneath the Earth's surface, the specifics of when and why a geyser will erupt remain a mystery. After erupting on a sporadic basis for nearly 40 years, **Giant Geyser**, BACKGROUND, came to life in September 1997, when the column of water that spewed from its cone reached a spectacular 250 feet. Giant Geyser first warns of an eruption with a "hot period," a complex hydrothermal interaction among the several adjacent geysers. Nearby Bijou normally erupts intermittently for hours until it shuts down completely. But if a pause exceeds three minutes, geyser experts look to the "bathtub"— a deep ditch around neighboring **Mastiff Geyser**, RIGHT INSET—to fill with water. When the bathtub overflows, adjacent **Feather** and **Feather Satellite** vents, FAR LEFT INSET, start to erupt. Soon, more vents begin to surge, as does the water in **Giant Geyser's cone**, LEFT INSET. By this time, Mastiff Geyser has become more violent and spouts up from two different vents to about 40 feet. Seconds later, Giant erupts in a huge water column that lasts for an hour. Even **Catfish Geyser**, FAR RIGHT INSET, normally not a very tall geyser, shoots straight into the air. The rare sight of four geysers erupting in concert is spectacular. This performance is typical of what is called the "Mastiff function," which occurs when Giant explodes simultaneously with nearby geysers.

RIGHT: Between eruptions, **Great Fountain Geyser,** near Firehole Lake Drive in the Lower Geyser Basin, looks like a 16-foot-diameter hot pool. Its constantly rising water, however, starts boiling heavily, and usually within an hour, a fountain eruption occurs, sending water 150 feet into the air.

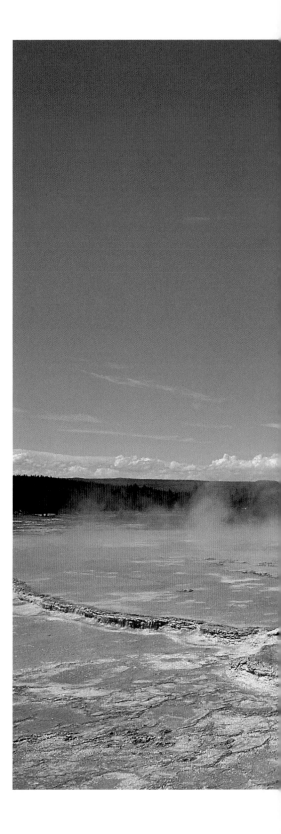

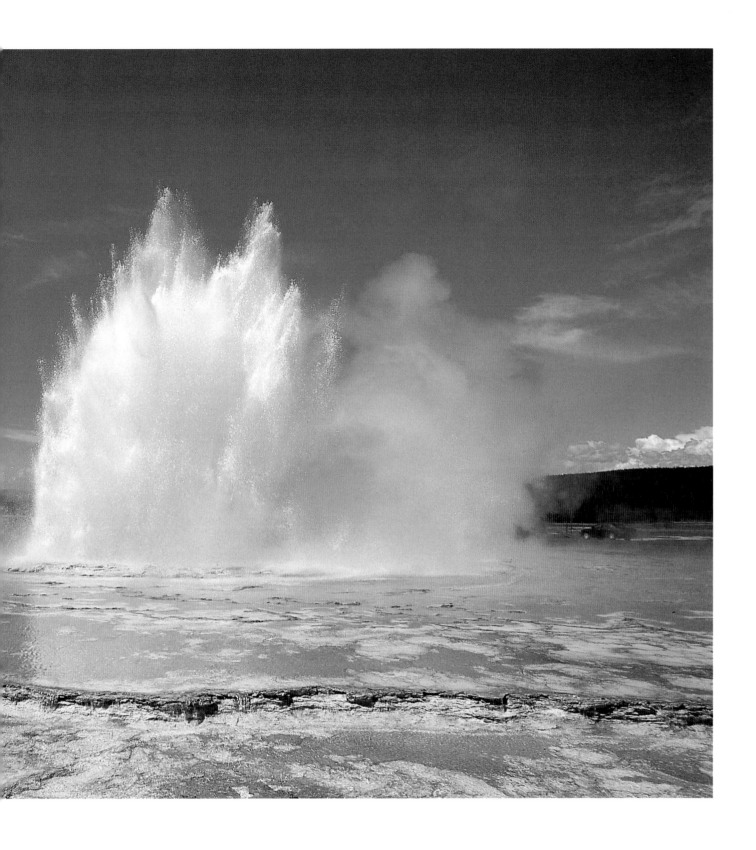

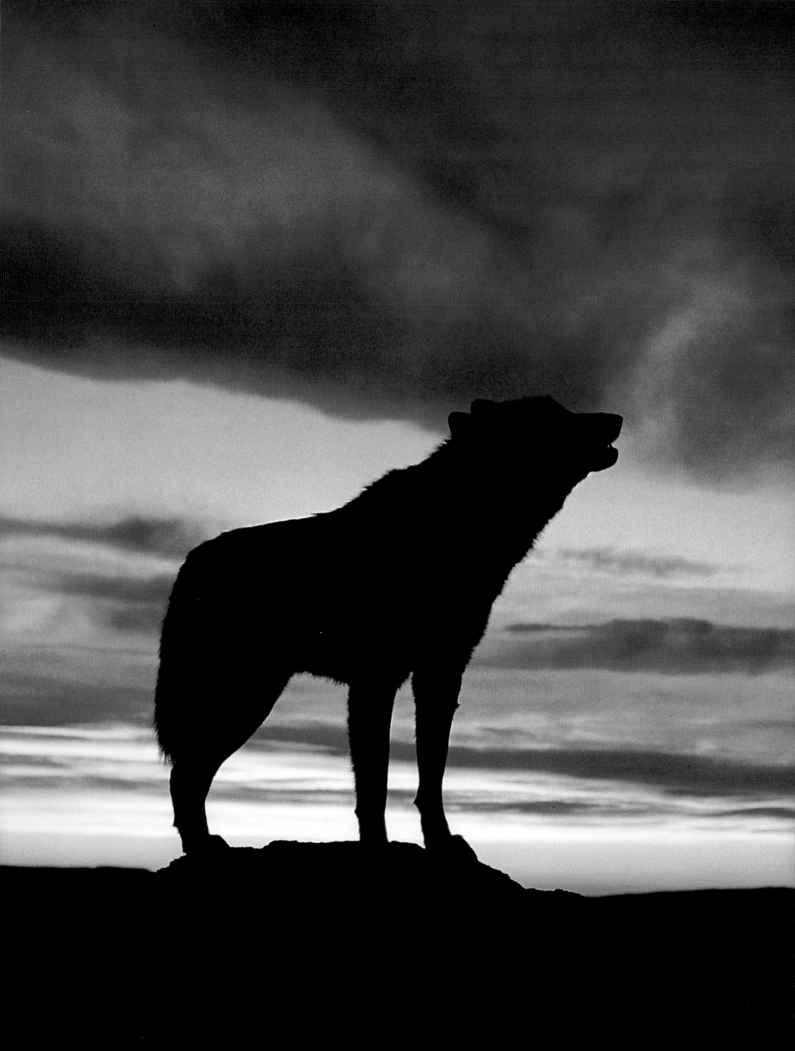

BORN
TO BE WILD

IN EARLY MORNING AND LATE EVENING, YELLOWSTONE'S
wildlife species emerge from seclusion and begin their
ritual activities: Wolf packs circle the Lamar Valley in
search of prey, trumpeter swans dabble in the Madison
River, moose browse thickets of summer shrubs, osprey
snag fish from the Yellowstone River, and bison graze the
Hayden Valley. The park hosts one of the largest concentra-
tions of free-roaming wildlife in the lower United States
and in the world's temperate zone, some 60 species of
mammals, 290 of birds, 18 of fish, 6 of reptiles and 4
of amphibians—a veritable wilderness tapestry of related
animals and plants in which each species provides clues
about the well-being and abundance of all.

Yellowstone's inaccessible and discrete geography has al-
lowed it to sustain an intact ecosystem, making it one of the
handful of places that can support large carnivores. A thriv-
ing waterfowl population shows that plentiful plant life pro-

A HOWLING **wolf**, SILHOUETTED AGAINST
the pinks, oranges and blues of the day's
waning light, LEFT, is the ultimate symbol
of the North American wilderness. For
millions of years, *Canis lupus* roamed the
region, but campaigns of persecution by
settlers and hunters had extirpated the
species from the United States by the
early 20th century. After decades of de-
bate, a reintroduction program was initi-
ated to bring wolves trapped in Alberta
and British Columbia to the park's
Lamar Valley in 1995. With ample big
game to hunt, at least 150 wolves are
now established in Yellowstone, according
to 1997 estimates.

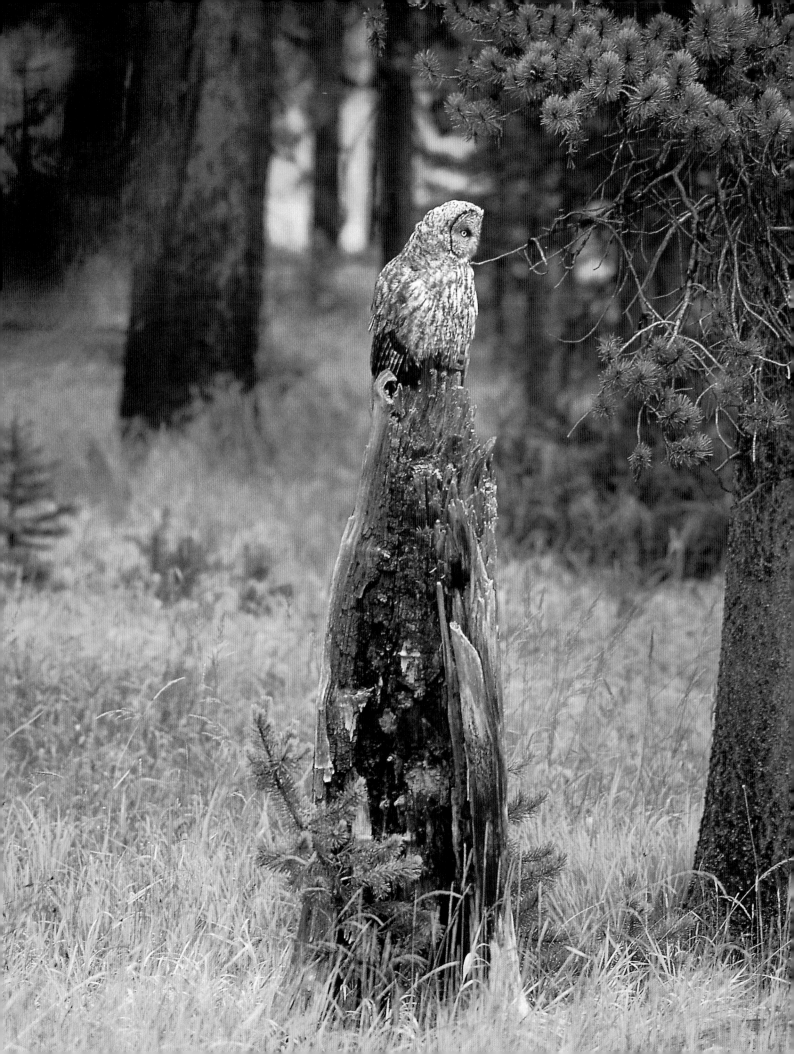

vides food and nesting habitat; a healthy wolf population reveals that elk and deer are abundant; and a bear sighting indicates ample supplies of fish and berries. Protecting wildlife means preserving not only the territory but also the plants the animals need.

Yellowstone's unspoiled habitat has held lessons for wildlife managers in the preservation of natural communities. Nearly all the species that roamed Yellowstone in the past live here again today. And as our understanding of biological relationships has grown more sophisticated, scientists have come to appreciate that a natural predator-prey balance ultimately benefits all species and is a necessary part of the Yellowstone ecosystem. For example, in 1923, Yellowstone's rules and regulations referred to the mountain lion as the "most destructive predatory animal in the park." Wolves and coyotes, ranked not far behind, were killed "for the protection of the game animals."

By the end of the 1920s, the wolf had been virtually eradicated from the park. But within a few short genera-

tions, attitudes about predator control had changed: The gray wolf no longer had a bounty on its head, and conservationists around North America were struggling to aid in its recovery. The National Park Service's sentiments reflected that change, identifying both the aesthetic and ecological price paid for the missing wolf: "It was like an orchestra without a brass section, a library without a mystery shelf."

Though controversial, the reintroduction of the wolf in 1995 meant that Yellowstone's wildlife mosaic was once again complete, with a strong overall biodiversity. By controlling the numbers of prey animals, wolves prevent them from overgrazing, thus maintaining a healthy balance in the environment. Researchers also estimate that as many as a dozen other species—from bears and foxes to weasels, bluebirds and carrion beetles—scavenge at a wolf kill. Just as Yellowstone is not an island distinct from the territory beyond its boundaries, each of the park's species is inextricably linked to all the others.

STEALTH IS THE SECRET OF SUCCESS FOR the **great gray owl**, LEFT, one of North America's largest owls. Its cryptic plumage of barred gray tones allows this bird of prey to blend invisibly into its perch atop a broken tree spire in the dense forest near Canyon Village. A mother **wolf**, RIGHT, endures the playful affection of her 3-month-old pups outside their den. Wolf packs operate on a strict hierarchy headed by the alpha male and female, the pack's only breeding pair. The cubs, however, are raised cooperatively by all pack members, which contribute a whole range of support, including baby-sitting, nursing and bringing solid food to the precocious pups. By this age, the cubs are weaned and eating meat. As pack members return from the hunt, the young pups bite their faces in a begging behavior that stimulates the adults to regurgitate chunks of undigested meat which the youngsters heartily devour.

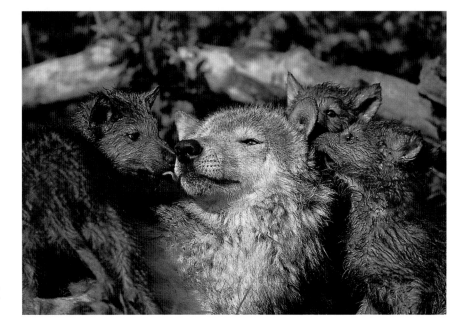

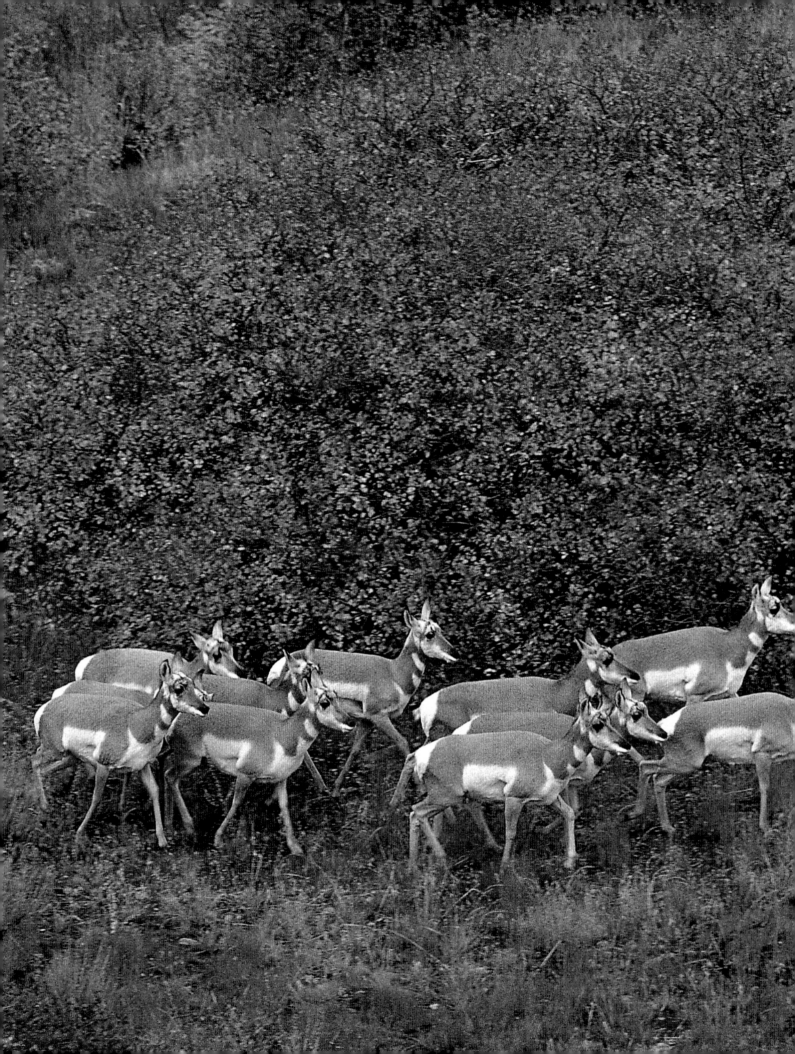

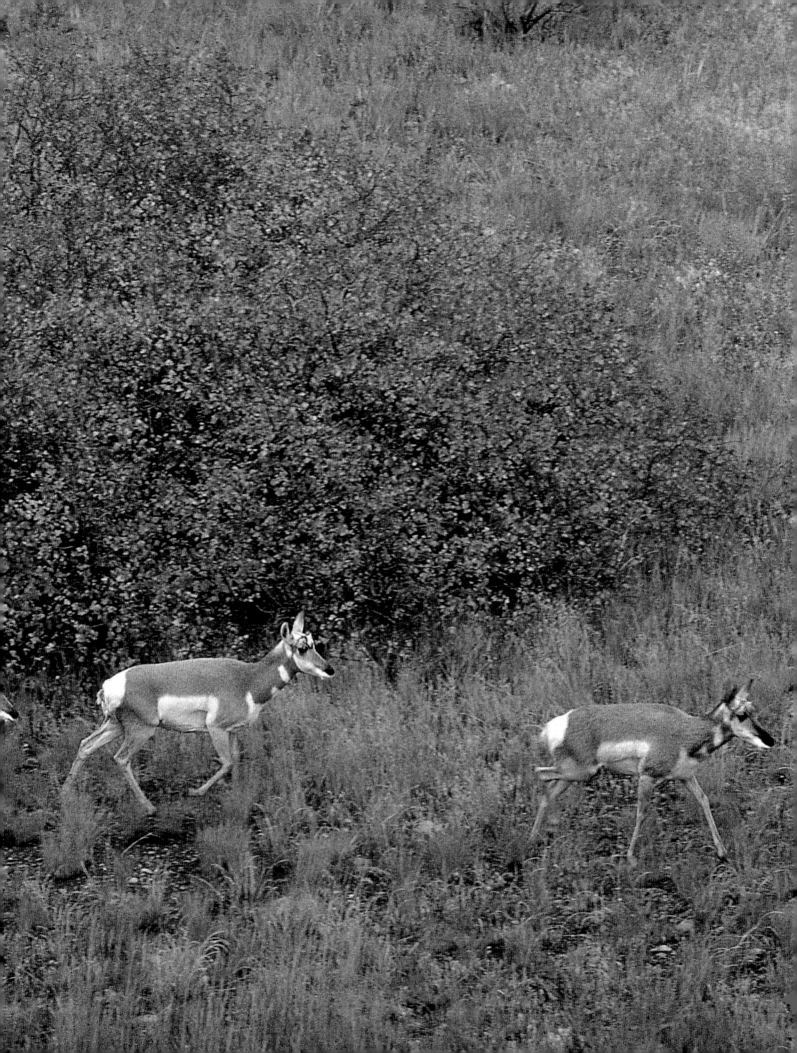

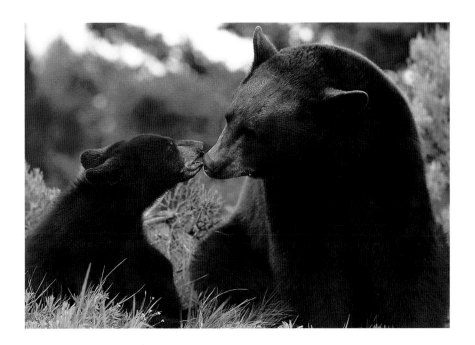

PREVIOUS SPREAD: IN A HALTING GAME OF FOLLOW THE LEADER, a **pronghorn herd** lightly prances through the colorful late-autumn brush. Photographed in October, this herd is typical of the postbreeding-season aggregations that spend the winter traveling in search of food. *Antilocapra americana* is one of the fastest terrestrial creatures, frequently clocked at speeds of up to 60 miles per hour. The only animal in the world with branched horns, the pronghorn is a creature of the open plains, relying on speed and a bounding stride to escape predators. The **black bear**, ABOVE, is one of the most common of the large carnivores visible in the park. In winter, *Ursus americanus* hibernates in a rocky crevice or an excavated den or under a pile of deadfall, during which time the cubs are born. The cubs are utterly helpless for the first six weeks, and bear families, such as this mother and cub, make their debut by early spring and begin the warm-weather foraging for the smorgasbord of wild food—berries, nuts, leaves, twigs, insects, eggs and small mammals—that they like to eat. In June, before the snow melts, bear families are visible in the higher elevations near Tower Falls and in the Lamar Valley. A young cub remains with its mother for the first year. Black bears fearlessly pilfer garbage left at picnic sites, but despite their inquisitive nature, these creatures, which can weigh more than 500 pounds, are not tame and should be avoided.

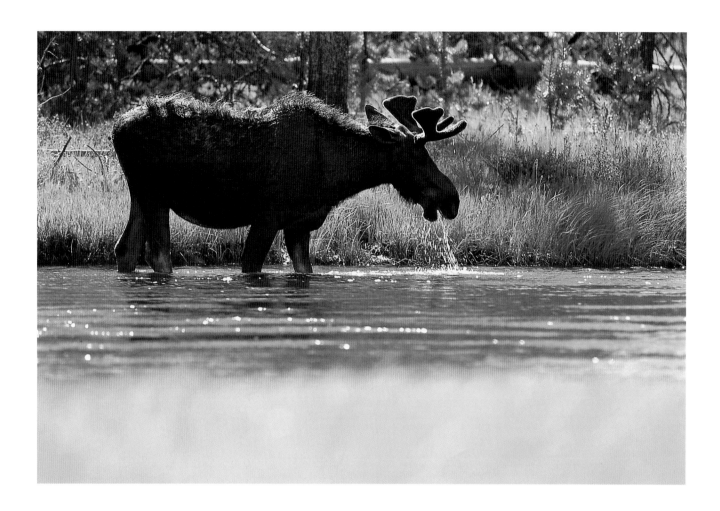

WADING THROUGH THE SHALLOW WATER OF THE FIREHOLE
River on a warm afternoon in June, a **bull moose**, ABOVE,
browses on tender grasses and water plants rooted in the
riverbed. The largest member of the deer family, *Alces alces*
typically stands almost eight feet tall at the shoulder and
weighs more than 800 pounds. Only the male grows an
enormous rack of shovel-shaped antlers, which are an
important status symbol and a useful weapon in disputes
over mates. A blood-engorged layer of soft furry velvet
covers the antler rack until it is fully developed.

To MAINTAIN ITS TERRITORIAL CONTROL, A MALE **yellow-headed blackbird**, ABOVE, sings almost continuously throughout the breeding season. *Xanthocephalus xanthocephalus* nests in colonies of dozens of pairs. While the female constructs a basket-style nest in a vertical stand of grass, the male defends the territory. The **trumpeter swan**, RIGHT, the largest of North America's waterfowl, is also one of the most spectacular of the avian fauna in Yellowstone. Unrestrained hunting in the 19th century for both its feathers and its meat nearly pushed *Cygnus buccinator* into extinction. When the species count was at an all-time low across the continent, some 60 birds remained within the boundaries of Yellowstone. Through strict regulation and management, however, the trumpeters recovered by the 1960s. This trumpeter swan has spread its massive seven-foot wings as if to hide its downy cygnet from view.

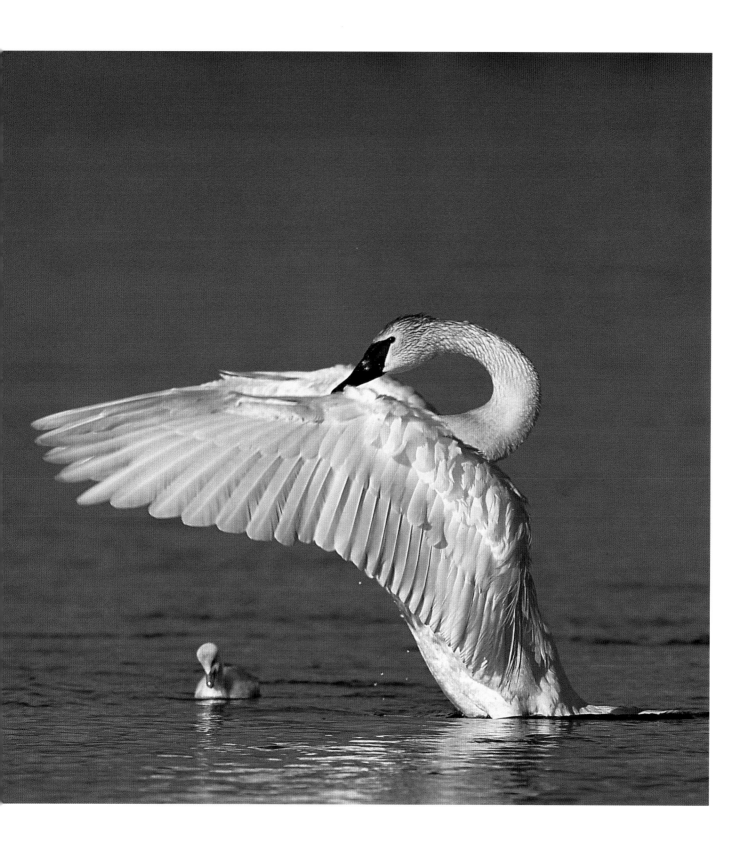

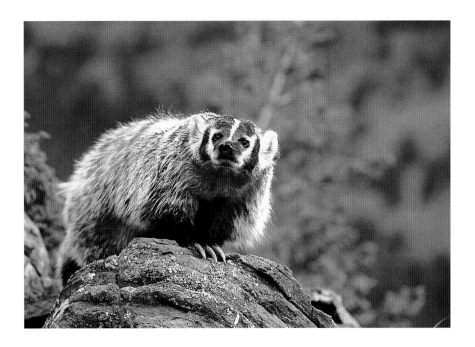

A GROWLING **grizzly**, LEFT, DISPLAYS THE FEROCIOUS EXPRESSION that has earned it the title King of the Wilderness. The greater Yellowstone ecosystem, where the grizzly now numbers between 300 and 600 individuals, is one of the last strongholds of the 600-pound eight-foot-tall bear. A top-of-the-line predator, the grizzly needs a vast habitat to provide the squirrels, fish, insects, nuts and carrion that form its diet. Given the bear's territorial requirements, the region is currently at carrying capacity. Yellowstone's popularity with humans has always been a liability for the bears, and until the 1970s, when strict rules prohibited visitors from approaching and feeding either black or grizzly bears, human-bear conflicts were common. To reduce the problems associated with the bear's acquired taste for the garbage found at campsites, in roadside canisters and at dumps, wildlife managers have bearproofed every square inch of the recreational sections of the park and have concentrated the majority of the population on the perimeter of the park boundaries. The **badger**, ABOVE, is one of 60 mammal species that occur in Yellowstone. Large, powerful and built close to the ground, the badger is a vicious member of the weasel family and resides in the sagebrush valleys that are common to the northern sections of the park.

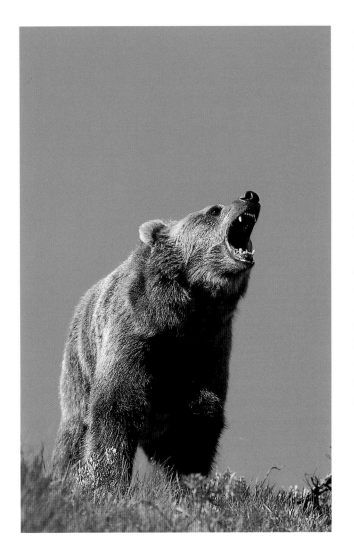

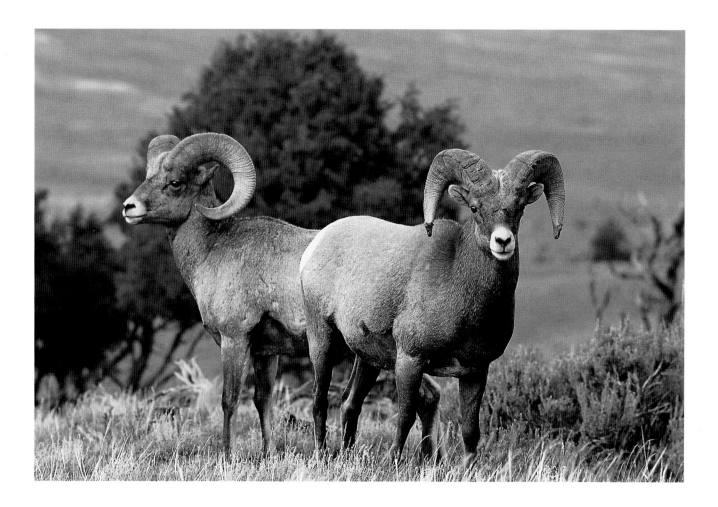

YELLOWSTONE BOASTS A GREATER DIVERSITY OF WILD ANIMALS
than any other region in the continental United States.
Picture-perfect in their grayish taupe coats and elegant head-
gear, **bighorn sheep**, ABOVE, are among the park's majes-
tic creatures. Surefooted climbers that live in groups of up to
50 animals, bighorn sheep roam the park's craggy mountain
slopes grazing on grasses and shrubs. Both sexes sport horns,
but the male's are more elaborate and fully curled, while the
female's are slender and only slightly curved. During the sum-
mer, the bighorns live in the park's remote backcountry; in
winter, they approach civilization and are often spotted by vis-
itors. This pair was photographed near the town of Gardiner,
Montana, at the park's North Entrance.

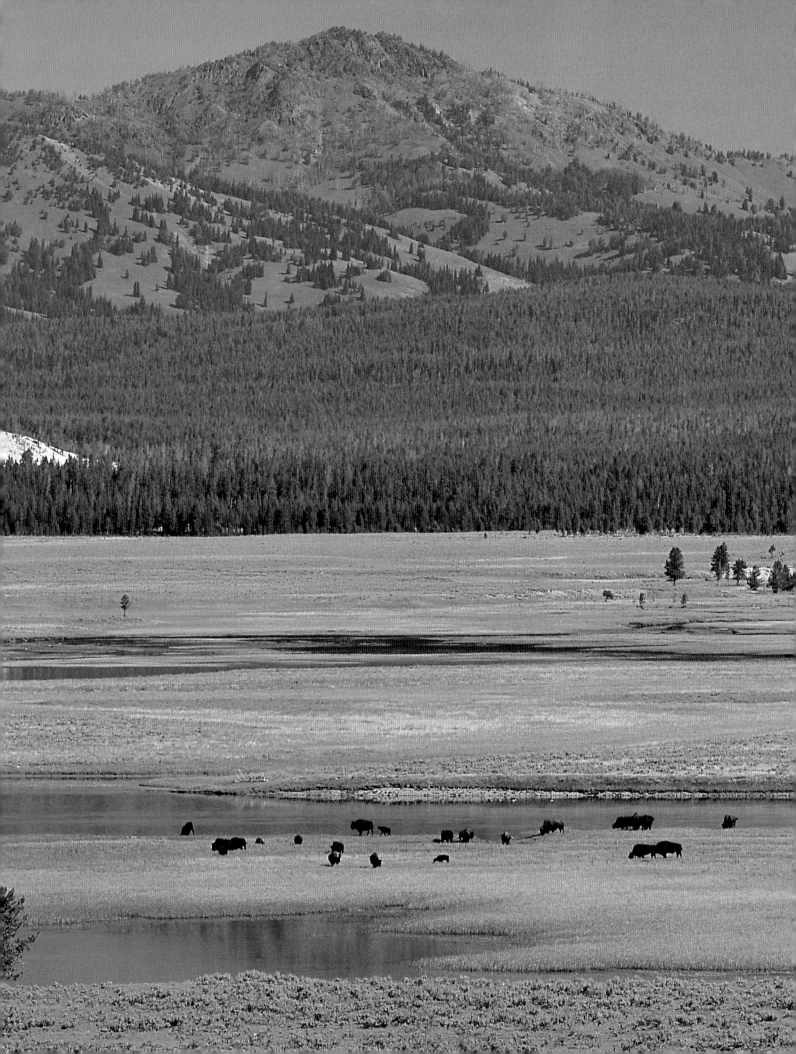

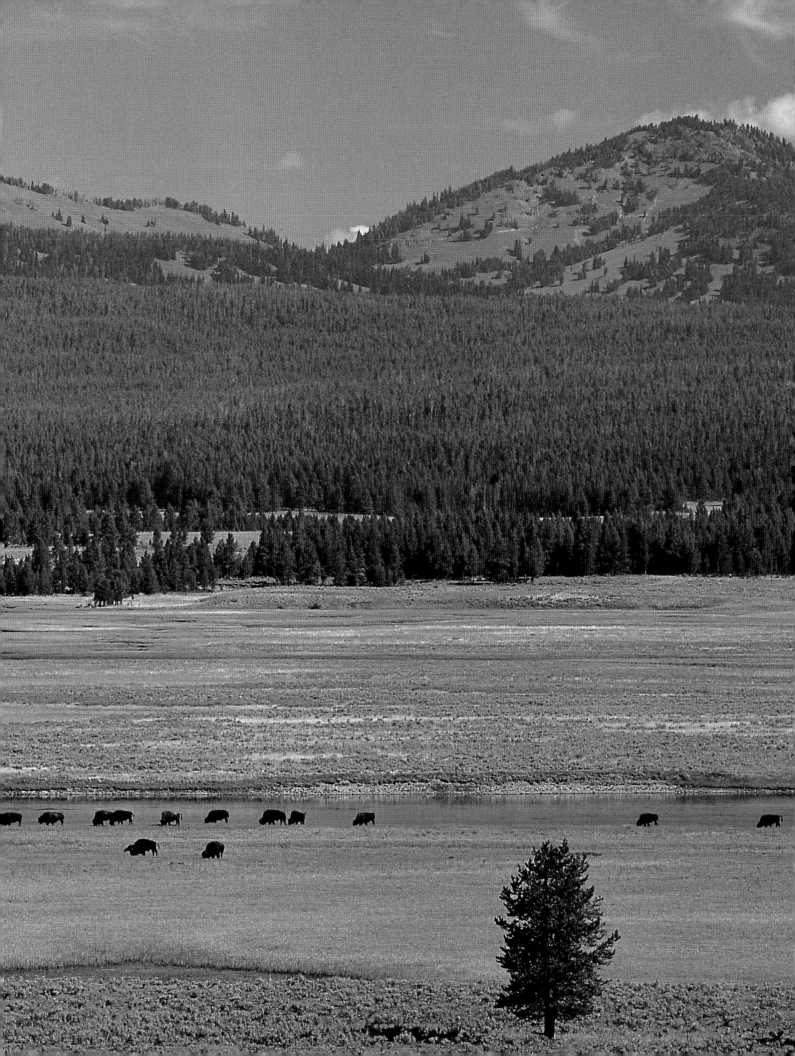

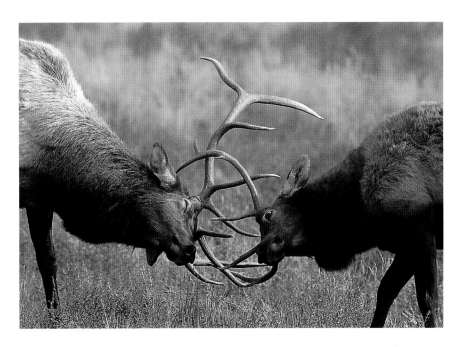

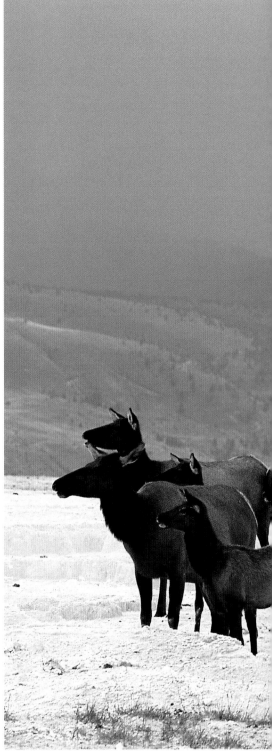

Previous spread: A **bison herd** grazes on its spring range in the Hayden Valley. It is estimated that at one time, some 65 million bison roamed the North American plains. By the 1900s, excessive slaughter by humans for food and sport had reduced the vast herds to some 1,000 animals, a scandalously small handful. Poaching also occurred within Yellowstone's boundaries until the U.S. Army arrived to protect the park's resources. The damage had been done, however, and by 1903, only 23 free-roaming *Bison bison* remained. Through strict management and the introduction of pen-raised bison, the Yellowstone herds have rebounded to about 1,500 animals. Yellowstone and the adjoining Grand Teton National Park boast the largest aggregations of **elk** in the world. Each fall, male elk, above, compete for control of a harem of females. A large antler rack, a thick neck and broad chest muscles are an advantage during these head-crashing territorial disputes, which resound throughout the forest for miles. The winner of such an encounter, right, earns the privilege of heading a harem of cows that will bear his young. Among deer, *Cervus canadensis* is second only to the moose in size, with females weighing more than 600 pounds and the largest males weighing as much as 1,000 pounds. This herd of 52 animals—a sample of the 40,000 to 50,000 elk in the region—had retired to the inaccessible terraces of Mammoth Hot Springs to avoid a crowd of human onlookers. They rested there for hours until awakened by a light rain.

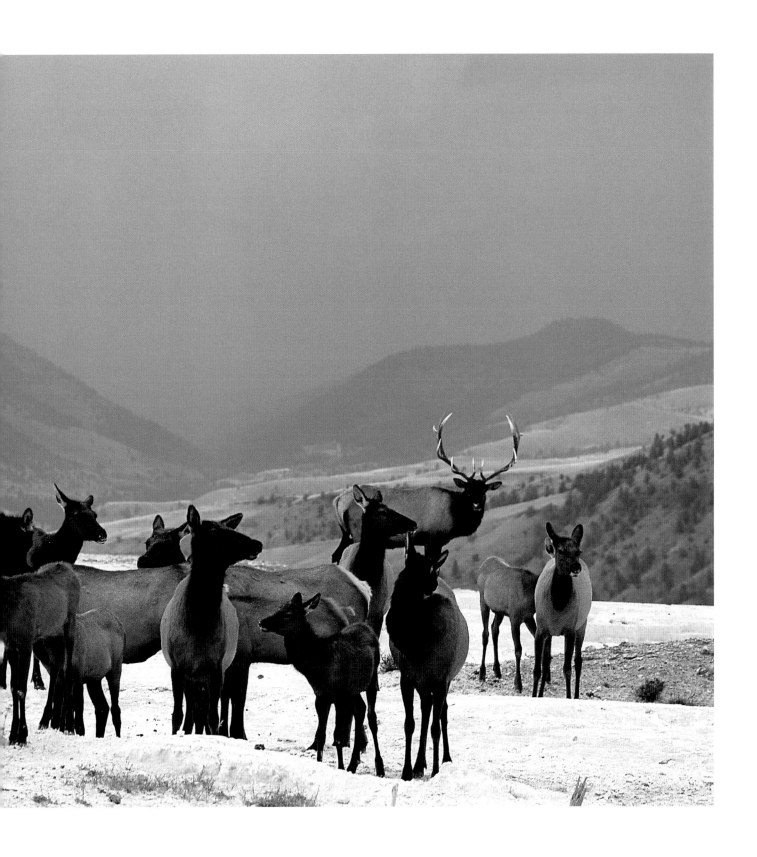

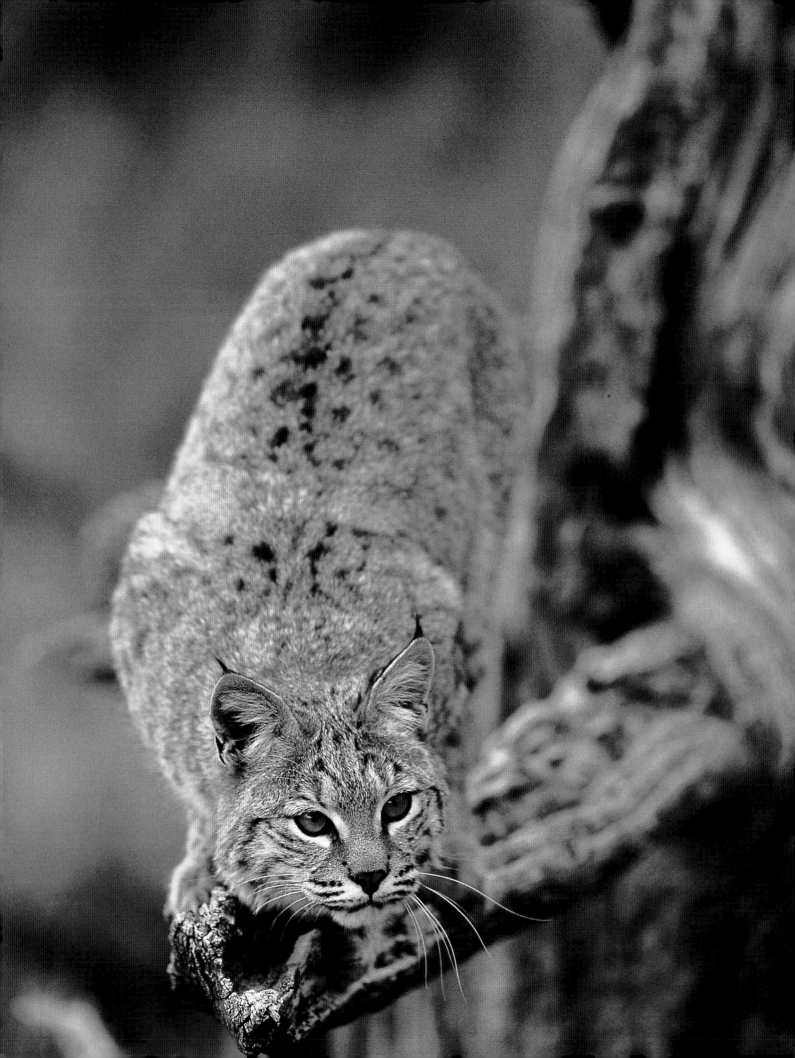

Relying on its camouflage for concealment, this **snowshoe hare**, ABOVE, crouched in the same position for almost an hour while a parade of park visitors and photographers wandered past. *Lepus americanus* is common throughout the park but often goes unnoticed, as its coat blends in with the surrounding landscape. In summer, the rusty brown-tipped pelage is the color of dried pine needles and leaves, while in winter, the white fur renders the animal indiscernible against the snow. The **bobcat**, LEFT, is the smallest and most successful of North America's large cats, yet few remain in Yellowstone and those which do are rarely seen. The continent's big cats have been persecuted since Europeans first settled here, as have wild canines such as wolves, coyotes and foxes. Traditionally a small-game specialist which preys on rabbits, hares, rodents and birds, *Lynx rufus* has a reputation as a voracious predator of domestic livestock and game animals, such as deer and antelope, that far exceeds reality but has made it unpopular with ranchers and hunters.

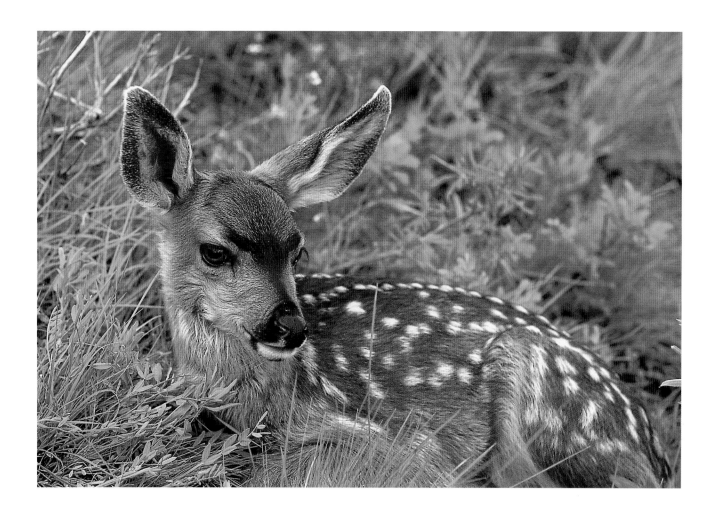

Only a few weeks old, a delicately spotted **mule deer fawn** rests in the spring grass, ABOVE. *Odeocoileus hemionus*, the western relative of the white-tailed deer, is common throughout Yellowstone. It derives its name from the large, widespread mule-like ears that are an adaptation for detecting approaching predators. Although the newborn calf is left alone for brief periods of time, its mother is never far away. Within a month or so, the fawn will be sufficiently strong to abandon its den area to join its mother and begin to supplement its diet of milk with tender summer grasses.

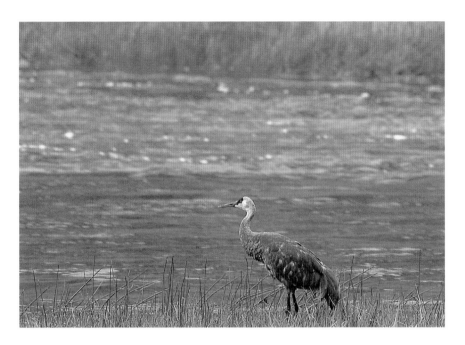

A TALL, STATELY AVIAN PRESENCE ON THE Yellowstone landscape, the **sandhill crane**, LEFT, nests each year in the park's wetlands. Its intense call, which can be heard for miles, rivals the wolf's howl and the loon's song for its spine-tingling evocation of wilderness. In winter, *Grus canadensis* migrates to New Mexico. The flock's trumpeting during the journey, which has been compared to the sound of a chorus of French horns, is a strategy for keeping the birds together. Dwarfed by its 1,000-pound mother, a **bison calf**, BELOW, enjoys an intimate moment of head rubbing. After a nine-month gestation, a bison calf, covered with thick reddish fur, is born in April or May. Within a few days, it is able to join the herd, but it will continue to nurse for seven months. The gentle doelike eyes of a *Bison bison* calf endear it to the park's visitors.

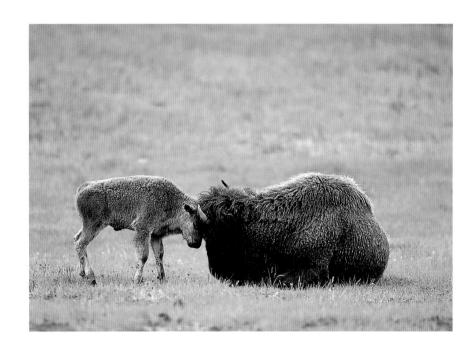

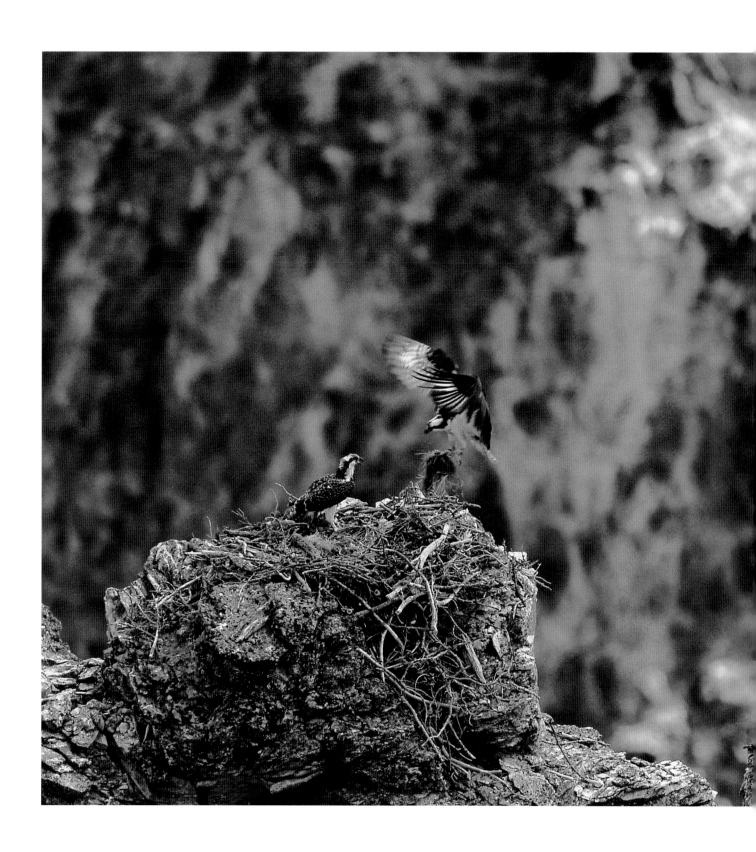

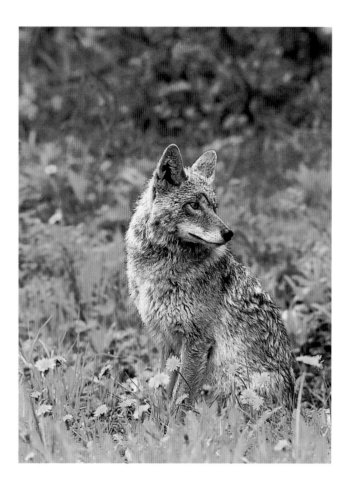

Of the 200 or so bird species that brighten the park, none is more interesting to visitors than the majestic **osprey**, LEFT, which frequently nests in the remote rocky cliffs of Yellowstone's Grand Canyon. In 1997, as many as seven pairs raised their young in this region. A fishing bird, *Pandion haliaetus* takes advantage of the abundance in the river below. Raising a raptor chick is intensive work, which begins when the adults build their nest in late May. This last chick did not leave home until the beginning of September. The **coyote**, ABOVE, despite its troubled history since the settlement of North America, remains one of the most successful wild canines, especially in Yellowstone. With its thick, grayish brown coat, *Canis latrans*, shown here sitting quietly in a dandelion meadow at the Lava Creek picnic area, is a bold member of the park's fauna. The highly opportunistic ways of the coyote, however, have not robbed it of its wild nature: Late at night, the sound of singing coyotes travels for miles through the still air.

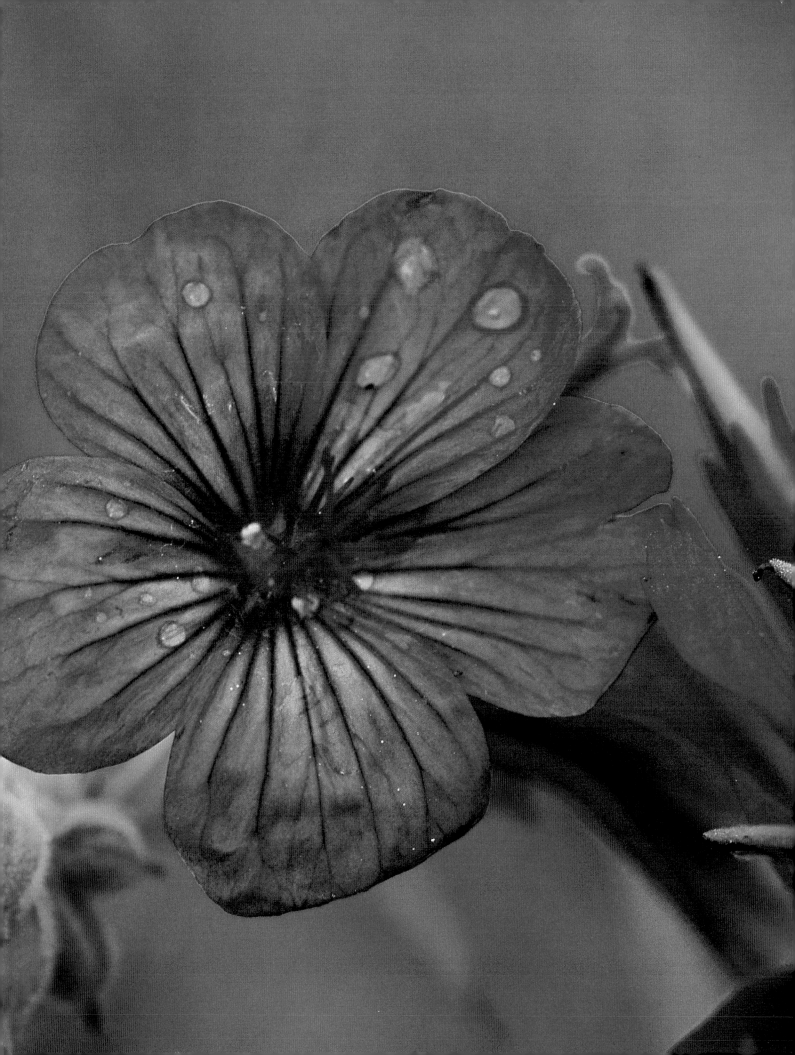

LIFE ON THE LAND

EVEN BEFORE YELLOWSTONE IS RELEASED FROM WINTER'S icy grip, the park is alive with color. As if to make up for the short growing season, an explosion of spring blossoms appears virtually overnight, and at elevations with permanent snow cover, entire gardens push up through the snow, carpeting alpine meadows with wildflowers. It is difficult to find an area within the park that is not adorned with flowers, grasses, shrubs and forest. Hardship has bred plant communities that thrive in Yellowstone's climatic extremes and boldly take root in the thin layer of soil which covers the surface of this volcanic land.

In this dry, mountainous region, the single most important catalyst for change, diversity and the future prosperity of the park's vegetation is fire. A decade after the great fires of 1988, the park is already rebounding from the inferno. Fire brings continual renewal to the Yellowstone landscape. The park is filled with hardy specialized plant species that not only have evolved in harmony with fire but depend on

MAGENTA **sticky geranium** AND VIVID red **Indian paintbrush**, LEFT, are familiar sights at Mount Washburn each summer. Elk and deer eat all parts of the sticky geranium, and moose devour the flowers. A western genus of the figwort family, Indian paintbrush (the state flower of Wyoming) ranges in color from cream to yellow, pink and red. Legend has it that the lively palette of *Castilleja rhexifolia* originated when an Indian brave threw his brushes to the ground in frustration after failing to paint a prairie sunset, giving rise to the colorful foliage that hides a tiny flower.

81

fire for their survival. Nearly 90 percent of Yellowstone is forested, and more than three-quarters of that is lodgepole pine, a long, straight, slender hardwood which grows in dense groves reaching 75 feet high. One of the park's fire-hardy species, the lodgepole pine stores seeds in its cones and releases them for dispersal only when subjected to the extreme heat of a forest fire.

Much more than a destructive force, fire returns vital nutrients to the soil, rivers and streams, thereby revitalizing the ecosystem. Fire allows for greater diversity in the age of the forest's trees and discourages a monoculture of trees from encroaching on grasslands. The accumulation of ash helps increase the water-holding properties of the park's soil cover, which allows the trembling, or quaking, aspen to send out its sprawling roots. Fire opens areas where sunlight can reach the ground, giving unprecedented opportunities to sun-loving plants.

Recolonization following a fire is an orderly succession of plant growth that covers the burned-out landscape. Weeds are the first to flourish, and they offer temporary protection to the soil, safeguarding it against the effects of wind and water erosion and harsh sunlight. Grasses and wildflowers soon begin to grow, followed by shrubby brush and tender saplings. With new growth comes improved forage, a boon to animal species of all kinds, from rodents to large browsing ungulates like moose and elk.

Humans have a fickle relationship with fire: We depend on it even as we fear its power. Yet what we find aesthetically pleasing or commercially valuable is not always what nature protects. In art and literature, fire is often used as a symbolic regenerative force, and with good reason. Over the long term, fire stabilizes plant communities by removing stagnant growth and inspiring successive generations of new life. It is one of nature's ways of ensuring that vegetation and the animal species which rely on it survive into perpetuity.

WITH ITS MOTTLED RUST-AND-YELLOW GOBLET-SHAPED BLOSSOMS, the **checker lily**, RIGHT, is among the more than 1,000 native plants that grow in Yellowstone. *Fritillaria atropurpurea* is one of 18 members of this lily-family genus that are exclusive to western North America. Despite the furnacelike temperatures above the ground, wildflowers are among the first plants to recolonize the landscape after a fire because their seeds, bulbs and tubers, safely buried in the soil, can withstand the heat of the blaze.

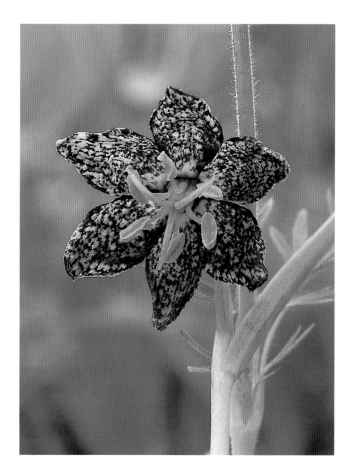

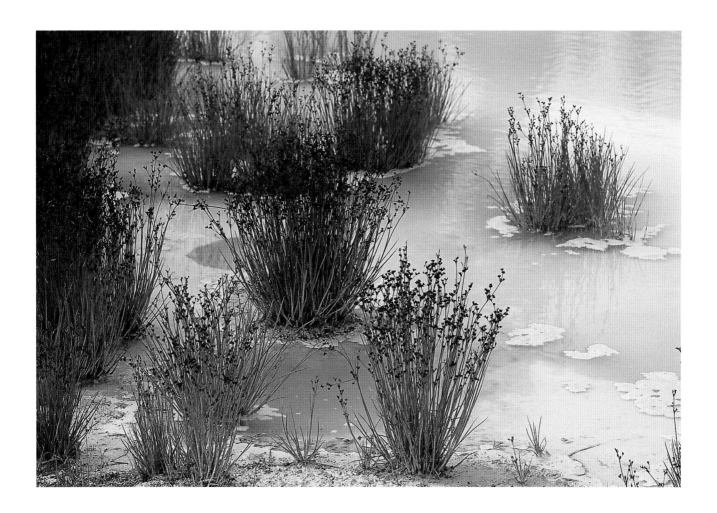

Spike rush grass, ABOVE, GROWING IN A HOT MUD POOL AT THE West Thumb Geyser Basin, is an example of the unusual aquatic plant communities that thrive in Yellowstone. Exclusive to the park, *Eleocharis pauciflora* is a member of the sedge family and features a small flower head at the end of each greenish yellow stem. The dense bunches of grass are very hardy and favor settings that offer environmental extremes, such as excessive cold, heat or acidity. Spike rush grass not only provides excellent nesting habitat for the park's waterfowl, including the majestic trumpeter swan, but also serves as a food source for the birds.

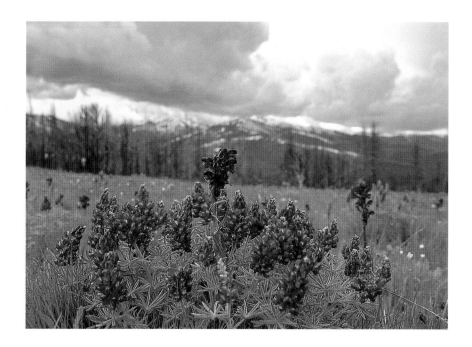

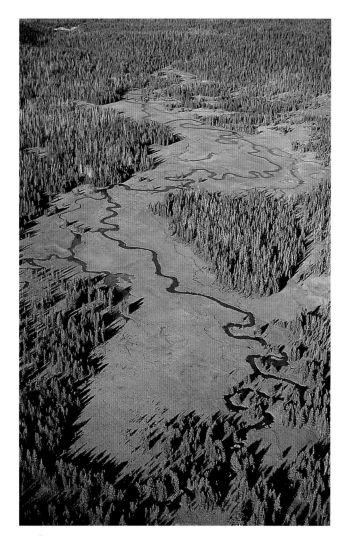

Lupins, ABOVE, BLOOM THROUGHOUT THE PARK AND COVER THE mountain slopes at the peak of the season in July and August. The showy blue, purple and white or creamy flowers of 10 species of *Lupinus* are among the most plentiful flowers in the park. Although alkaloids make lupin seeds and seedpods poisonous to wildlife, the vegetative parts are eaten by bears, rodents and grazing animals. The **Little Firehole River**, LEFT, twists and turns through Yellowstone's remote swampy areas, which are home to many animal and plant species. Meandering waterways are common in Yellowstone, the result of centrifugal forces that sweep the current from one bank to another along the river's course. This tributary of the Firehole River is important in the drainage of Biscuit Basin. RIGHT: The yellow foliage of a grove of **quaking aspen** rattles in the slightest breeze in the Lamar Valley. The broad-leaved *Populus tremuloides*, also known as trembling aspen, is the most common deciduous tree in Yellowstone and grows to a height of some 60 feet. Although this true poplar, a member of the willow family, is vulnerable to attack from parasitic fungi and wildlife such as the beavers, deer and elk that browse on its tender bark and buds, it is a hardy pioneer species and among the first trees to re-grow after an extensive fire. One reason for its success is an elaborate root system, which continuously sends out suckers that begin to grow as soon as the dense forest canopy has been eliminated and the sun's rays are able to reach the ground.

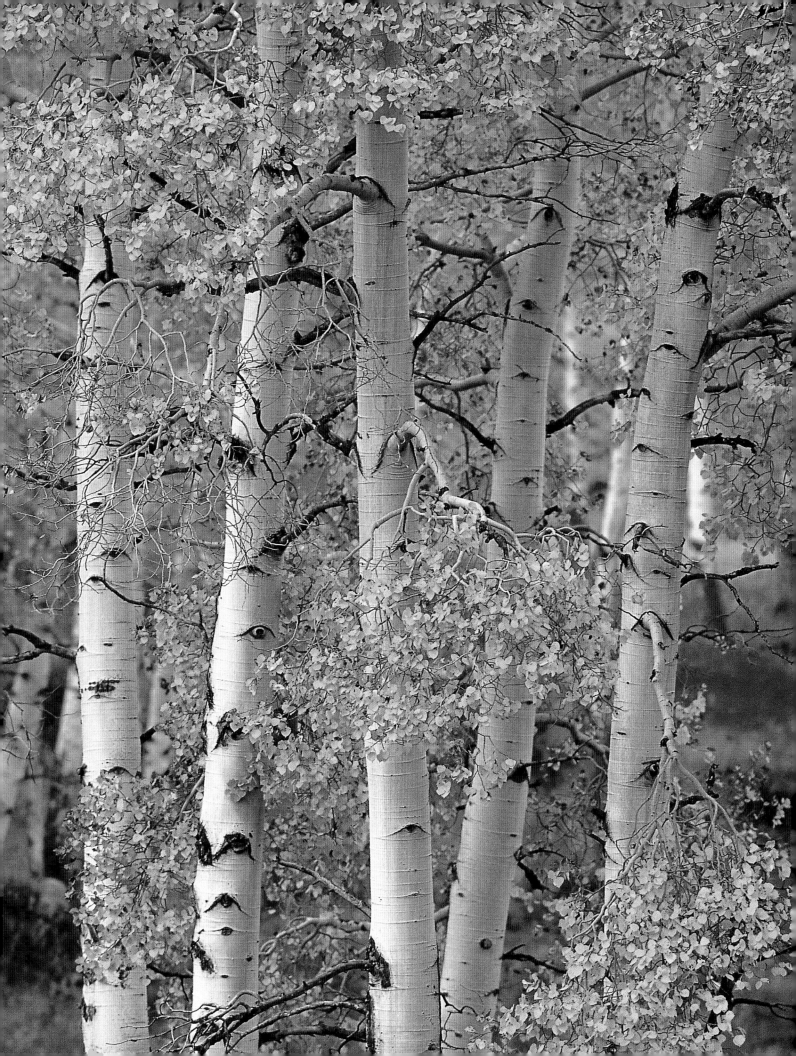

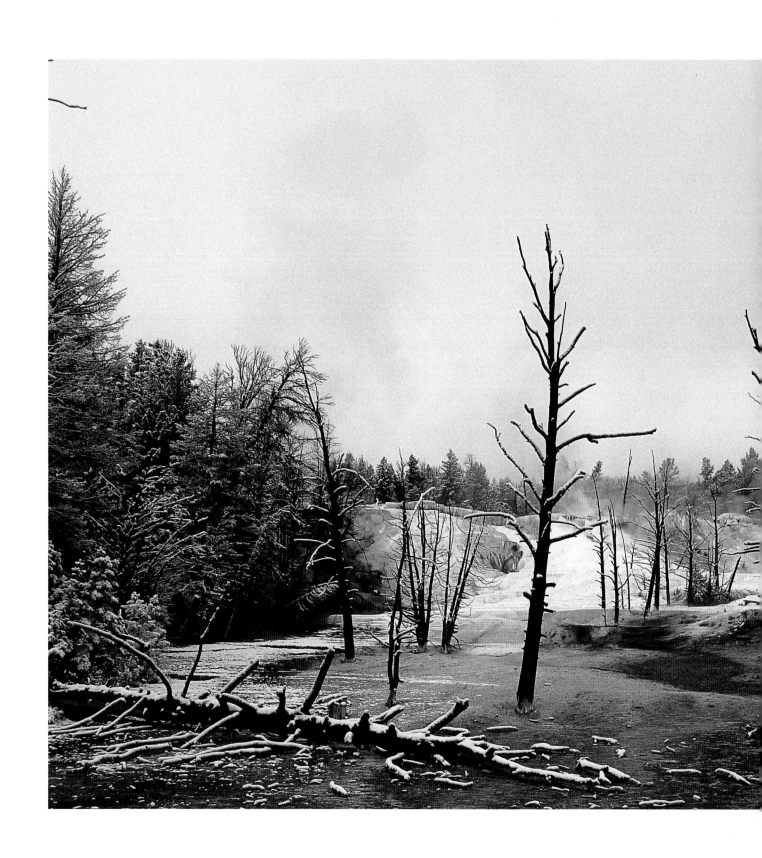

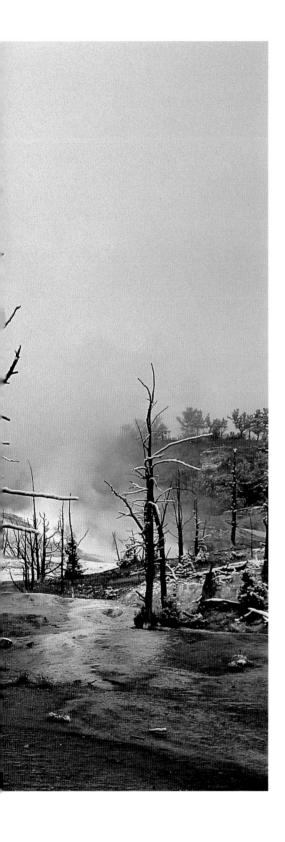

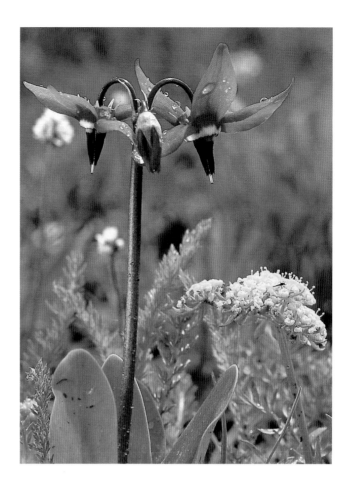

Flowers such as the **shooting star**, with its curled-back petals, and **yellow mountain parsley**, above, waste little time making their debut each spring. These flowers are among the earliest to bloom, barely waiting for the snow to melt before they open. A stark contrast to the luxuriant meadows carpeted in wildflowers are the forlorn and sparsely scattered barren tree trunks near **Angel Terrace** at Mammoth Hot Springs, left. Only a few years ago, these trees were still alive, but the steaming runoff has roasted the trees' roots, and the mineral-laden water can no longer support green vegetation.

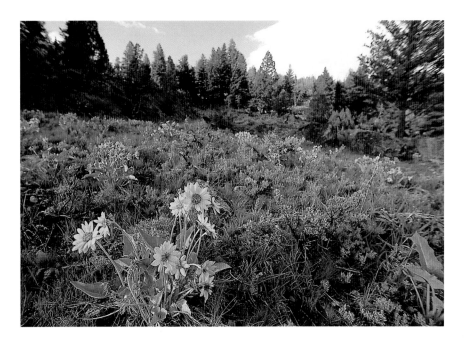

ONE OF THE EARLIEST SPRING FLOWERS IN THE LAMAR VALLEY and on the hills near Mammoth Hot Springs is the **yellow arrow-leaved balsamroot**, ABOVE, which rapidly takes hold after overgrazing and fires. RIGHT: Until relatively recently, Yellowstone was 90 percent forested, but in the summer of 1988, eight raging blazes destroyed about 1.4 million acres of trees—more than half the total park area. Until the 1970s, park policy had encouraged fire suppression, but increased understanding of ecology in general and the Yellowstone ecosystem in particular taught park managers that fires are a natural part of a forest's life. Among other benefits, fire eliminates leaf litter and deadfall that might otherwise accumulate to catastrophic levels. In one summer, however, it seemed as though Mother Nature was playing catch-up for all the seasons of fire suppression. The long, dry summer of 1988 dehydrated fallen trees to the moisture level of kiln-dried lumber—less than 2 percent—and paved the way for lightning and human error to set off an inferno, the likes of which had not been seen for more than 200 years. Despite the initial devastation, new forests are already growing. The burnout has allowed for greater diversity in the types and ages of plant growth and opened once densely forested areas to a variety of wildlife species.

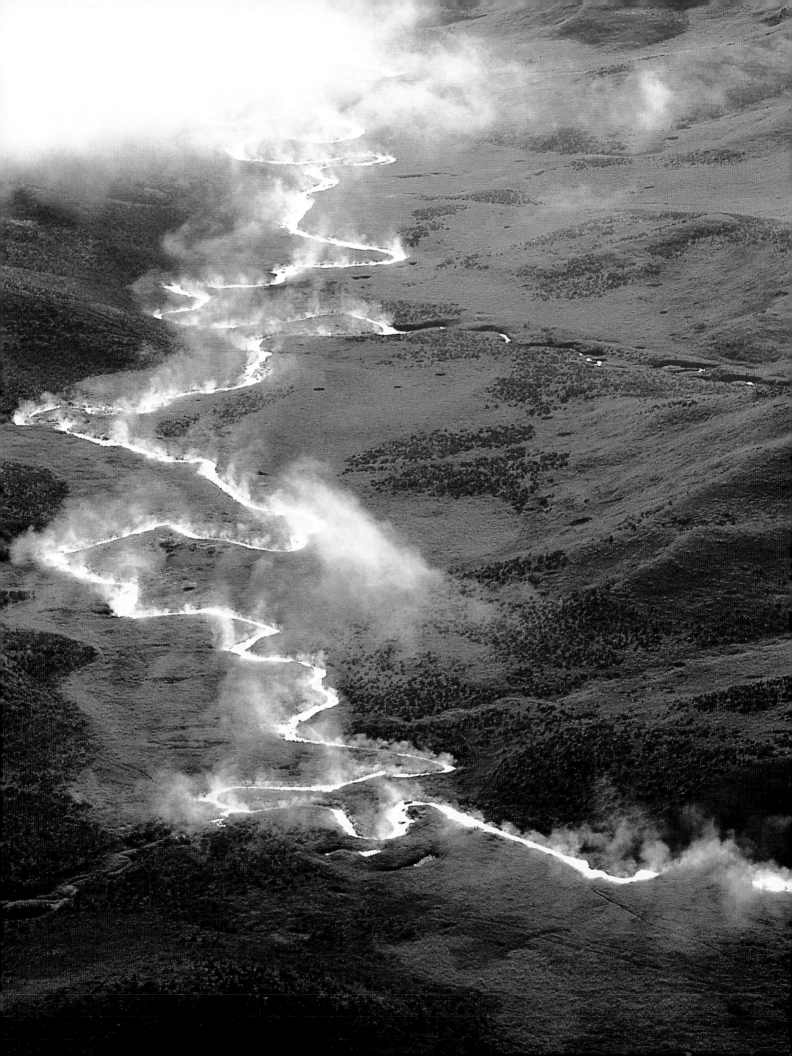

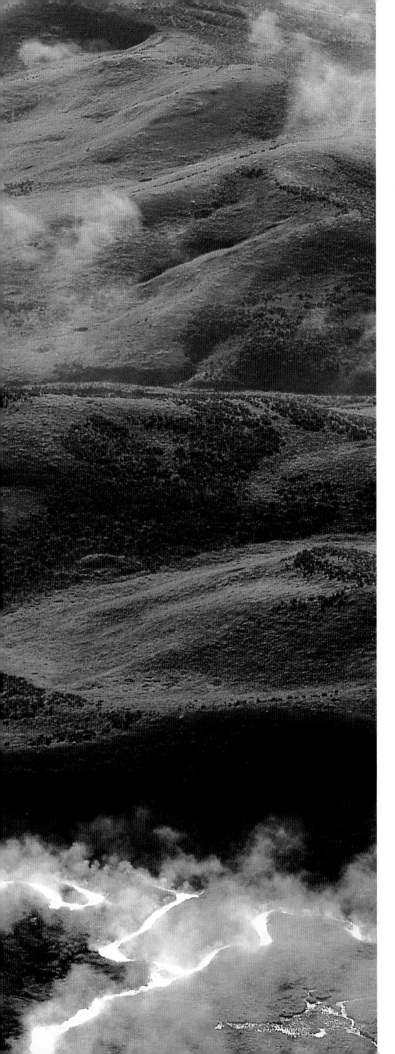

LAND OF FIRE AND ICE

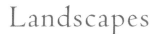

SHORTLY AFTER 11:30 P.M. ON AUGUST 17, 1959, VISITORS to Yellowstone National Park were awakened as the ground shook violently beneath them. The 7.5 Richter rumblings were among the most severe in American history. The earthquake tremors opened a seam in the Earth's crust, setting off a sequence of 300 erupting geysers. Nearly half these geysers had been previously silent or dormant, and when they returned to life, hundred-pound boulders were blasted into the air. The massive earthquake was a graphic reminder that Yellowstone is never at rest. And when change occurs, it can be dramatic.

Yellowstone began as a flat plain periodically covered with water that surged and retreated. The transformation of a featureless land into today's magnificent landscape began with three major periods of explosive volcanic eruptions, the first of which dates back two million years. The most recent and significant eruption occurred 600,000 years ago. It devastated a 1,000-square-mile area, creating the

ON A COOL SEPTEMBER MORNING, the thermal runoff from **Alum Creek**, LEFT, smokes like a burning fuse as it twists through Hayden Valley. In summer, the clear water of the narrow creek reaches a temperature of 60 degrees F. When the earliest frontiersmen returned from Yellowstone with tales of spectacular geysers and waterfalls, colorful pools, breathtaking canyons and stone trees, city folk greeted them with disbelief. St. Louis trapper Jim Bridger described the waters of Alum Creek, which still taste potently of sulfates of alum, as strong enough "to shrink horses' hooves."

Yellowstone Caldera, a dishlike depression in the central area of the park. These explosive eruptions spewed the Earth's crust and rocky debris upward and accordioned the surface into mountains. Hot lava oozed over the terrain to become the durable rocky layer that now covers much of the park area. Relentless lava flows, which continued for 500,000 years, filled in the caldera. With an unusually thin surface crust—2 miles deep instead of the average 20—Yellowstone remains susceptible to seismic activity.

The face of today's Yellowstone came about through the gradual sculpting, erosion and compression of the Earth's surface by massive sheets of glacial ice about 30,000 years ago during the Pinedale Glaciation, the last period of glacial activity. Glaciers advanced into the park from the south and the north, covering it to a depth of over 3,000 feet in some areas. More than 90 percent of Yellowstone territory, the center of which is now Yellowstone Lake, remained buried in ice for 17,000 years. As the glaciers retreated, they crushed, wore down, pushed up and carved a variety of land formations—valleys, riverbeds, waterfalls, sparkling lakes, geysers, mountains and rivers—and deposited the soil that supports Yellowstone's vegetation.

When faced with the varied landscape that is Yellowstone today, it may indeed be a challenge to conjure up the flat plain it was in the past. Yet water perpetually boils beneath our feet, and day after day, dissolved materials, drawn to the surface from the ground, discreetly augment the park's geyser cones. Weathered sediments invisibly erode from the canyon walls, while dozens of minor tremors ripple undetected through the region each year. Yellowstone is a dynamic, living place. All that remains to be seen is what it will be in the future.

Towering **Sheepeater Cliffs**, RIGHT, line the road between Mammoth and Norris in the northwest section of the park. These magnificent pillars of basalt were formed when expansive lava sheets began to cool and crystallizing rock shrank into columns. Gradual erosion has calved some of the Sheepeaters, relegating pieces of them to rocky rubble at the base of the cliffs. The cliffs were named for the Sheepeater Indians, who were reported to be the only year-round human residents of the park territory. A Shoshone band that may have migrated to the park as early as 1200, the Sheepeaters were specialized hunters of mountain sheep and were celebrated for the durable bows they made from sheep horns. FAR RIGHT: Sunset at **Mount Washburn** shows the colorful horizon and clear air at 10,243 feet. Formed by volcanic activity, the peak is alive in spring and summer with red snapdragons and wild geraniums and is home to bighorn sheep.

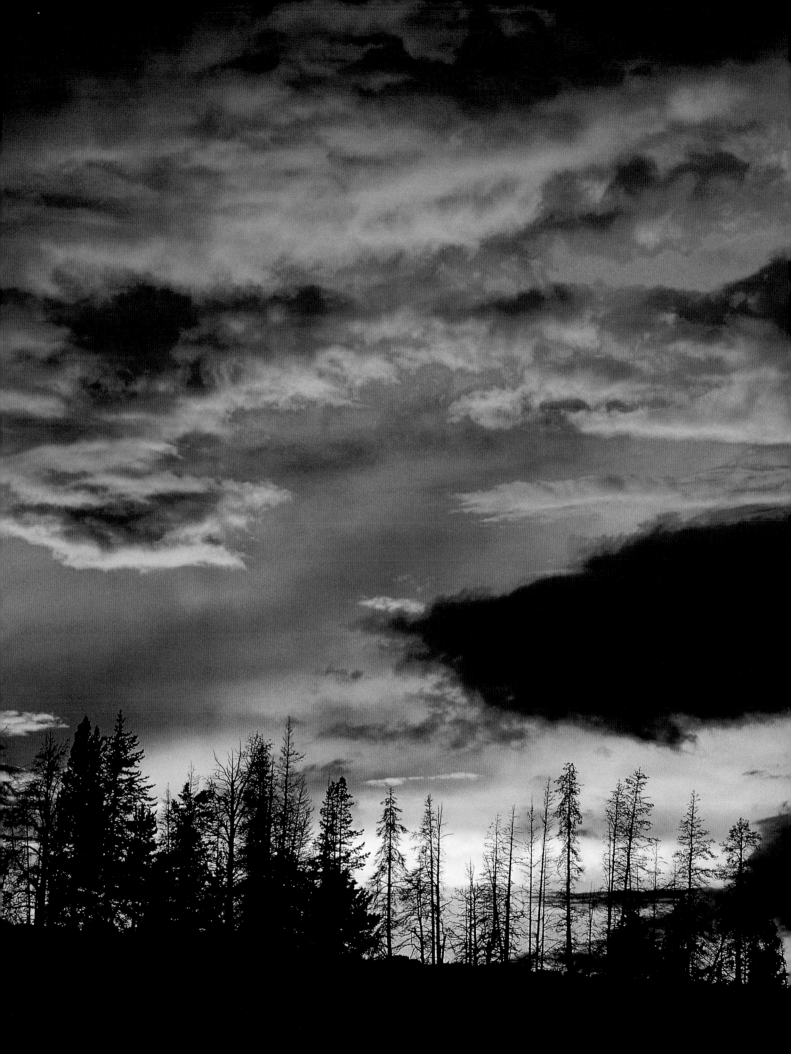

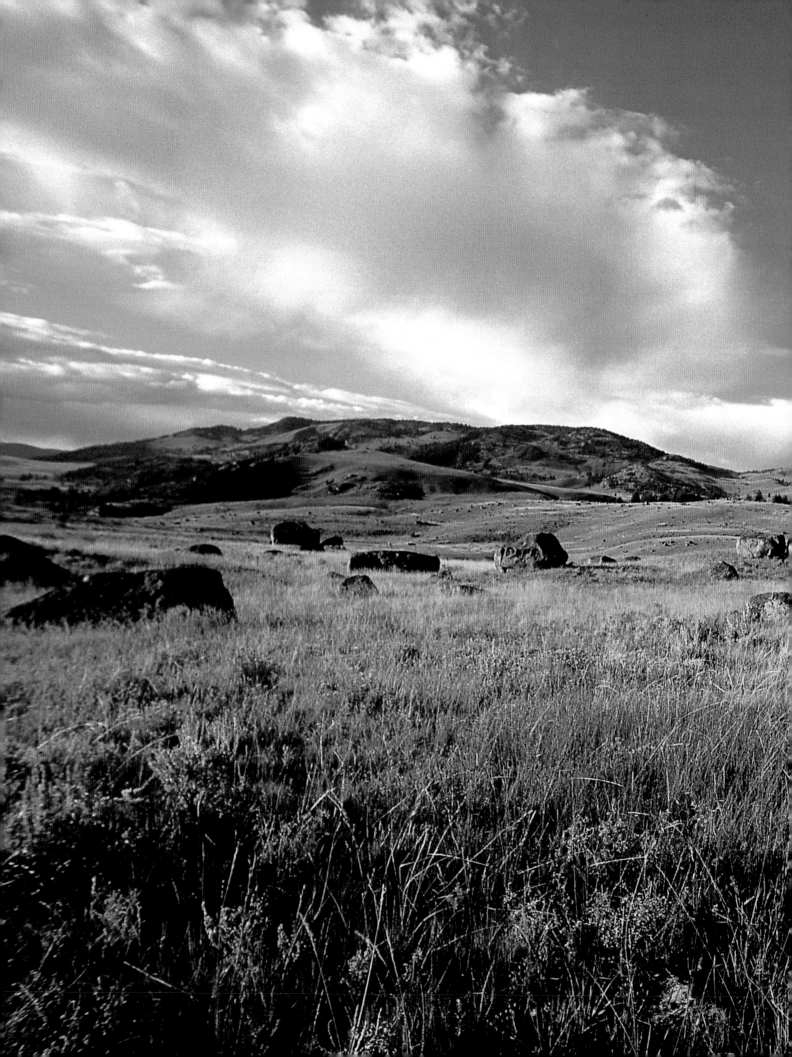

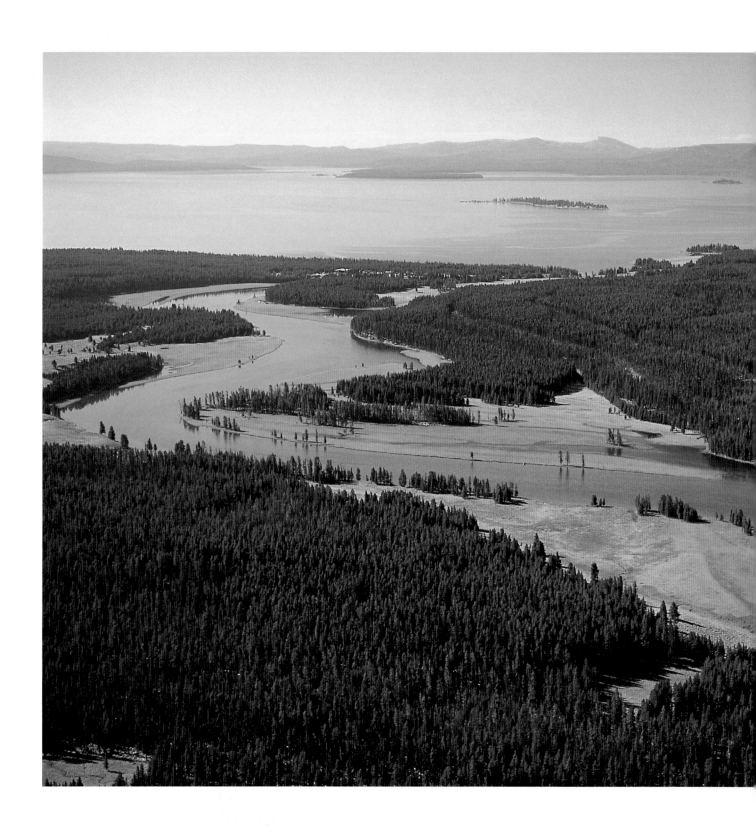

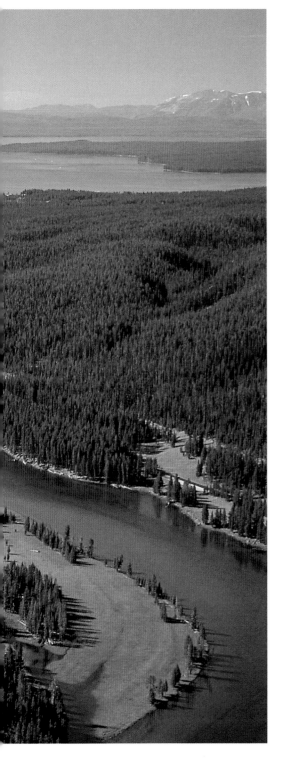

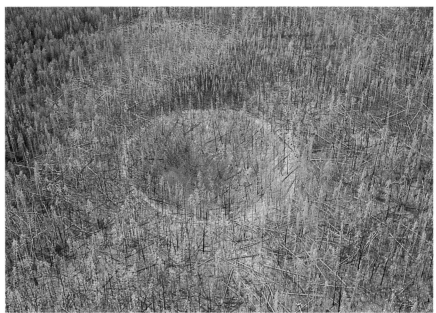

PREVIOUS SPREAD: BOULDERS STREWN ABOUT THE **Lamar Valley** are remnants of the last Ice Age, when glaciers swept through the Yellowstone territory, burying some areas beneath a 3,000-foot-deep sheet of ice. The glaciers' legacy to the valley is a host of richly varied formations—rolling hills, flowing creeks and rivers, steep hills and colorful aspens—which provide an inviting habitat to many species, including bison, elk, deer, coyotes, wolves and bears. Born on the slopes of the 12,161-foot Younts Peak, some 25 miles south of the park, the **Yellowstone River**, LEFT, makes its way north to Yellowstone Lake on a 671-mile journey through forests, falls and canyons to the Missouri River. The last undammed river of note in the United States, the Yellowstone is fed by the several-hundred-year-old runoff from geysers and hot pools and is a paradise for trout anglers. Viewed from the air, thinned-out forests from the devastating fires of 1988 reveal an unnamed **crater**, ABOVE, that appears as a shallow dimple on the Yellowstone landscape atop Obsidian Cliff. The origin of this crater is unknown, but different theories explain it as a meteorite scar left thousands of years ago or a collapsed gas bubble. Due to the clean margins of the circular depression, the latter theory is more readily accepted.

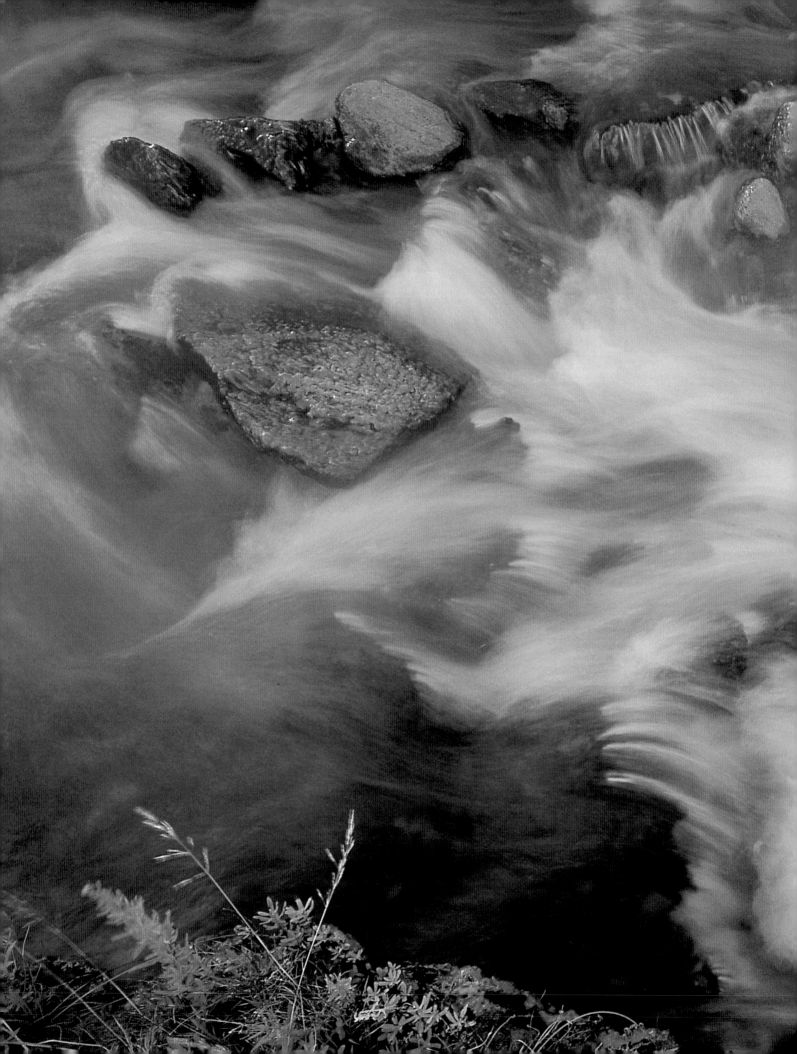

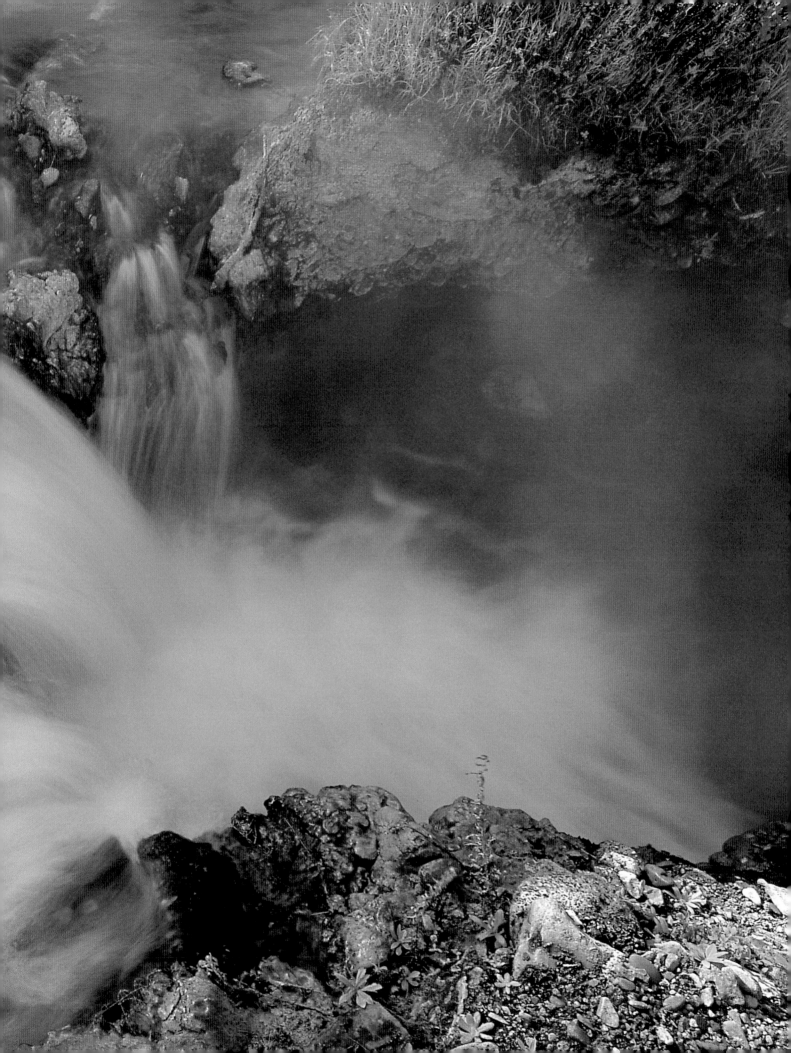

Previous spread: Cascading in an impressionistic blur, the **Boiling River** descends from Mammoth Hot Springs. At one time a popular bathing spot, the river epitomizes the fire-and-ice dynamic of Yellowstone. The riverbed is lined with hot rocks over which flows a curious combination of near-boiling and icy-cold water that is capable of burning and freezing at the same time. Right: On the road between Tower Falls and Mammoth at Tower Falls Gorge, you can see the Earth's history written in the rocky strata of Yellowstone's **hoodoos** and their alternating layers of basalt, gravel and travertine. Sculpted by wind and water, these rocky columns take shape as the soft layers of glacial sediments from one era dissolve, leaving the more enduring rocky layers behind. The resulting remnants, the consequence of subtractive sculpture, stand near the Yellowstone River.

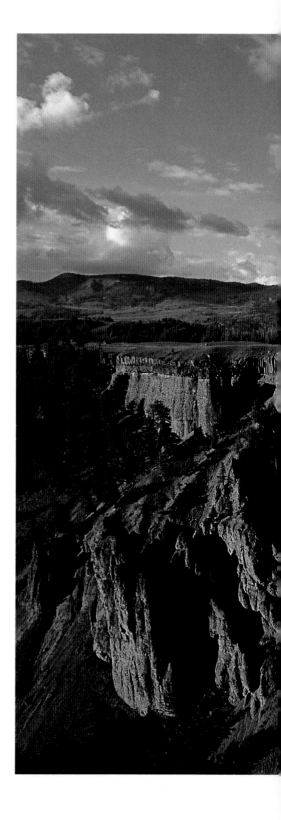

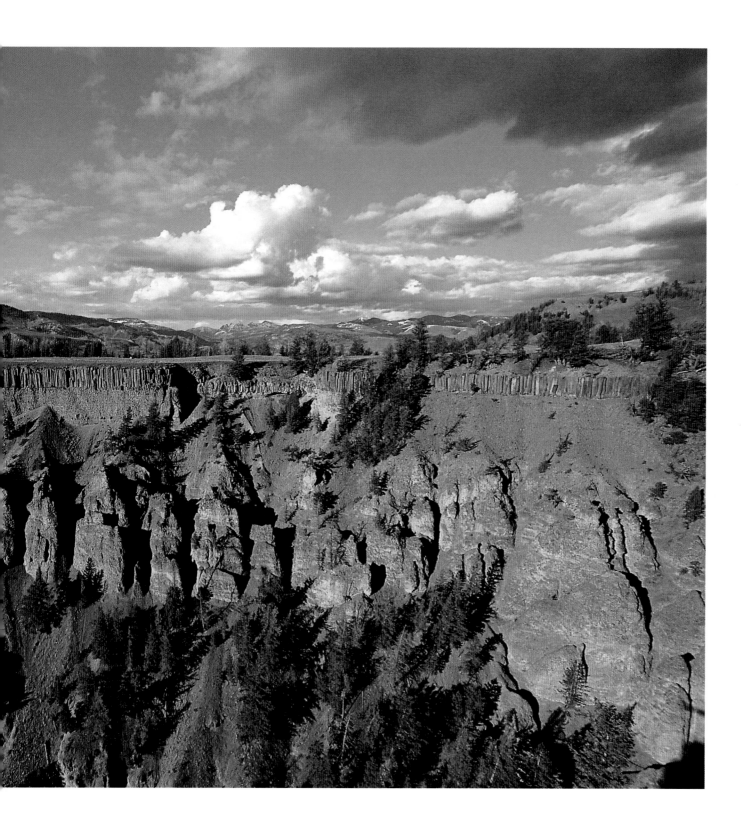

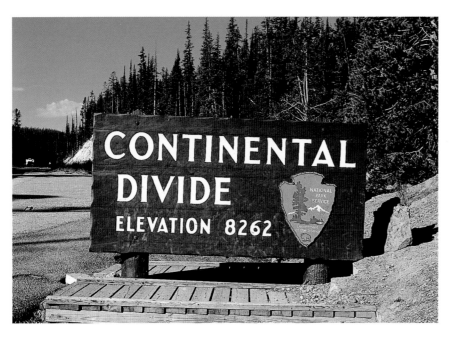

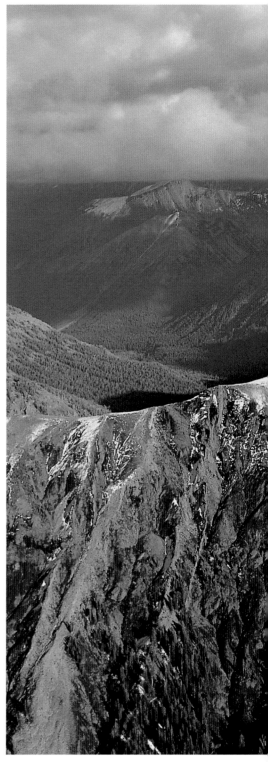

Situated in the heart of the Rocky Mountains, Yellowstone Park has an average elevation of about 8,000 feet above sea level; its extremes range from a little over 5,000 feet to more than 11,000. North America's backbone, the Continental Divide—marked on a roadside sign at **Craig Pass**, ABOVE, near Isa Lake—cuts through the heart of the park. As a result, 75 percent of the park's water sources drain to the Atlantic, while the remainder flow to the Pacific. Little Isa Lake straddles the divide, and its waters drain in both directions. RIGHT: A breathtaking vista of the **Absaroka Range**, which cuts across the southeast corner of Yellowstone, shows one of the wildest high-mountain regions in the park. Boasting some of the park's most spectacular mountains, including Eagle Peak—which, at 11,358 feet, is the highest—the area has a few hiking trails into the mountain country above the tree line.

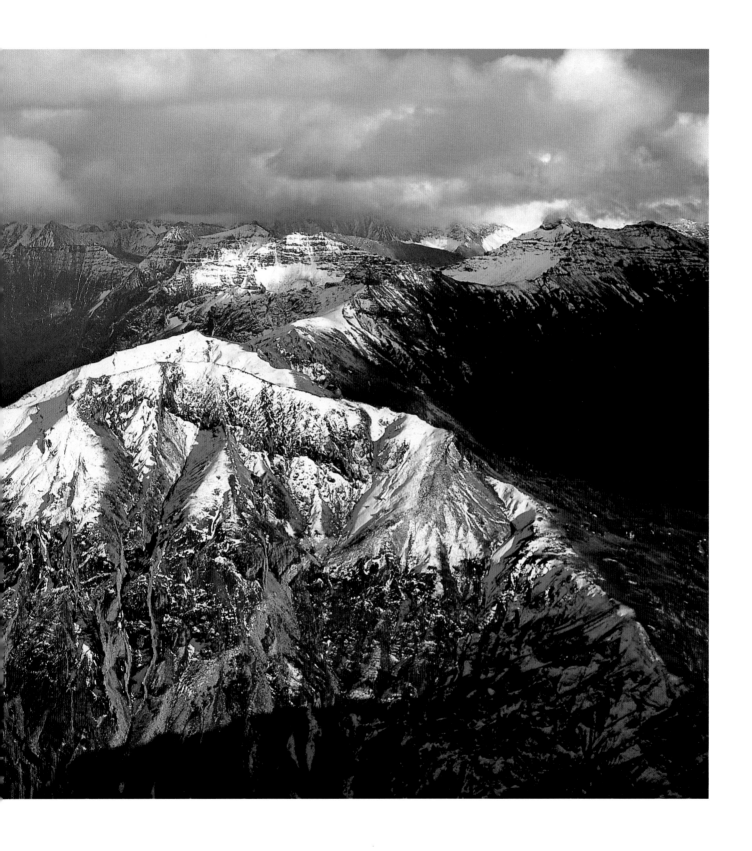

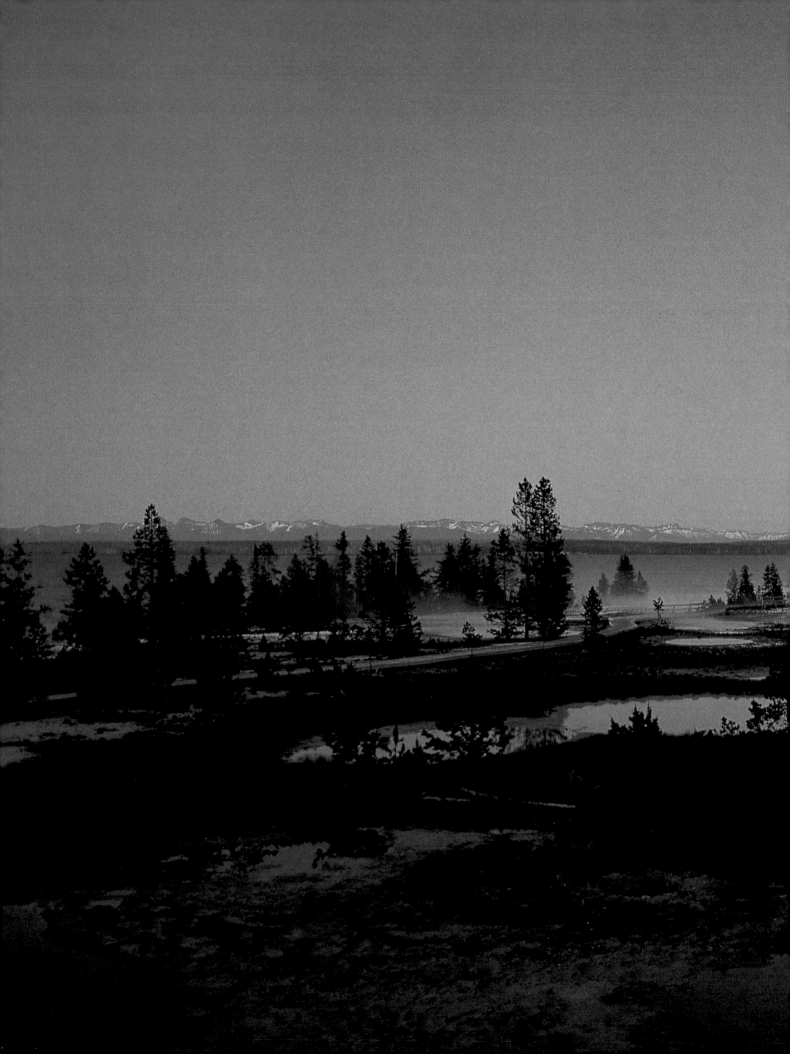

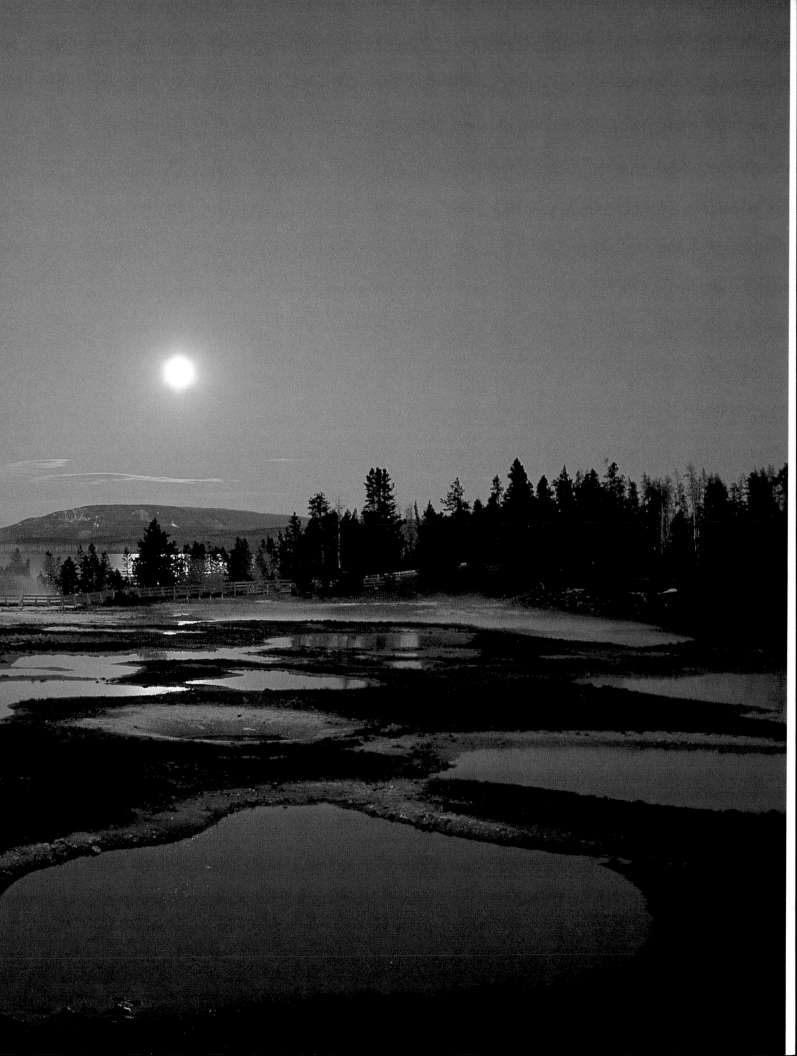

PREVIOUS SPREAD: A FULL MOON RISES OVER WEST THUMB ON **Yellowstone Lake**, the park's largest lake. Occupying 140 square miles and reaching depths of several hundred feet, this pristine lake is situated 7,000 feet above sea level, which makes it one of the largest in the world for its elevation. Early explorers compared the lake's fingerlike outlets to the shape of a human hand, hence the "thumb" designation for this western portion. Yellowstone Lake is home to such waterfowl as trumpeter swans, white pelicans, Canada geese and several duck species. A large petrified stump in the **Lamar Valley**, LEFT, is typical of the stone trees in Specimen Ridge, where distinct layers of petrified flora have been found. In his colorful and exaggerated descriptions of Yellowstone, frontier trapper Jim Bridger gave a tongue-in-cheek account of the region "where petrified leaves and branches still cling to petrified trees, and among them sit petrified birds that sing petrified songs."
ABOVE: Yellowstone's **fossilized forest** is also distinguished by an abundance of precisely petrified leaves, twigs, needles, cones and seeds, often tinted by mineral impurities in the silica. A close look shows the details of knots, rings, branch joints and ancient wood grain cast in stone for eternity.

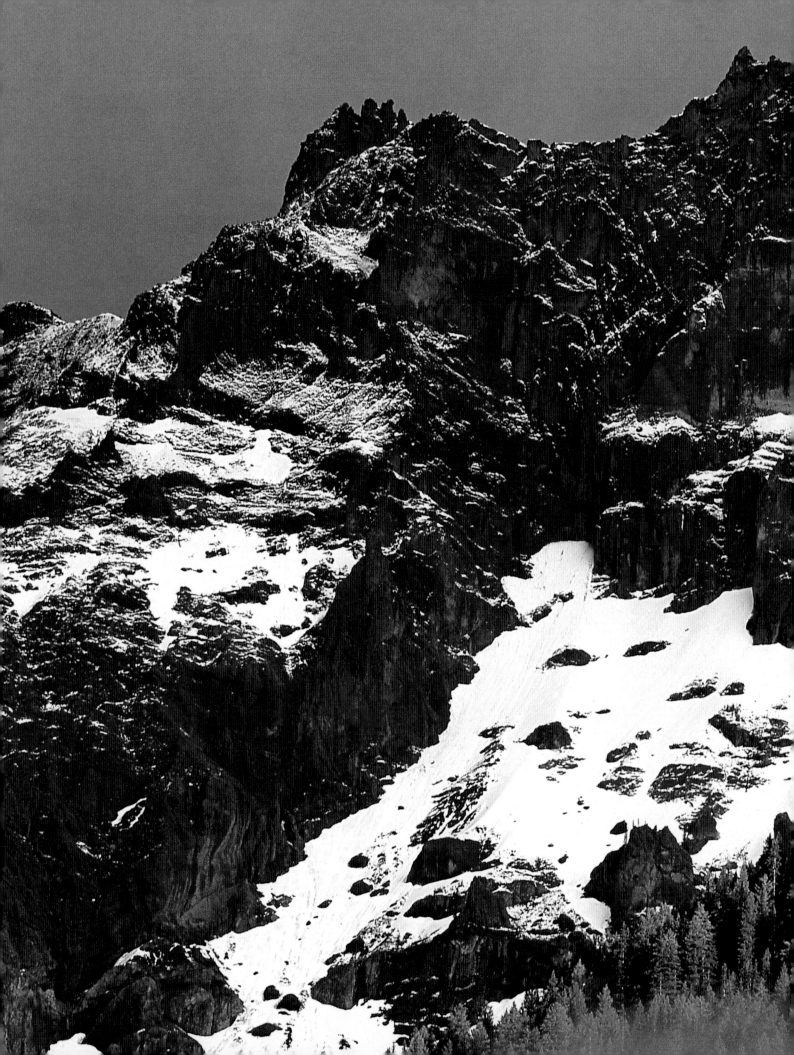

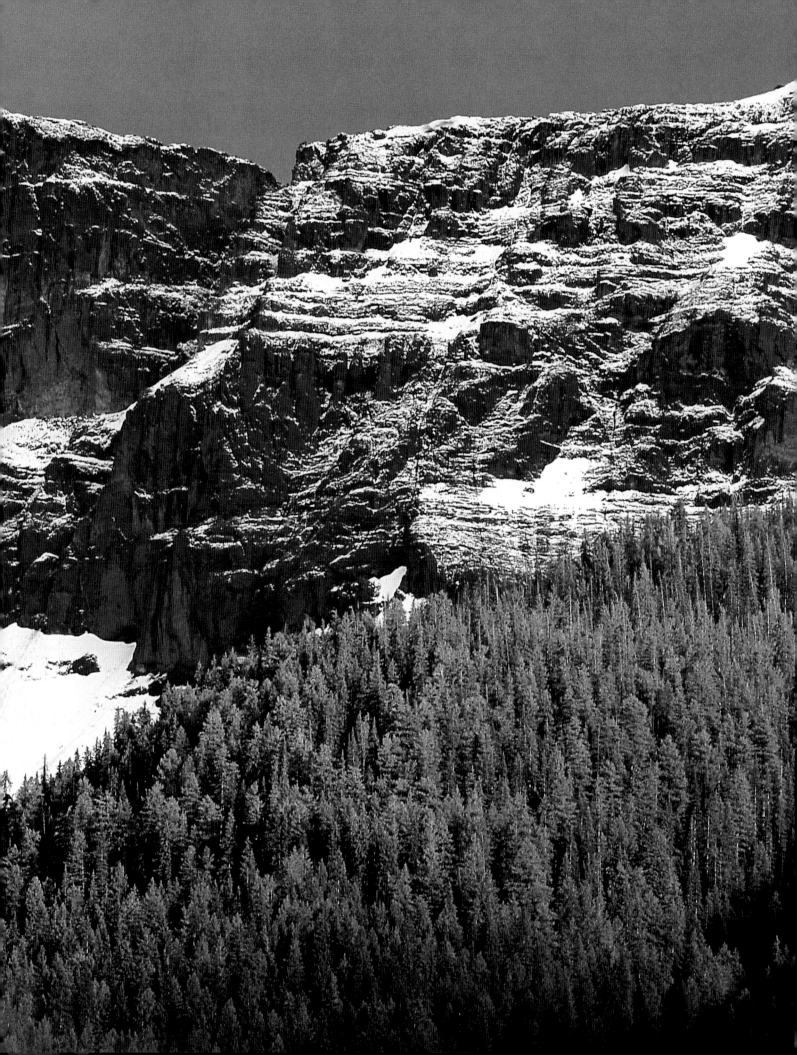

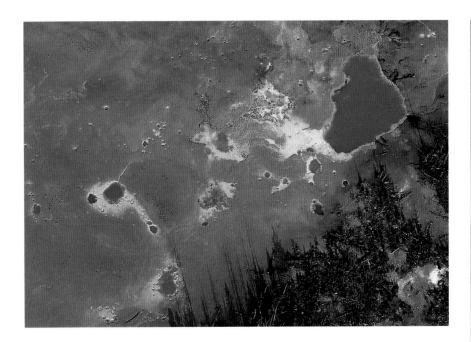

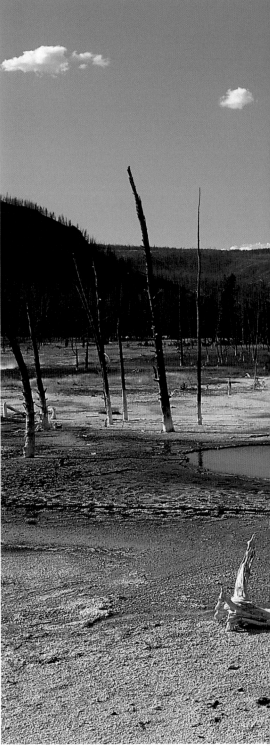

Previous spread: The **Absaroka Range** forms the eastern mountain boundary of Yellowstone Park. An aerial view of **Norris Geyser Basin**, above, resembles a moonscape with blue and green lakes and pools, steaming vents and deep green geyser runoff, all scattered across a desolate and barren land. Amid its stark surroundings, Norris Geyser Basin is unique among Yellowstone's geothermal regions. While it does not have the brilliantly colored noneruptive pools associated with many of Yellowstone's thermal regions, Norris is nonetheless the hottest of the geyser basins, and what it lacks in color, it makes up for in activity. Among its features is Steamboat Geyser, the largest geyser in the world. Although it has not been active since 1991, Steamboat puts on a spectacular show, throwing a water column 250 to 380 feet into the air.

Right: **Opalescent Pool** at the Black Sand Basin, near the Upper Geyser Basin, is outstanding for its iridescent, brightly colored water resulting from cyanobacterial growth. When geysers flood areas that host stands of trees, the silica-laden runoff fills the wood cells in the trunks, eventually turning the young trees white. There they will remain standing, supported by their new stony stems.

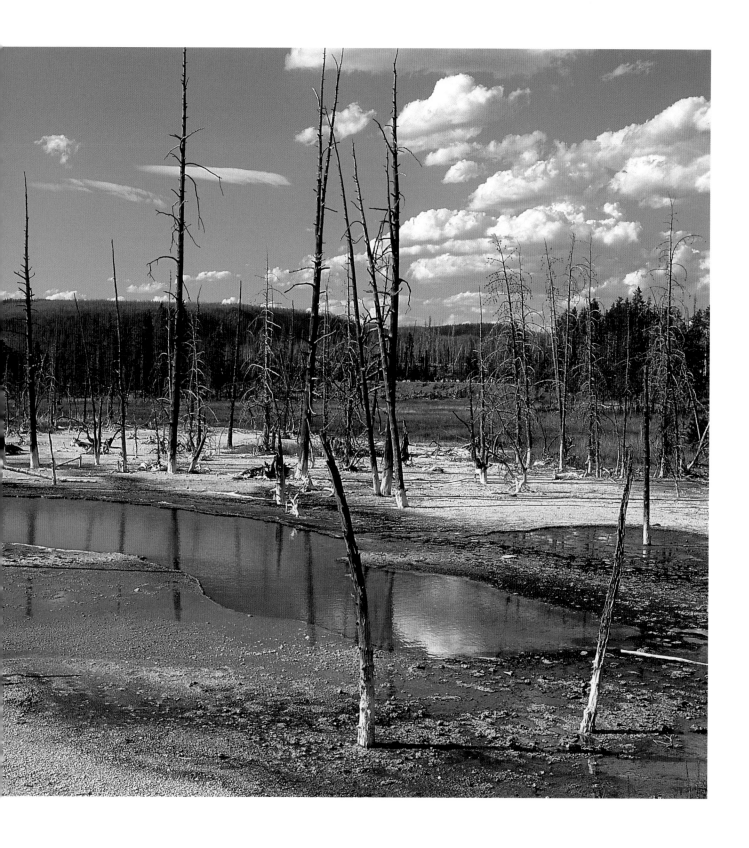

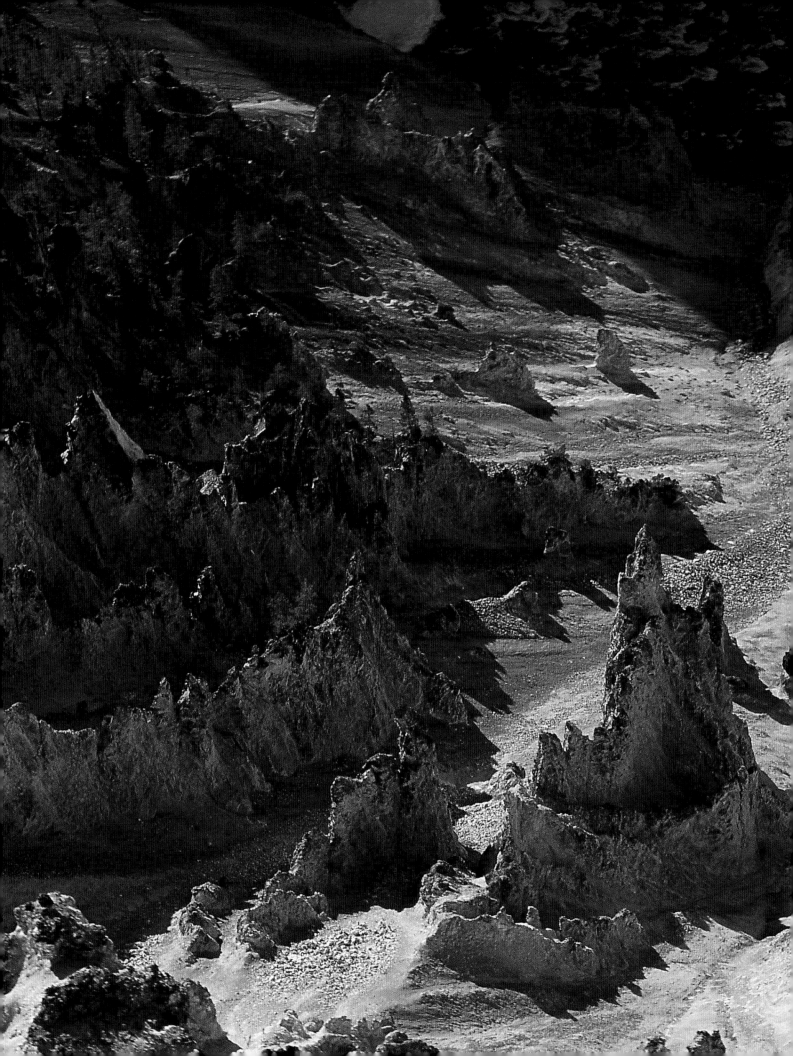

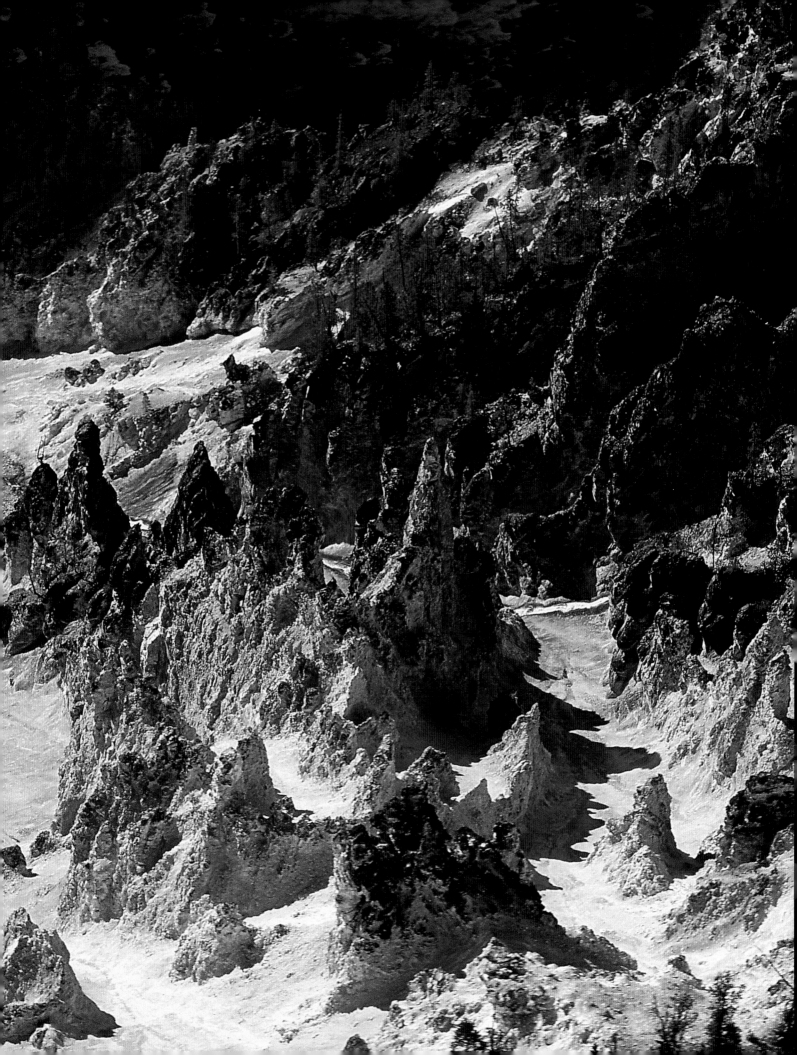

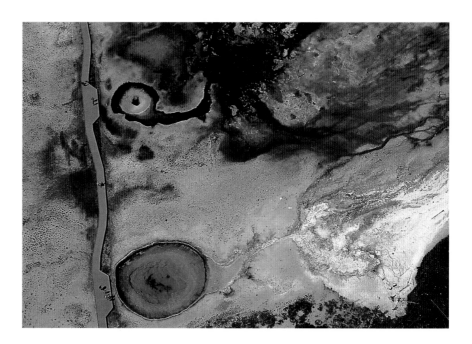

PREVIOUS SPREAD: EARLY-MORNING SUNLIGHT ILLUMINATES THE jagged castlelike spires of the **hoodoos** of the Grand Canyon near Inspiration Point. They are among the park's most dramatic illustrations of the sculptural effects of wind and water erosion on soft rock. ABOVE: Viewed from the air, **Beauty Pool and Chromatic Pool** in the Upper Geyser Basin look like colorful blue and green eyes staring out from the face of Earth. Conjoined pools, Beauty and Chromatic provide an excellent example of "exchange of function," a relationship in which either heat or water shifts from one hydrothermal phenomenon to another. The result is an asymmetrical response in activity: a decline in one and an increase in the other. When the shift occurs between Beauty and Chromatic pools, one overflows and the water level in the other drops.

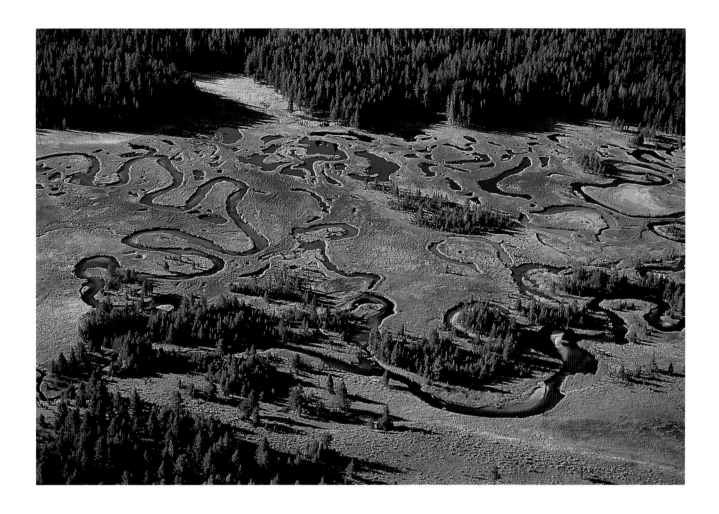

From the air, **Sour Creek**, above, is a colorful mosaic of meandering streams, ponds, ditches and wetlands that cross open pasture. Located just south of the Grand Canyon, Sour Creek joins up with Cotton Grass Creek and flows into the Yellowstone River from the east.

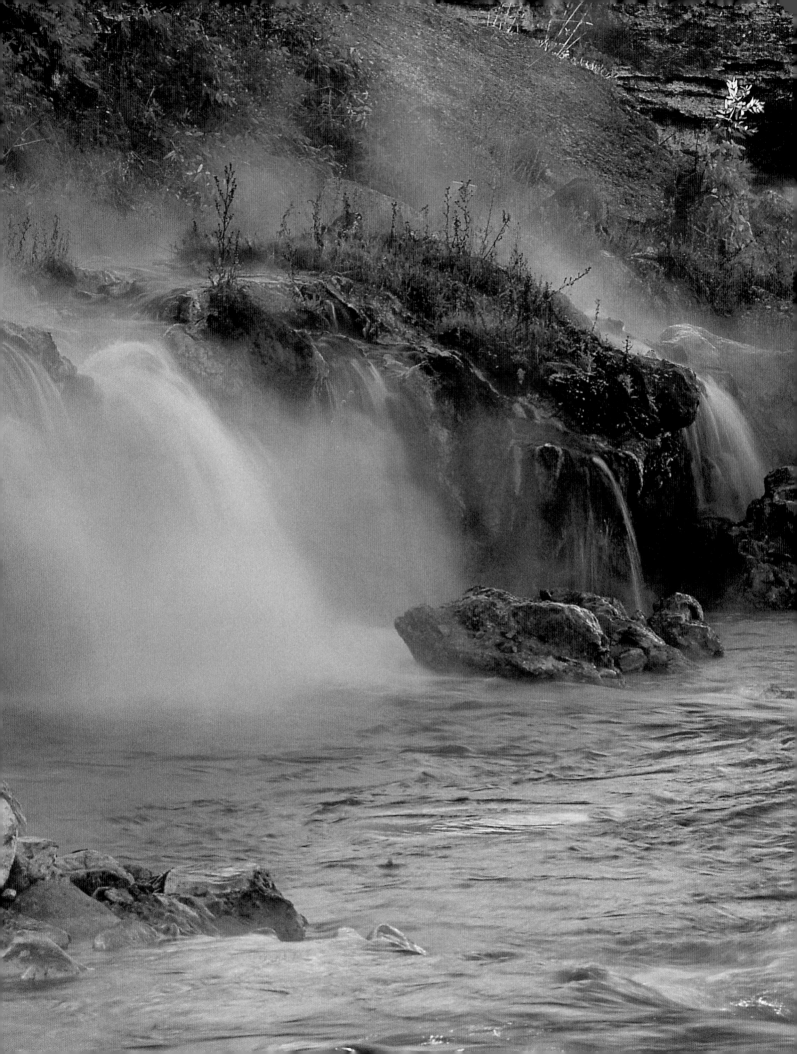

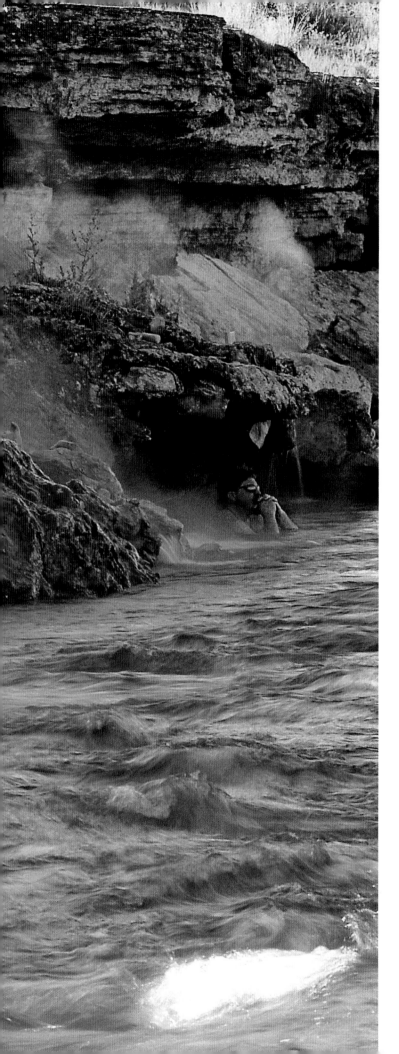

THE PEOPLE'S PARK

THE INSCRIPTION ON ROOSEVELT ARCH AT THE NORTH Entrance to Yellowstone National Park reads: "For the Benefit and the Enjoyment of the People." This gateway has served as both symbolic greeting and practical rendezvous site since early visitors traveled here by stage-coach from the nearby rail station in Gardiner, Montana, to see the world's first national park. In the early 1920s, the park welcomed 20,000 visitors annually; today, that number has soared to three million. Most are curious naturalists who enjoy the visual feast of geysers and breathtaking landforms, but many are also wilderness enthusiasts who ride horses, fish, camp or hike along the park's 1,500 miles of back-country trails in summer and cross-country ski or snowshoe in winter. During the frontier era, conservation was a radical concept and wilderness too often regarded as a missed opportunity to exploit nature's bounty. Rather than provid-ing riches for a few, however, Yellowstone is a measure of the true wealth of a nation, preserved for all to share.

A PARK VISITOR HUNKERED DOWN IN THE **Boiling River**, LEFT, enjoys the restora-tive effects of the hot-spring-infused current. When the park officially opened in 1872, people afflicted with rheumatism began to visit the conflu-ence of the Boiling and Gardner rivers, then known as McGuirk's Medical Springs. Today's weary visitors still enjoy a dip in the soothing warm water.

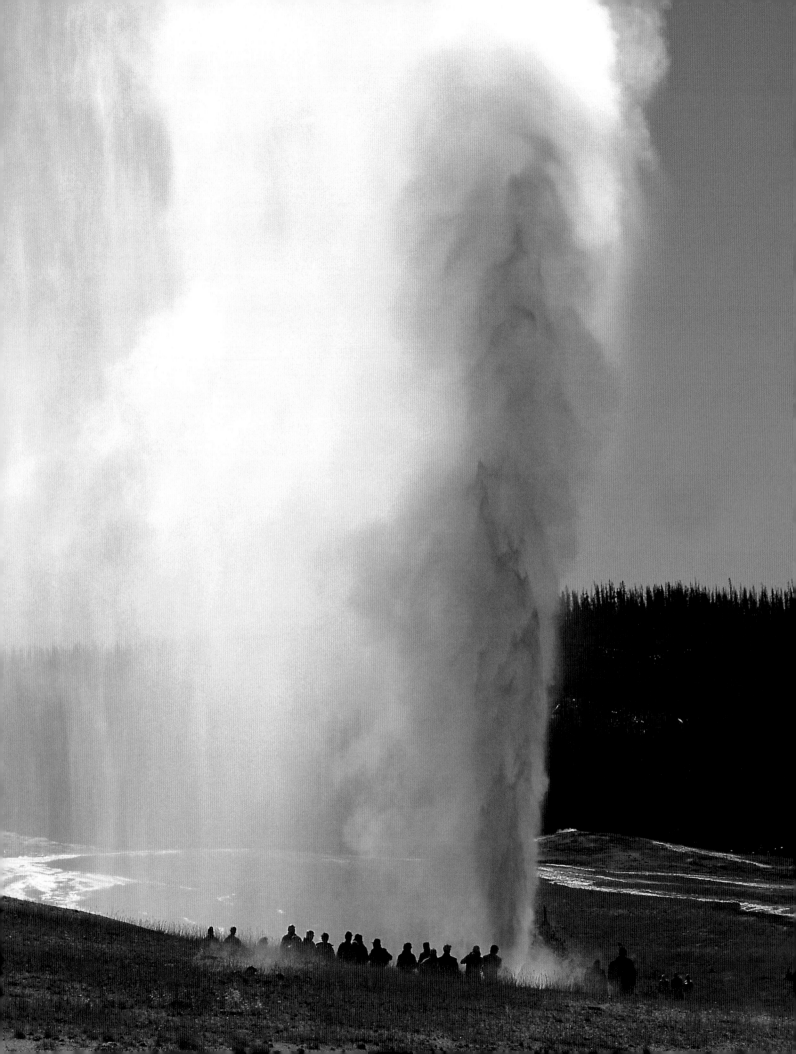

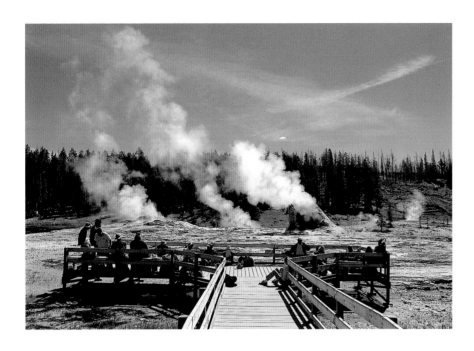

LOCATED A SHORT DISTANCE FROM OLD Faithful, **Beehive Geyser**, FAR LEFT, erupts to a height of 150 feet. Watched by small groups of people, the unique bee-hive-shaped four-foot-tall cone erupted twice a day during the summer of 1997. The clue to Beehive's activity is a nearby steaming vent, dubbed the Beehive Indicator, that forecasts the main geyser's explosion some 20 minutes later. Steaming vents signal to visitors standing on the platform to **Giant Geyser**, LEFT, that patience and good timing will soon be rewarded with a spectacle which had otherwise occurred only once a year throughout the past four decades.

BELOW: Lightning flashes over **Roosevelt Arch** at the North Entrance to the park. On April 24, 1903, President Theodore Roosevelt laid the cornerstone to the new arch, which was constructed of local columnar basalt, similar in composition to the stone found in the Overhanging and Sheepeater cliffs. Rising 50 feet high and buttressed on each side by 12-foot walls, the arch was the first of five entrances established around the perimeter of the park.

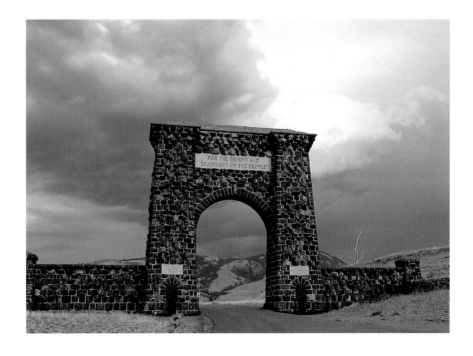

THE RETURN OF *Canis lupus* REPRESENTS the reinstatement of a star wildlife player in the dramatic Yellowstone ecosystem. RIGHT: Loaded down with expensive cameras, heavy binoculars, field scopes and elaborate telephoto lenses, **photographers** patiently wait for the daily parade of wolves, about half a mile away in the Lamar Valley. Although six wolf packs now appear to have established themselves since the species was reintroduced in 1995, wolf watchers must sometimes wait for days—often from sunrise to sunset—for the ideal photo-op of an entire pack playing, hunting or resting in the open. **Snowcoaches**, BELOW, and snowmobiles are the only vehicles permitted in the park during winter. A regular snowcoach service shuttles visitors between all the main villages and Old Faithful. If these vehicles look like a throwback to the 1950s, it's because the original fleet of Bombardier coaches—retrofitted and updated several times—is still in operation.

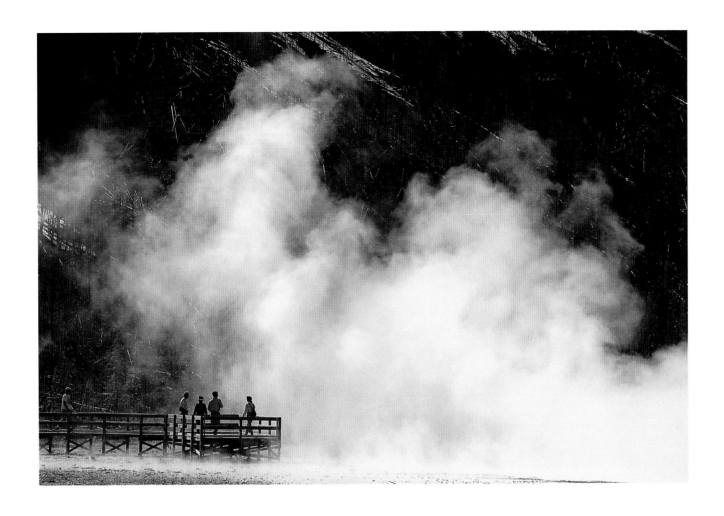

TOURISTS ON A PLATFORM OVERLOOKING **Sunset Lake**, ABOVE, become lost in giant clouds of thick steam rising from the hot water below. Only on very windy summer days is it possible to see the middle of the deep blue lake. Although the eruptions are generally low-level bursts of bubbles that sputter less than 10 feet into the air and last only a few seconds at a time, Sunset Lake is regularly active throughout the day. The lake is in the Black Sand Basin, which is a mile from Old Faithful in the Upper Geyser Basin.

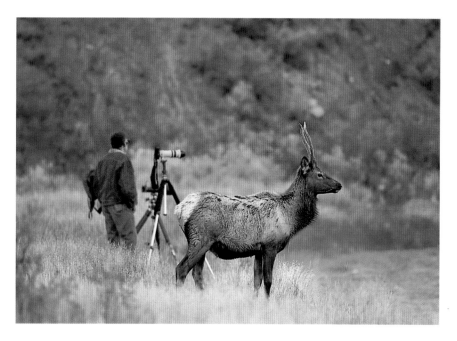

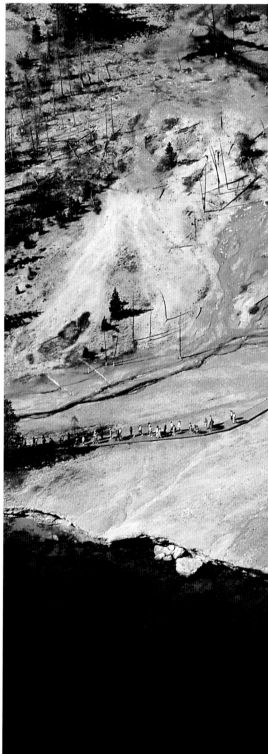

WHILE PHOTOGRAPHING ELK ON THE FAR SIDE OF A RIVER, a visitor is taken by surprise by a curious second **bull elk**, ABOVE. This encounter ended peacefully, but park visitors must take care not to threaten wildlife. Male elk, in particular, can be aggressive during the breeding season, perceiving any kind of confrontation as a threat to their territory. From the air, boardwalks are visible, twisting and turning their way to **Black Pool and Abyss Pool**, RIGHT, at the West Thumb Geyser Basin. The name Black Pool is something of a misnomer, since this pool was never truly black but a deep greenish color caused by a colony of cyanobacteria, more commonly known as blue-green algae, that once thrived in the low-temperature waters. In 1991, however, the frequent eruptions of an adjacent hot pool gradually heated Black Pool, raising its temperature enough to kill off the "algae" and leaving it extremely hot and a brilliant dark azure. Yellowstone's boardwalks, such as the one that skirts Black Pool, are necessary to allow people to move safely through the volcanic park; visitors are discouraged from straying from the beaten path.

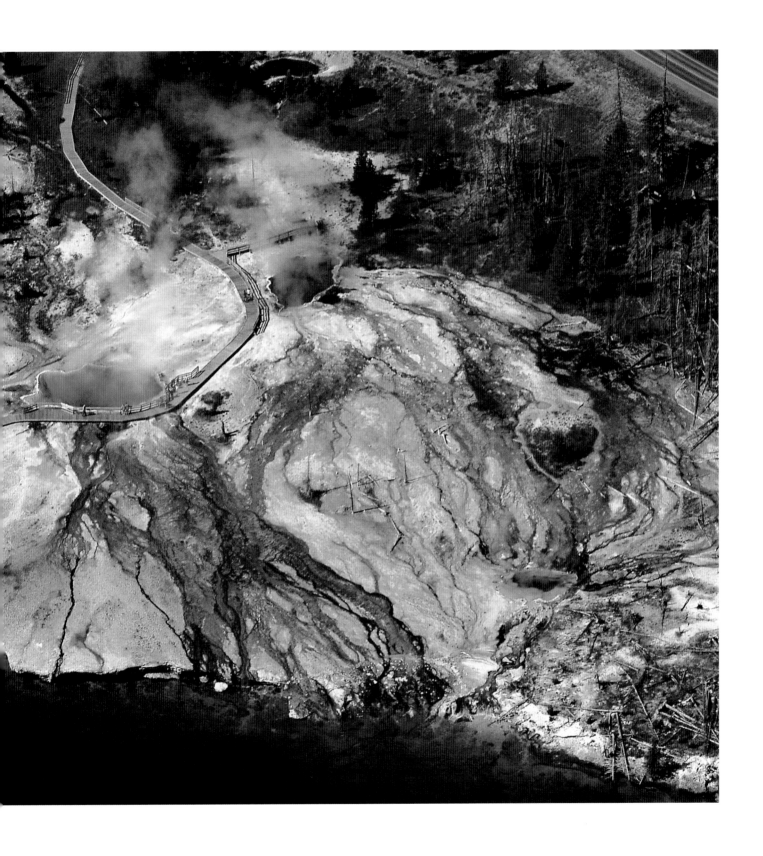

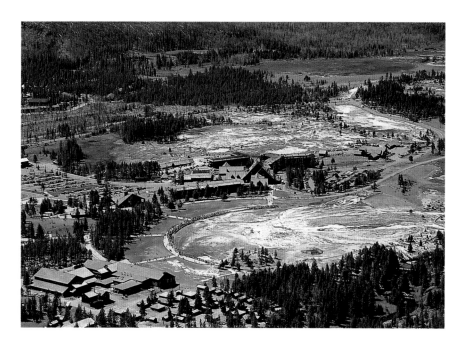

EMBLEMATIC OF YELLOWSTONE GRANDEUR, Old Faithful is a must-see on every geyser gazer's itinerary. To accommodate the geyser's unrivaled popularity, the area surrounding it has become increasingly developed over the years. A handful of the 750 structures in the park, including the **Old Faithful Inn**, LEFT, are National Historic Landmark buildings. Constructed in 1903 with materials found in the area—such as rhyolite lava stones and lodgepole pine logs—Old Faithful Inn epitomizes the rustic design principle of Yellowstone's historic structures. Reputedly the world's largest log structure, the inn boasts a 90-foot-high cathedral ceiling in its lobby. Despite all the improvements to satisfy visitors' needs, less than 3 percent of Yellowstone territory is developed. A herd of elk grazing on the lawn of the **Mammoth Hot Springs Hotel**, BELOW, exemplifies the close contact between humans and wildlife. At home in this setting and tolerant of humans, the elk revert to their shy, wild ways once they return to the outlying meadows.

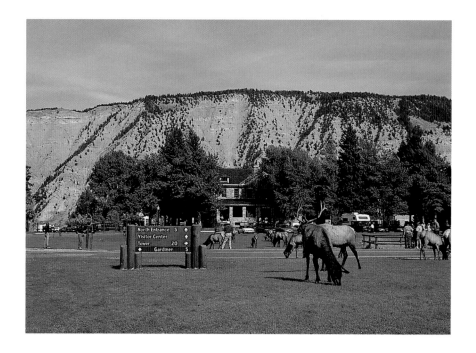

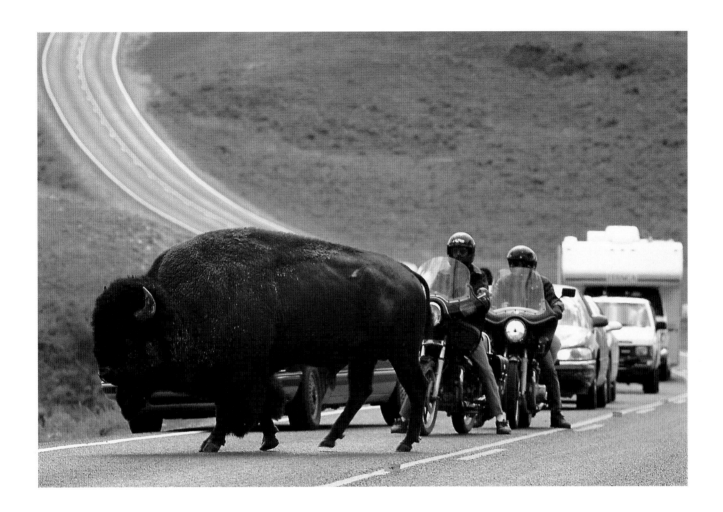

Traffic respectfully stops when North America's largest land animal, the **bison**, ABOVE, strolls across the road in Hayden Valley, the prime summer grazing spot for these gentle giants. Yellowstone is the only location in the United States where bison have lived and roamed freely throughout their history, and since 1968, the Yellowstone population has been allowed to grow and shrink in response to natural environmental conditions. The only exception to the plan is that bison straying outside the park into neighboring Montana are tested for brucellosis and, if necessary, slaughtered to protect the domestic livestock on ranches bordering the park.

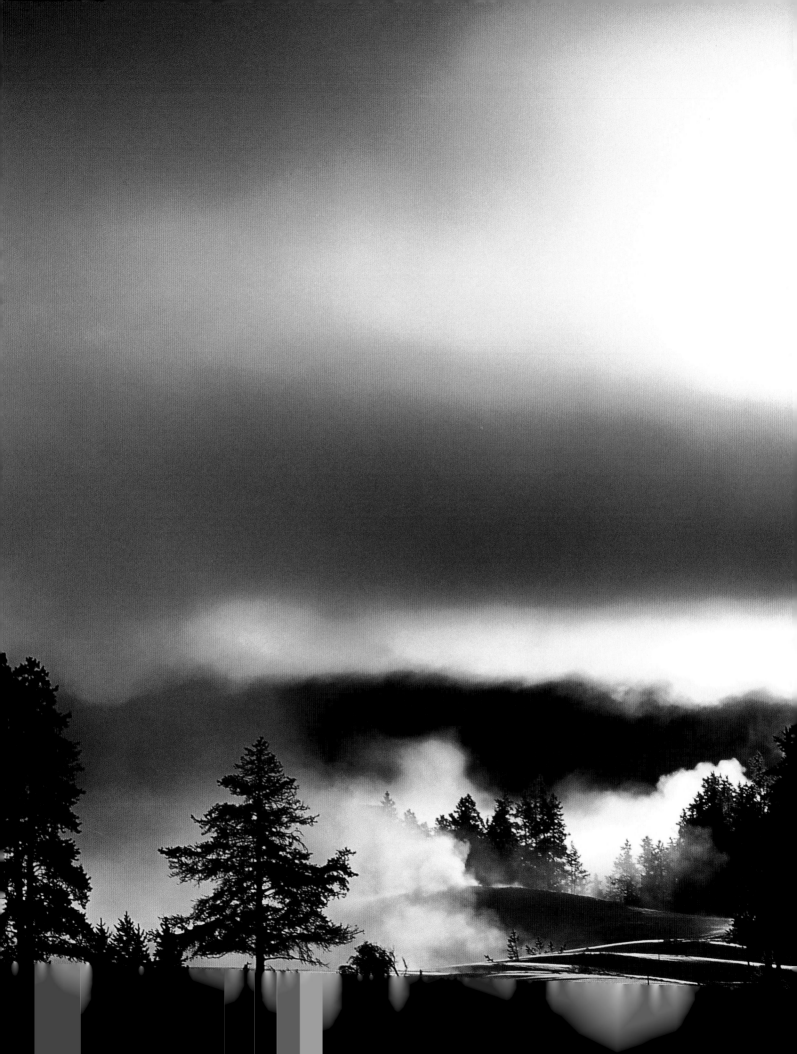

Winter in the Park

THE LONGEST SEASON

LORD BYRON'S FAMOUS OBSERVATION ABOUT ENGLAND'S winter—"ending in July to recommence in August"— aptly describes Yellowstone's longest season. The first hint of winter's imminent arrival is plummeting summer temperatures; shortly afterward, a below-freezing night in September leaves the park covered in a crusty layer of white frost; and by mid-October, the icy subtleties have given way to full-blown winter. The dramatic variations in the park's elevation give rise to equally dramatic differences in temperature and precipitation. Even at the lowest elevations, where the wildlife commonly seeks refuge, temperatures throughout the winter average a bitter 10 degrees F. At these relatively habitable altitudes, the snow cover remains for more than 210 days, accumulating to 10 feet in some areas. Yellowstone's winter belongs to the hardiest wildlife residents and human visitors alike, both eagerly awaiting the first signs of thaw in May.

THE HARSH CONTRAST BETWEEN TWO OF Yellowstone's features—seasonal cold and thermal springs—is the genesis of some of nature's most glorious landscapes. On this morning, as temperatures dip to minus 30 degrees F over the **Upper Geyser Basin**, LEFT, the ice fog that forms over the steaming area of Old Faithful stands in bold relief against the crisp morning air and the darkly silhouetted trees. Hanging heavily in the air, a foggy veil scatters the rising sun's golden light over the surrounding snow-covered land.

127

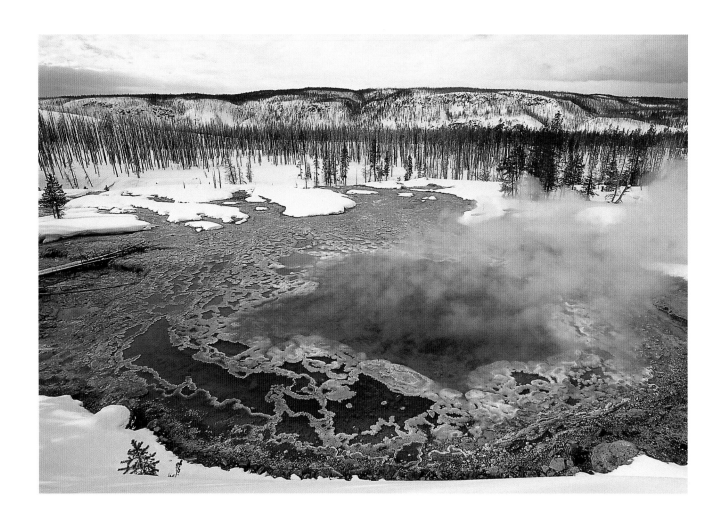

Artemisia Geyser, ABOVE, WHOSE CRATER IS ONE OF THE
largest in Yellowstone, is a steaming rocky cauldron in winter.
Artemisia takes its name from the color of its spectacular sin-
ters—mineral encrustations formed by heat or pressure—which
have the same blue-green tone as North American sagebrush
(*Artemisia* spp). Located a few minutes from Morning Glory
Pool, the geyser erupts every day at 8-to-16-hour intervals.

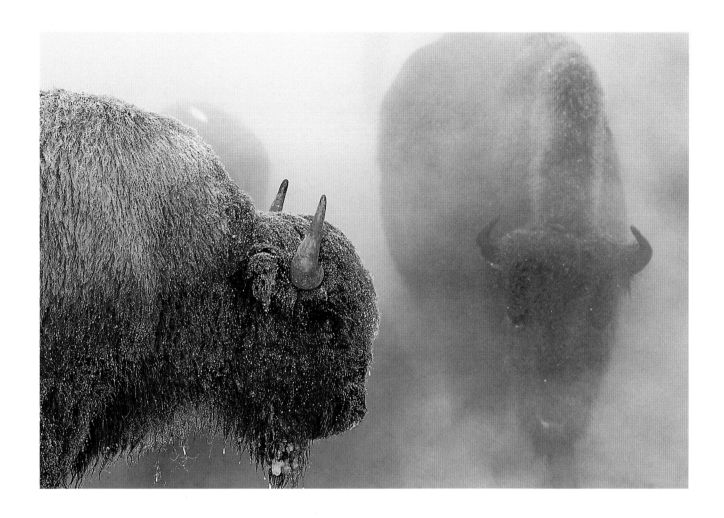

Bison, ABOVE, MEASURE SIX FEET HIGH AT THE SHOULDER AND weigh one ton. Yet even these giants among terrestrial creatures must seek warmth during the harshest Yellowstone season. Hot fumaroles, popular winter meeting places, offer steaming relief from the climatic extremes that have always played a role in the boom and crash of bison populations. Cold, however, is not the most punishing winter threat. When ice covers the meager forage and deep snow makes it difficult for herds to travel to new feeding grounds, many animals starve.

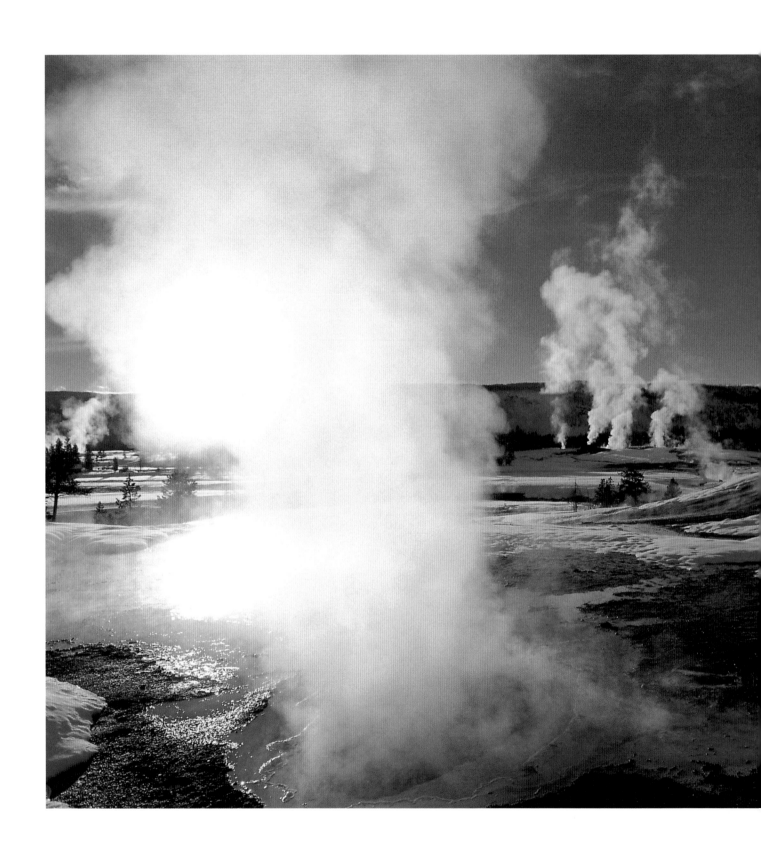

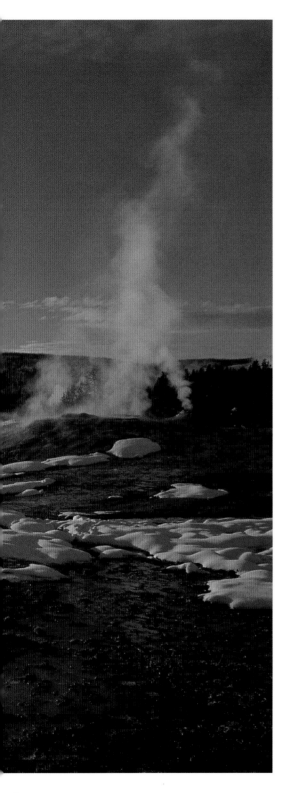

Fuming vents dot the terrain of the **Upper Geyser Basin**, LEFT. As these columns of steam suggest, the basin is the geothermal heart of the park and the home of many of the big-name geysers—Old Faithful, Grand Geyser, Castle Geyser, Cascade Geyser and Giantess Geyser, to name a few. The basin contains some 200 geysers, nearly one-fifth of the world's total number. The basin itself, however, is an extremely small area that covers less than two square miles. While the basin is a must-see attraction for all who visit the park, it has so much thermal activity that for their own safety, visitors must not stray from designated boardwalks and pathways. ABOVE: The high, bitterly cold winds of Yellowstone sculpt a landscape out of snow and ice. Steaming mist released day after day from nearby **Excelsior Geyser** combines with snowfall and flash-freezes to build up thick frosty layers on trees and bushes. Excelsior's most celebrated eruptions occurred in the 1890s, when towering fountains of water sprayed 300 feet into the air. While more than six million gallons of water still burble through Excelsior's cone every day, it is believed that the great eruptions of the past may have permanently damaged the geological pipelines, so the geyser now lies dormant.

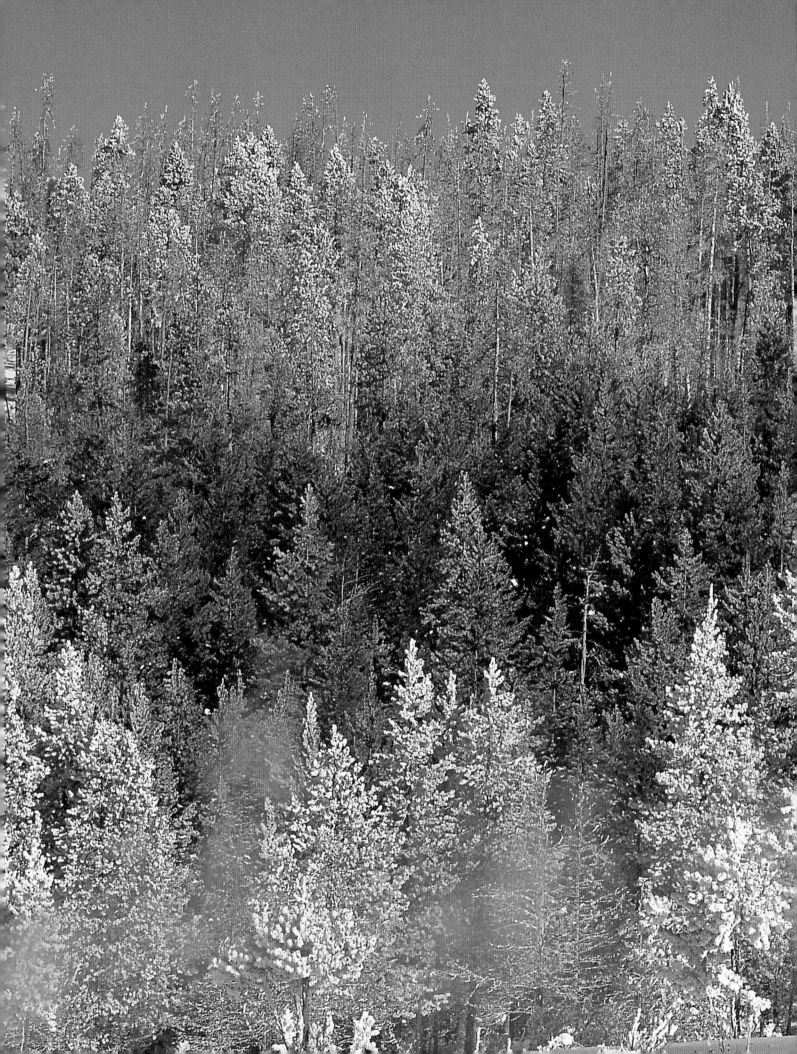

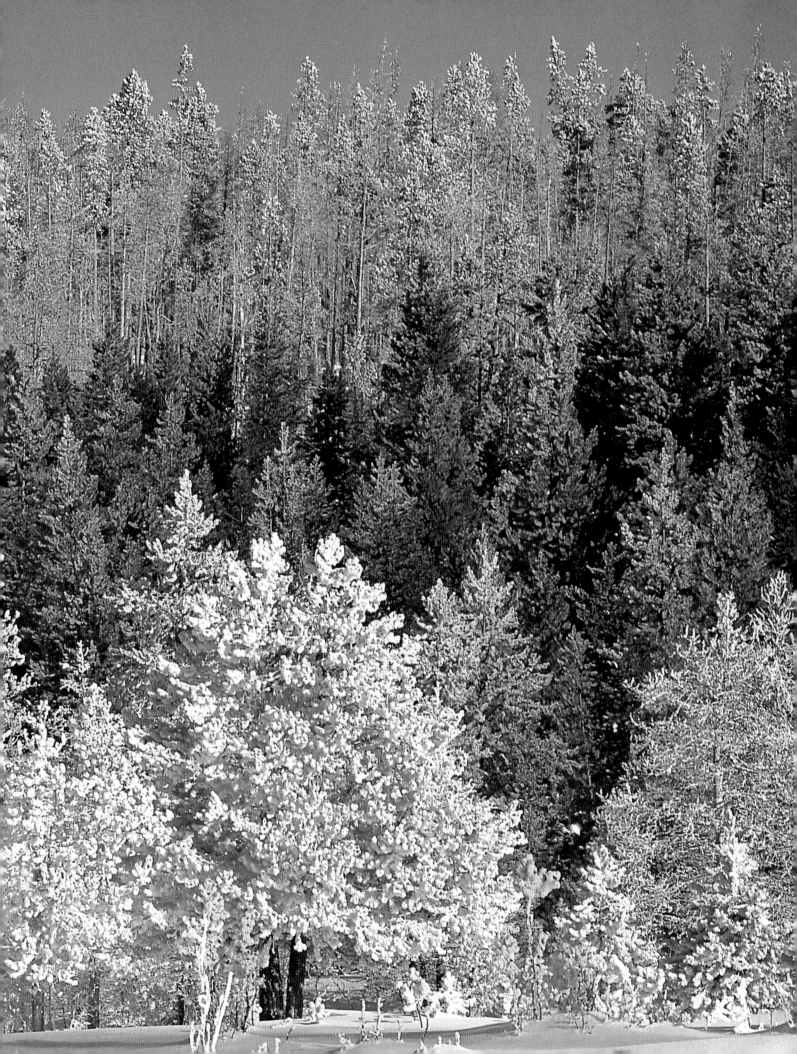

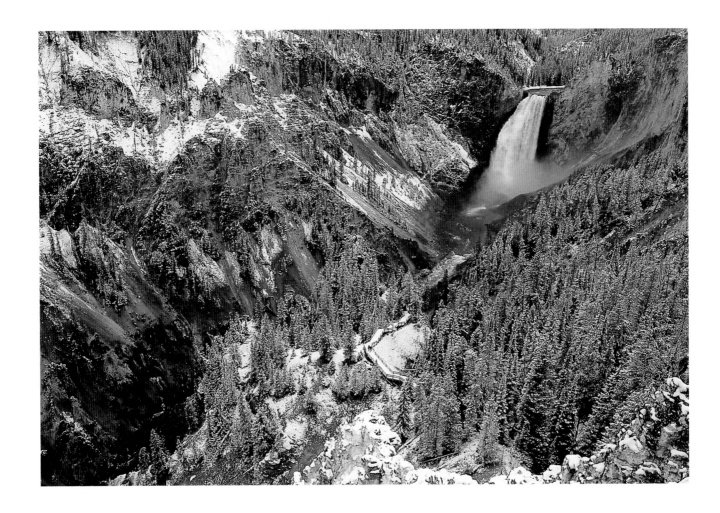

Previous spread: On a clear February morning, hoarfrost covers a forest vista near the Firehole River. Even at the lowest elevations, icy coatings such as this can first appear during Yellowstone's frequent below-freezing September nights. Higher than Niagara Falls, the **Lower Falls**, above, of the Yellowstone River cascades 308 feet to the valley floor. In winter, the Lower Falls partially freezes, and only a stream of water runs from the top of the icy column. Snaking along the canyon, the Yellowstone River has, over thousands of years, created the Grand Canyon of the Yellowstone, seen here from Lookout Point. Twisting and turning for 25 miles, the canyon's sheer rocky embankments tower 1,200 feet above the canyon floor. The action of water on rock has revealed the colorful strata of the canyon walls, the result of overwhelming mineral oxide tints.

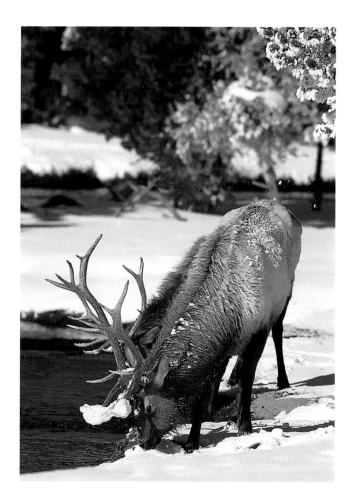

AFTER SCRAPING AWAY SNOW WITH THEIR ANTLERS, TWO **bull elk**, LEFT, feed peacefully near the Firehole River in February. Elk conserve precious energy by traveling as little as possible during winter months. While Yellowstone's wildlife relies on millennia-old adaptive strategies, humans are tireless in their quest to find more convenient ways to optimize their wilderness experience. **Snowmobiles** outside a park lodge, BELOW, are proof of such change. Until 1915, no motorized vehicle was allowed inside the park boundaries (although one resident of Gardiner, Montana, attempted to bring Yellowstone into the automotive age by driving his 1897 Winton through the park gates in July 1902). Nearly a century after that daring feat, snowmobiles, which were first allowed on the groomed roads in the 1970s, are now a familiar part of the winter landscape. During the peak season, as many as 5,000 zip through the park, where their relentless droning shatters the wilderness stillness. Humankind's progress has a price for bison and elk, which risk injury when they share the plowed roads.

Surrounded by a halo of colorful light, an apparition resembling two Yellowstone visitors rises from the boardwalk at the edge of steaming **Excelsior Geyser**, RIGHT. This phenomenon, which allows you to see your own ghost, is known as the Brocken Specter, or Brocken Bow. With the sun behind them and the prismatic droplets of water in front, observers can see their own enlarged silhouettes cast in the cloudy haze. The Brocken Specter was named by climbers who first witnessed such "ghosts" on Brocken Mountain, the highest peak in the Harz Mountains in Germany.

137

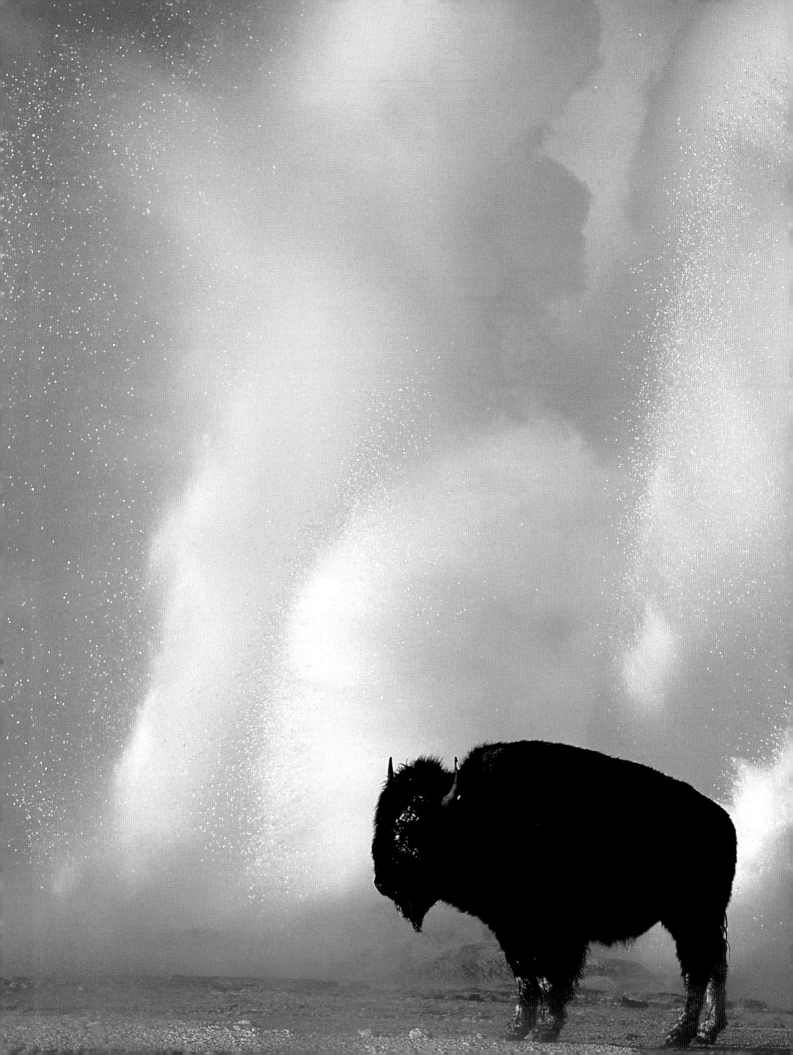

Photo Techniques

BOTH IN THE FIELD AND DURING MY SLIDE PRESENTATIONS, I am invariably asked about the type of equipment I use. While I have had several different systems since I first took up photography, I have, for years, been happily using 35mm Leica R cameras and lenses (no autofocus) with R6.2, R7 and R8 bodies equipped with motor drives. I've discovered, however, that the ease with which my equipment can be handled is even more important than the brand of camera, the lens or the film. The camera has become an extension of my hands, and every photographer should feel just as comfortable with his or her own equipment.

Depending on the circumstances, I employ a variety of lenses. Quality lenses produce the best results in sharpness, brilliance and color saturation. Each of the following lenses (especially the APO series) is designed to be used at wide-open aperture. My preferred lenses range from 15mm super-wide-angle to 50mm standard and 800mm telephoto. I use just one zoom lens, which is a 70-180mm. All the others are fixed-focus lenses: 2.8/19, 2.8/24, 2.8/28PC, 1.4/35, 1.4/50, 1.4/80, 2.8/100 Macro, 2.0/180, 4.0/280 and the Apo Telyt Module System ranging from 2.8/400 to 5.6/800mm. On occasion, I use polarizing filters for better color. I shot most of the images for this book using Fujichrome Velvia 50, Fujichrome Sensia 100 and 200 and Kodachrome 200 films.

The best lens is wasted, however, when vibrations or excited heartbeats blur the image. I use a very stable tripod for 90 percent of my photographs. A professional Manfrotto is great for regular shooting, but when heavy telephoto lenses such as the 5.6/800mm Apo Telyt are used, I recommend a Linhof professional heavy-duty tripod. Although these tripods are weighty to carry around, the results are outstanding.

THE STEAMY SPRAY OF THE HEAVILY erupting **Clepsydra Geyser**, LEFT, offers welcome warmth and a spectacular watery backdrop to a bison in winter. LEFT. Located in the Lower Geyser Basin, Clepsydra has been perpetually active for decades, falling quiet only when Great Fountain Geyser erupts.

139

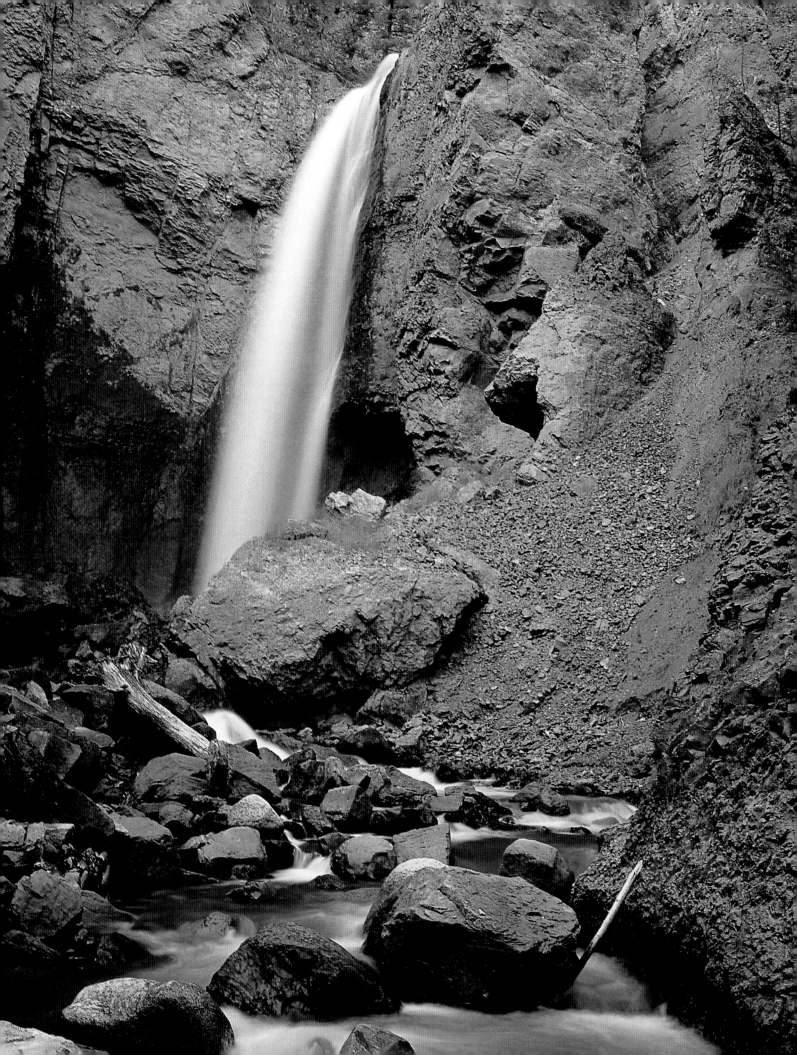

Beyond equipment, a photographer's most important ally is patience, a quality that is especially valuable when the assignment includes photographing the geysers in Yellowstone. I sat for hours at Grand, Castle and Beehive geysers; at Giant, I spent days and weeks waiting for the right light to coincide with its renewed eruptions. At the park's Grand Canyon, you can be rewarded with perfect light on nearly any day of the week, but as you become more discriminating, it may take a lot longer for the right conditions to materialize. For example, I had to make about 20 visits to the canyon for the images I had in mind, an investment in time and energy that ultimately paid off.

But no matter how spectacular the view, novice and experienced photographers alike can benefit from first getting a feel for their subject. Even as a seasoned photographer, I was overwhelmed by the beauty of Yellowstone's thermal features, animals and landscape when I visited for the first time in August 1995. Before taking any pictures, I traveled and talked with visitors and park rangers about some of Yellowstone's unique features. The information I gleaned from them, combined with my own observations, helped shape my sense of where I wanted to begin.

These days, the field of photography is flooded with a multitude of new tools for manipulating photographic images. Every outstanding photograph published or exhibited in a show is now questioned: "This can't be real! Was it done in Photoshop?" As a result, nature photographers who do not alter their photographs spend a lot of time defending the authenticity of their work. The photographs in this book and in my other books are not manipulated on a computer. I will add, however, that I photographed the wildlife images that appear on the following pages under controlled conditions so as not to create an invasive presence in the wilderness habitat: 4, 58, 61, 64, 68 (top) and 76.

When I began taking photographs 20 years ago, I had no money, little equipment and a head filled with dreams. If somebody had told me then that I would become a polar bear and Arctic photography specialist or that one day I would spend a year in Yellowstone National Park, I would not have believed it possible. But I was determined to be a nature and wildlife photographer.

I have found books, magazines and exhibitions featuring the works of famous photographers such as Ansel Adams, Ernst Haas, Frans Lanting, Art Wolfe, Galen Rowell, Sebastiao Salgado, Fritz Poelking, Konrad Wothe, Gunther Ziesler, Dan Guravich, Fred Bruemmer, Thomas Mangelsen, Michio Hoshino and Leonard Lee Rue III to be an endless source of inspiration. Reading, studying and looking over the shoulders of other photographers in the field will likewise open up the world of photography to you. Joining a photographic association is another rewarding way to improve your technique.

Some of the world's most beautiful photographs have been taken with equipment that is primitive by today's standards, but such images are memorable because of the artists who composed them rather than the complexity of the camera system used. In the end, the eye behind the viewfinder determines when the shutter is clicked.

SURROUNDED BY JAGGED RHYOLITE SPIRES, **Tower Falls**, FAR LEFT, is a rumbling waterfall at the north end of Yellowstone's Grand Canyon. Tower Falls was among the magical landscapes presented to the world by artist Thomas Moran, who traveled to the Yellowstone region in 1871. Moran's work, along with the photography of William Henry Jackson, played an important role in making a tangible reality of an apparently mythical landscape and helped persuade both the public and the U.S. Congress that the region was worthy of protection. LEFT: The exquisite **calypso orchid** is one of the park's many wildflowers.

Index

Further Reading

The Geysers of Yellowstone (Third Edition). T. Scott Bryan. University of Colorado Press, 1995.

The Discovery of Yellowstone Park: Journal of the Washburn Expedition to the Yellowstone and Firehole Rivers in the Year 1870. Nathaniel Pitt Langford. University of Nebraska Press, 1972.

Further Information

Yellowstone General Information: (307) 344-7381

Visit the Yellowstone Home Page: http://www.nps.gov/yell/index.htm

The North American Nature Photography Association (NANPA)
10200 West 44th. Ave. #304
Wheat Ridge, CO 80033

Photo Index

Map of Yellowstone

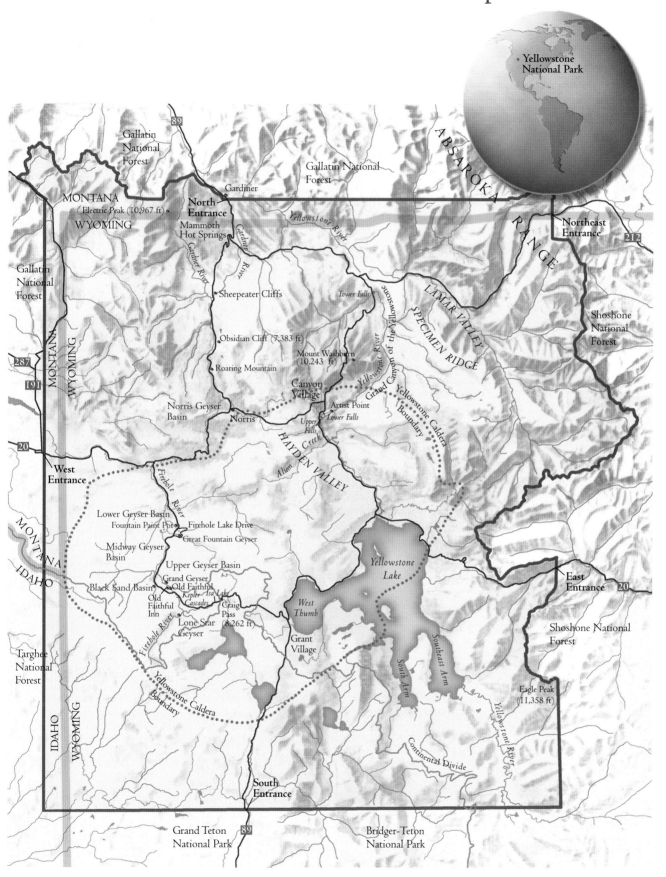

Yellowstone
National Park

ABSAROKA RANGE

89

Gallatin
National
Forest

Gallatin National
Forest

Gardiner

MONTANA
WYOMING

North
Entrance

Electric Peak (10,967 ft)

Mammoth
Hot Springs

Gardiner River

Yellowstone River

Northeast
Entrance

212

Gallatin
National
Forest

287

191

20

Sheepeater Cliffs

Obsidian Cliff (7,383 ft)

Roaring Mountain

Norris Geyser
Basin

Norris

Gardner River

Tower Falls

Mount Washburn
(10,243 ft)

Canyon
Village

Artist Point
Lower Falls

Upper
Falls

Grand Canyon of the Yellowstone

Yellowstone River

LAMAR VALLEY

SPECIMEN RIDGE

Shoshone
National
Forest

Yellowstone Caldera
Boundary

MONTANA
WYOMING

West
Entrance

Firehole River

HAYDEN VALLEY

Alum Creek

Lower Geyser Basin
Fountain Paint Pot
Midway Geyser
Basin

Firehole Lake Drive
Great Fountain Geyser

Upper Geyser Basin
Grand Geyser
Old Faithful
Black Sand Basin
Old
Faithful
Inn

Kepler Isa Lake
Cascades
Craig
Pass
(8,262 ft)

Lone Star
Geyser

Firehole River

Yellowstone Caldera
Boundary

MONTANA
IDAHO

Targhee
National
Forest

IDAHO
WYOMING

West
Thumb

Yellowstone
Lake

Grant
Village

South
Arm

Southeast Arm

East
Entrance

20

Shoshone National
Forest

Eagle Peak
(11,358 ft)

Continental Divide

Yellowstone River

South
Entrance

89

Grand Teton
National Park

Bridger-Teton
National Park